New Eyes for Plants

New Eyes for Plants

A workbook for observing and drawing plants

Margaret Colquhoun
and
Axel Ewald

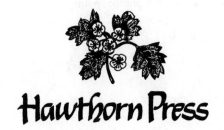

Hawthorn Press

New Eyes for Plants
© 1996 Margaret Colquhoun and Axel Ewald
Published by Hawthorn Press
Hawthorn House, 1 Lansdown Lane, Lansdown,
Stroud GL5 1BJ, United Kingdom

Typeset in Times New Roman by Bookcraft, Stroud.
Printed in the United Kingdom by Redwood.
Cover and all illustrations by Axel Ewald.

British Library Cataloguing in Publication Data applied for
ISBN 1 869890 85 X

Contents

Foreword

This book invites us to go on a journey, not simply of the imagination but also of activity and transformation. The invitation is to reconnect with the living forms around us by looking and doing so that our eyes are opened to the nature of plant life. The nature revealed has both the truth of scientific knowledge and the beauty of the creative act so that we experience plants as simultaneously archetypal and forever new. The door opens onto a new way of practising science as art that avoids the anaesthesia of a purely objective study of nature by including aesthetic experience or feeling and willing activity as primary, conscious components of our understanding.

Our guides on this journey are two practitioners of this new science, Margaret Colquhoun with a background in conventional science and Axel Ewald, an artist. The book grows out of years of collaborative exploration, research and teaching which has allowed them to construct this beautifully integrated work, with text and image speaking to each other on every page. The drawings resonate with the relationship to nature that inspires the work of Andy Goldsworthy and David Nash, while the text achieves the directness and the simplicity of intimate conversation arising from real understanding. The impulse engendered by this workbook to participate by looking, drawing and experiencing the plants that surround us is irresistible.

The tradition within which this union belongs goes back to Goethe and the romantics, who reacted against Kant's separation of science from art and his denial that there could ever be a "Newton of the grass blades". In one sense he was perfectly right – life resists the mechanical description of the type that characterises Newtonian science, as we can now see so clearly in the attempts of contemporary biologists to describe living processes in terms of genes and molecules. The result is that organisms have disappeared as real entities from biology; life slips through the fingers, leaving us nothing but skeletons. So we need to return to a tradition that allows us to truly encounter the living reality that surrounds us, on which we depend not simply for our survival but also to understand and express our own natures. This emerges repeatedly in the book, as in the following passage describing the meaning of the leaf sequence of a plant, out of which emerges the flower. All the wonderful transformations in the leaf regions are incomprehensible (or even unnoticed) until the plant flowers and then, in retrospect, their meaning is obvious.

Similarly the journey of getting to know someone or something is often like this. Again and again we reach a moment of recognition of the other for what it or he or she is which flowers in us again and again until at a certain moment there is the experience of inner union, of being at one with. It is a state of being, of intimate union, known and described by artists, lovers and mystics – no less by scientists:

> *The state of feeling which makes one capable of such achievement is akin to that of the religious worshipper or one who is in love –* Albert Einstein.

As contemporary biology loses its way in the tangled undergrowth of molecular detail and Just So Stories, and an objectivity that turns life into manipulable, marketable commodities – a new biology is emerging that preserves everything of value that has been learned but restores the wholeness, the integrity of life by healing our relationship to it. This workbook invites us to find out how this can be done.

Dr Brian Goodwin
Department of Biology
The Open University
Milton Keynes

Preface

This book has arisen out of a series of courses, known as the Life Science Seminar, which we have been offering since 1990 in different locations and varying social contexts within the British Isles. The Life Science Seminar was created in order to *bring together science and art in the doing*. In the courses carefully guided Nature observation has been complemented by artistic activities which aimed to deepen perception and allow the fruits of the cognitive process to flow directly into the doing. This breathing in and out between science and art has shown itself to be a very satisfying and therapeutic way of learning. Each of the courses, all of which have been open to anyone regardless of age or background, has been a journey of *awakening through experience*, both in perception of the world of Nature around us and of our own inner creativity; a journey onto which the course leaders and participants have embarked together and during which we all have learned from each other.

In writing this book we are responding to repeated requests to share some of the fruits of these journeys and to make them available to a wider audience. Of course, reading a book can never replace the living experience of intensively studying and creating with a group of people. We hope that, nevertheless, this little book will encourage you, dear reader, to embark on your own individual journey of discovery. Maybe you would like to share it with somebody else and ask a friend to accompany you on your excursion into the living world of plants.

This book is not meant as a source of information but rather as a *workbook*, the success of which depends on *your active participation*. Take it with you on your excursions into Nature, see and check for yourself, if you can verify our descriptions. This book describes many exercises which, we hope, will kindle your creative activity and inspire you to invent your own variations. The chapters follow the *course of the seasons*, starting with autumn in chapter 1 and concluding with autumn again in chapter 6. You may want to work your way through this book slowly reading each chapter in the season which it belongs to; or you might as well read the whole book first and then come back to each individual chapter when the relevant season begins.

If we succeed in engendering in you, our reader, a sense of wonder, an active interest in the living world of plants and a creative participation in their growth and development, then we can hope to have laid some seeds for the development of new organs of perception; seeds for the development of *"New Eyes for Plants"*.

We would like to take this opportunity to acknowledge the help, support and inspiration of a number of people without whom this book would not have come about: Firstly the many participants of our courses who provided supportive feedback and critique which proved to be indispensable for the refinement of the pedagogical method; then our teachers and mentors, of whom we can only mention those which have been most instrumental in allowing us to experience different aspects of the application of the Goethean method in science and art: Jochen Bockemuehl, Thomas Goebel and Wilhelm Reichert; and last but not least our publisher, Martin Large, without whose enthusiasm and support our ideas would not have grown beyond a few notes and scribbles into the book it has now become.

1 A Question of Life – or not

Stones and Potatoes

Imagine it is autumn – late October or November. Most of the leaves have turned and fallen, their rich red-gold carrying summer's warmth down, blanketing the earth. Grey ghosts of beech trees swathed in mist; the ground a mud-mixed mush of wet soil, rotting leaves and stems. You are grovelling, back bent, mind blank, hands by boots, both plastered in cloying clay, picking potatoes. Here a handful moves with ease, there one has to be dug out. A gentle rhythm shifts potatoes from soil to bucket. Here's a stone – throw it away – oh no! – perhaps it was a potato! How do I know the difference? What a question! Let's have a rest and straighten the back to consider this one.

Fig. 1. Picking potatoes in autumn – how do I know the difference between stones and potatoes? [pencil].

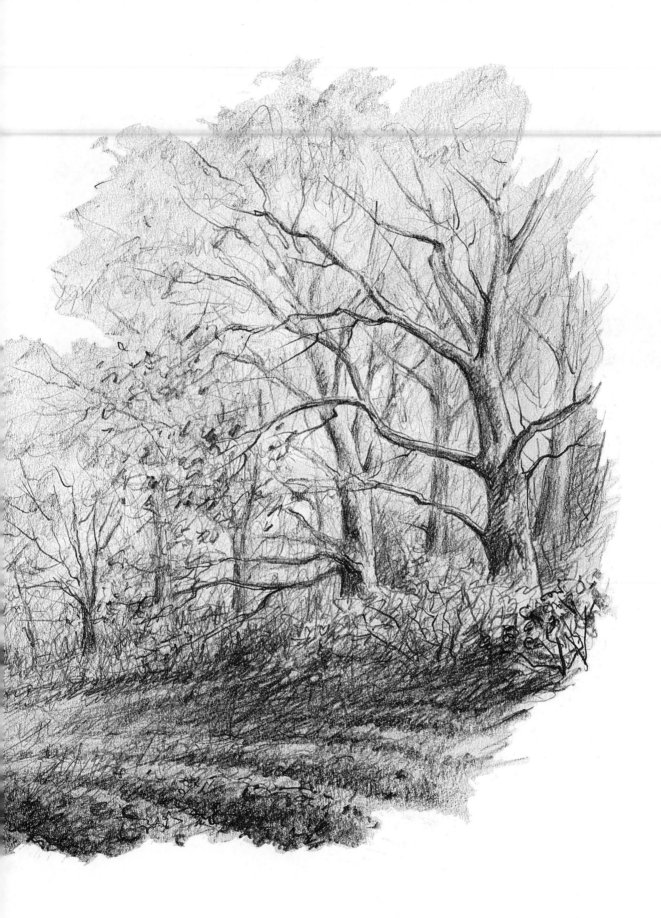

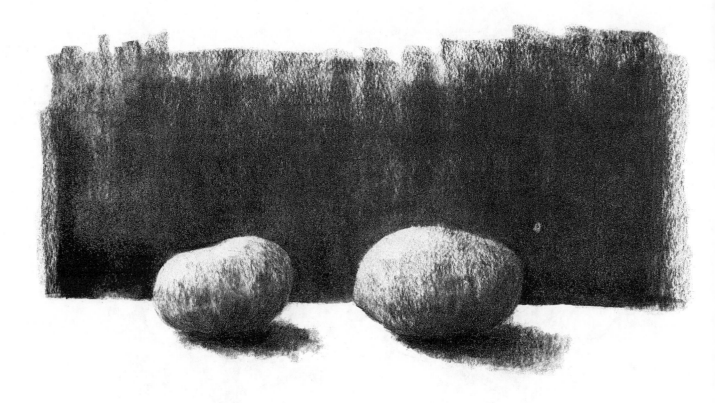

Fig.2. Stone or potato? [charcoal]

How do you tell the difference between a stone and a potato? (Fig. 2) Both are rounded and smooth, hard and heavy. Both fall to the ground if I drop them, make a similar impact in the soil, a similar sound in the bucket. Both are impervious to the light, cast shadows, resist the pressure of my finger, have a crusty exterior. But the inside of a stone is rather like the outside – at least with these sandy crumbling lumps lying here – whereas the inside of a potato is quite different from the outside! Where the rabbits have chewed them they glisten white, and some have gone mushy inside. This reminds me of the ones we planted in the spring. Perhaps it is one of them that is now a rotting wet mass. But where have the new ones come from – these hard rounded nuggets of food for the winter?

Thinking back to the spring, those we planted were quite different with their wizened, wrinkled skins and here and there white whiskers and little purple green sprouts (Fig. 3). You had to be very careful to put them in the ground with the whiskery roots down and the sprouts up and, of course, you had to remove all but the biggest sprouts. But how did such a wizened old thing produce all this mass of golden fruits? ("earth apples" they call them in some countries!). Of course there was a big green bushy plant there in between (Fig. 4), but does this explain how the new potatoes came about?

Fig. 4. Fully grown potato plant. [pencil]

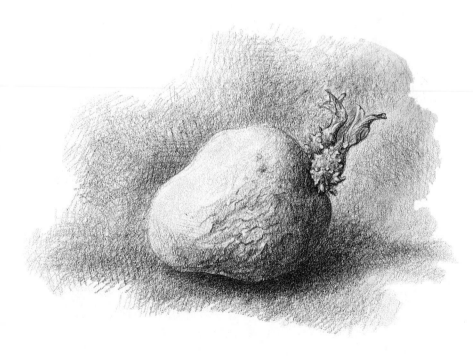

Fig. 3. Sprouting potato [pencil].

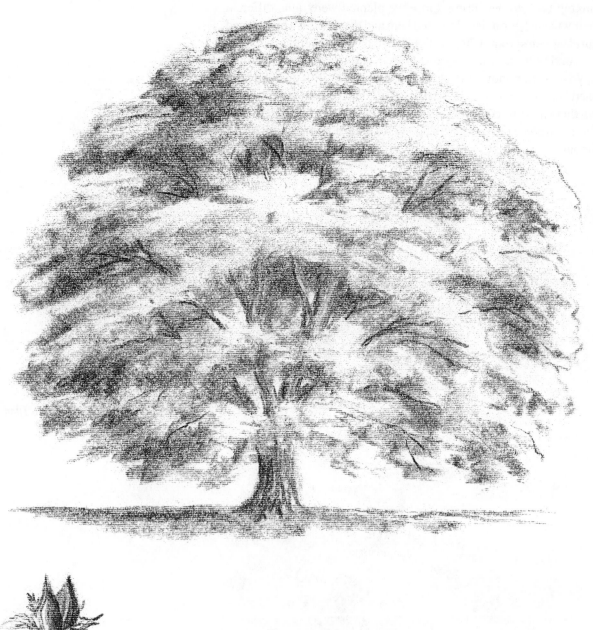

*Fig. 5. Beech tree and beech nut (not to scale).
[charcoal on Ingres paper]*

Come to think of it, how on earth did all these mighty beech trees along the field grow out of those tiny little beechnuts that are scattered around among the fallen leaves? (Fig. 5). It really seems rather impossible that this could happen – and yet it does!

By now one of the differences between stones and potatoes begins to be quite obvious: left to itself, the potato will change in time out of itself. Left under a sink, in a cellar or clamp, all the potatoes throughout the northern hemisphere of the globe will start to shrivel and make white whiskers and shoots at the beginning of the year. The stones which have managed to find their way into the cellar will not. They may be rubbed or chipped from the outside but they *do not grow*. Growing is a change in time which is inexplicable from the outer conditions such as warmth, light or water alone. It may be speeded up or slowed down by outer circumstances but growth itself is, to a certain extent, independent of external factors. It just seems to happen!

We are able to recognise the difference between stones and potatoes without too much difficulty. Holding one of each in our hands we might even be able to say with conviction that one is "alive" and one is not. But what does this mean and how can we begin to investigate this quality of being able to change, to grow, of *being alive* which the potato has and the stone has not?

Doing Science

The activity of doing science is the *pursuit of knowledge*. This is not only something that other people in white coats in laboratories do on our behalf but it is also what we ourselves do many times every day when we discover something we did not know yesterday. Science belongs to the basic daily activity of every human being; indeed it seems to be a basic human necessity. It began in each of us as children when we learned to wonder; when we started to explore things in our surroundings out of interest. Wonder or interest leads to questions and finding out the answers to the questions, one could say, is *doing science*.

Let us begin by simply looking at the world around us – and then reflect on the process itself of finding out how things work. Take a candle in some kind of holder and place it on a white tablecloth or similar light, smooth surface in a poorly lit room. Take a box of matches and light the candle. Place an object – the box of matches will do – on the cloth fairly near the candle (Fig. 6). What do you see on the table? Move the matchbox nearer to and further away from the candle. Lift the candle and move it whilst keeping the matchbox still. Observe everything very carefully and see if you can find a law which will encompass all the observable phenomena so that you can eventually predict exactly what will happen whatever you do.

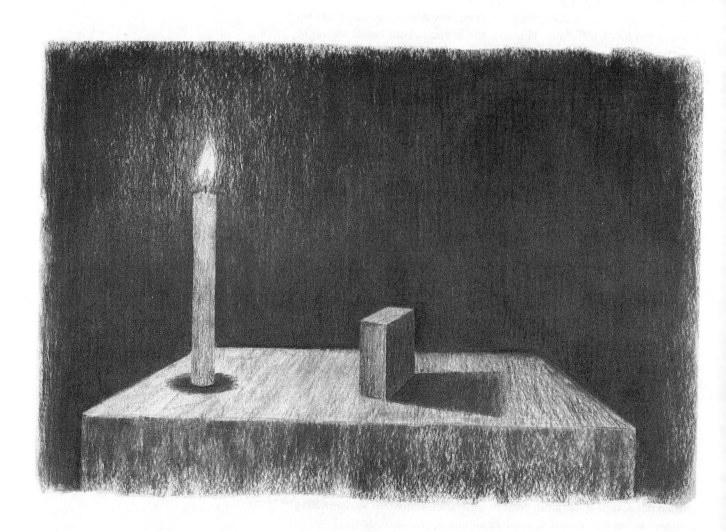

Fig. 6. Experiment using a candle and a matchbox to cast shadows onto the surface of a table. [charcoal]

Now take a twig from a beech tree and look at the buds (Fig. 7). Is it possible to find a law with which to predict how next year's shoot with all its leaves will come out of the bud? You can watch the leaves unfold in spring and the new twig grow (Fig. 8). You can note very exactly the sequence of events and the shapes of the leaves but can you explain or predict how many leaves there will be and exactly when and how they will grow or even which bud will open and which not?

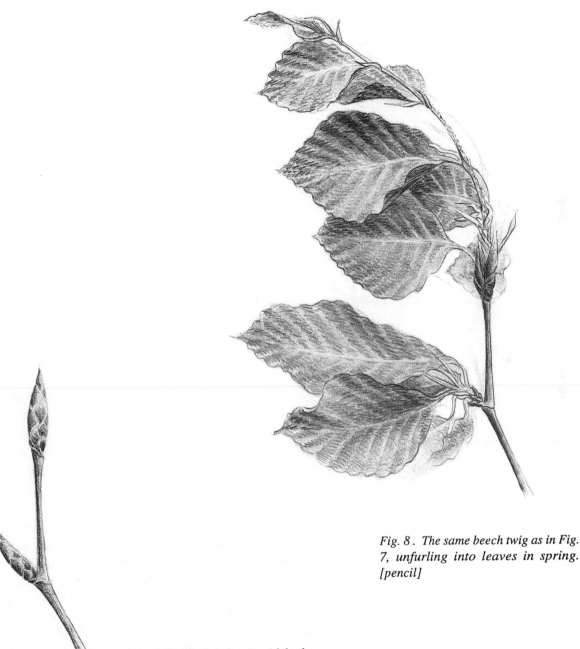

Fig. 8. *The same beech twig as in Fig. 7, unfurling into leaves in spring. [pencil]*

Fig. 7. *Beech twig with buds in winter. [pencil]*

Or perhaps you'd like to plant a seed and watch the resultant seedling appear, grow up, flower and produce seeds itself. You may be able to describe and draw, as we have done for this groundsel plant (Fig. 9), the sequence of events from seed to seedling to flowering plant and so on, but can you find the laws of plant development in the same way as were able to describe the laws of shadows "growing"? What is the difference?

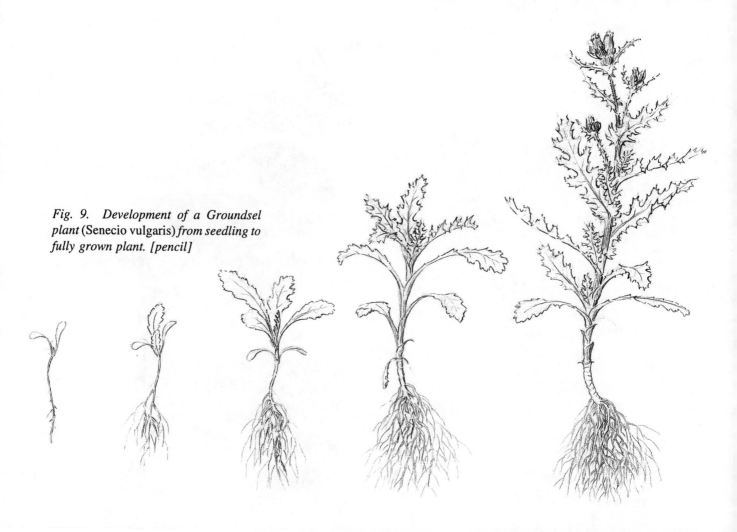

Fig. 9. Development of a Groundsel plant (Senecio vulgaris) *from seedling to fully grown plant. [pencil]*

We are back to the stone and potato question. Both stone and potato cast shadows. So do beech buds and groundsel seeds. But potatoes, buds and seeds have something that stones and matchboxes do not. This "something" is capable of producing a change in time for which outer circumstances alone are unaccountable. This apparently self-impelled development is inexplicable to that aspect of our understanding which can comprehend the shadow experiment. However hard we try and get near to an "explanation" through ideas of atoms, molecules, auxins (plant hormones) and the like no self-respecting scientist would ever admit to

being able to understand or explain the secret of life in the same way that it is possible to see through and comprehend absolutely clearly the cause and effect of shadow production from a given source of light. Roots are *not* the cause of the plant shoot. The sun does *not* create the flower. And yet there seems to be an inner lawfulness about the sequence of events we have described which happens more or less similarly to every groundsel that grows and to every beech bud unfolding or potato sprouting in the spring. How can we study this more exactly? How do we begin to investigate the phenomena of living organisms? How do we develop a way of perceiving and thinking which will do justice to life processes, and enable us to research into that "something" which makes the potato different from the stone and which makes groundsel grow? We will need this if we are to understand organic Nature as clearly as we can understand how shadows are cast.

Who is shining the Light?

The laws of shadow production are so obvious to healthy common sense that from any given set of circumstances involving a light source, a solid object and a plane surface we can easily predict the resulting shadow with the help of a simple geometrical construction. If a candle 6" high is placed a distance of 6" away from a matchbox 2" high, what is the length of the shadow on the table? The drawing (Fig. 10) shows you how to find the size of the shadow by drawing a straight line which projects the height of the matchbox onto the line representing the table. You can draw this to scale and check your findings with the real candle, matchbox and table.

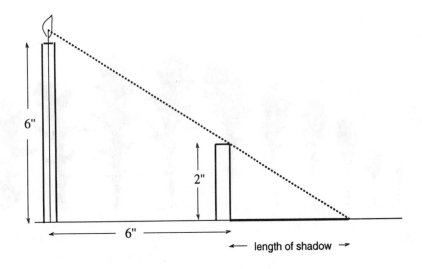

Fig. 10. Diagram illustrating the geometrical construction of shadow projection

6"

2"

6"

← length of shadow →

Fig. 11. Shadow patterns produced by a matchbox corresponding to a number of different positions of the lightsource (candle).

Once you have understood this "straight-forward" principle of shadow projection you can construct and predict the shadows of even more complicated objects. Also the perhaps otherwise perplexing outcome of the following experiment will become transparent to your understanding: With the matchbox standing on a white sheet of paper slowly move a lighted candle around the matchbox varying the height as well as the distance. Trace the outline of the shadows corresponding to a number of different positions of the candle onto the paper. The result might look like our illustration (Fig. 11). These patterns can be seen as a metamorphic sequence of two-dimensional forms resulting from a continuous event which happened in time in three dimensions. *We* have created a metamorphic sequence of forms. They can easily be reproduced in exactly the same way as long as the same set of circumstances is repeated.

This sequence of separate forms drawn in two dimensions is literally a shadow representation of a continuous event (involving somebody moving a candle) which happened in time in three dimensions. Something comparable to this, from a certain point of view, we can also find in our groundsel plant if we remove the leaves and lay them flat on a piece of paper, in the same order in which they grew on the plant. Fig. 12 shows a sequence of separate forms, appearing in two dimensions (flat), as a representation of a continuous event (groundsel growing) which happened in time in three dimensions. (These are photocopies made from

Fig. 12 (below). Leaf sequence of Groundsel (Senecio vulgaris).

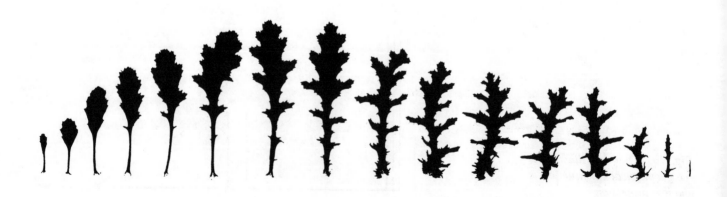

pressed leaves, all of which were taken from the same plant at the same point of time. If you want to do this for yourself make sure that you only pick the leaves from the main stem and arrange them in the order in which they grew on the plant. For instructions on how to press leaves please consult the appendix.)

You can also do this for yourself taking care only to remove the leaves on the main stem (Groundsel grows everywhere all the year round – its Anglo Saxon name groundeswelge means "ground swallower" and its modern Scots name is "Grundy swallow"). In doing this you might find yourself wondering what has caused this remarkable phenomenon?

Who is shining the light? What is projecting these forms into the physical planes of the leaves of a growing plant? What is more, how do we begin to investigate who might be shining the light?

J. W. v. Goethe – An Artist's Contribution to Science

It may be apparent by now that there is a large part of the process of "coming into being" of forms in organic Nature which is invisible to our eyes and incomprehensible to our normal powers of intellect. This gulf which obviously exists between the non-living and the living worlds was generally acknowledged by scientists (and mankind in general) to be present since science began and indeed, until recently, was considered to be insurmountable. "Life-force" or "ether" was the mystical factor that one had to add to the non-living parts to make sense of how something manifested life. Kant, the philosopher whose ideas still stand behind much of our modern way of thinking, even tried to justify why human beings could not bridge this gulf. He said the type of intelligence needed in order to "know" organic Nature would be an "intuitive intellect" ("intellectus archetypus") which was beyond the capacity of mankind. This is still believed by some people.

However, just over 200 years ago, one of Germany's greatest artists, the poet and playwright *Johann Wolfgang von Goethe (1749–1832)*, started to study plants among other natural phenomena. He had always taken his inspiration for his artistic work from the "universally open holy secrets" of Nature which he believed revealed themselves in the manifest world of sense-perceptible phenomena if only you knew how to look. He experienced both art and science as springing from or leading to that "primal source of all being" out of which has sprung the whole of creation. In turning from art to science – or rather using his art in science – he developed a way of looking at plants which enabled him to *do* what Kant had claimed to be impossible.

Most of Goethe's contemporaries did not take his scientific discoveries seriously. It was considered then, as now, that one person cannot be a genius in two such apparently polar opposite fields as science and art.

His many volumes of observations of clouds, plants, minerals, animals, colour and man lay in archives in Weimar. It was only when, 100 years later, the young scientist and philosopher *Rudolf Steiner (1861–1925)* was asked to edit this material, that the full extent and relevance of Goethe's scientific writings was acknowledged. Rudolf Steiner subsequently developed Goethe's work further as a scientific path of investigation which is accessible to everyone. He named Goethe the "Copernicus and Kepler of the organic world" in recognition of his deed; that deed of laying the foundation for a method of investigation into living organisms. Goethe's "way of seeing" was considered to be as great a contribution to the development of organic science as the clarity of perception and thinking introduced by these two giants to physics and astronomy.

In the course of this book we will try and take the first steps on a journey inspired by Goethe into the "hidden secrets" of the plant world. It will be a journey of exploration in which you are invited to take an active part – not just scientifically but also artistically. Goethe was great both as artist and scientist. To follow in his footsteps by doing science in an artistic way and by allowing art to be inspired by our search for the truth of those inner laws which created both ourselves and the world around us will be our striving. Goethe said:

> *"He who has art and science also has religion.*
> *He who has neither had better have religion!"*

Alongside the experiments and exercises in observation we will invite you to dip into the creative side of yourself and practise artistic exercises which will hopefully enable you both to see more deeply in your "daily science" and to free your imagination as an "artist of life" in general.

Doing Art

Whenever we change something in the outer world, in our immediate environment, we become creative as "everyday artists". Apart from their practical purposes, the arrangement of furniture in our living room, the daily choice of our garment, our handwriting or even just scribbles which we make on a notepad while telephoning are *outer expressions of inner qualities*. We find them reflecting our sense of order, the way we want to be seen, our personality or a temporary mood. Is there a way of working with our creative potential which goes beyond the mere expression of our subjective individuality and explores how our creations can bear the stamp of objective inner necessities, or lawfulness and truth? Can *doing art* shed any light on the questions which we have asked in this chapter?

Let us draw two "telephone pad scribbles" – only this time in a more disciplined and conscious way (and without the telephone!). It is advisable that you draw them on a large sheet of cheap drawing paper (newsprint or sugar paper) with either a soft pencil or crayon.

For the first drawing (Fig. 13) start with the outermost square. Try to draw the straight lines without a ruler – the effort which it takes to accomplish this is part of the exercise! For each of the four lines which make up the square you have to consciously set off with a new aim. Add the next square inside the first one by placing the points in the middle of the sides of the previous one. Proceed further inside following the same principle.

The second drawing is evolving from a small circle in the centre. A second curve is drawn around the first one beginning to slightly undulate in bumps and indentations. The following curves pick up these undulations and amplify them.

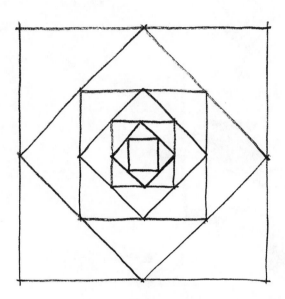 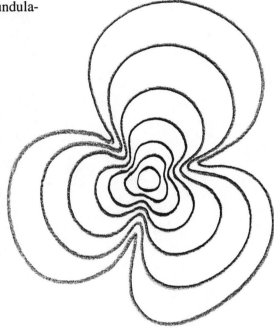

Figs. 13 (left) and 14 (right). Exercises with straight and round lines. [pencil]

How do you experience the difference between these two drawings? What is it like to draw them and how do the results affect you? You are using straight lines in the first drawing and curved ones in the second. Is your involvement the same in both cases? How do you proceed from one square to the next? There is a very clear law which *determines* one square out of the previous one. We have to be quite awake and constantly measure and judge in order to correctly draw this form. In comparison the second drawing leaves you more possibility for variation and allows you to dream a little in the doing. But what is leading you from one curve to the next? Are these lines drawn arbitrarily? Can you experience an inner necessity which lets one form *grow* out of the other? You will have noticed that if you are not fully *inside* the rhythmically growing movement with your feeling involvement you fall out of the living rhythm and your drawing will look awkward and stiff. If on the other hand you allow your "dreaming" to go wild the drawing will look chaotic and inconsistent.

You might find that these two drawings in a certain sense echo our question concerning the difference between the inorganic and the organic world. They also introduced us to the polarity of lawfulness and arbitrariness, order and chaos and the possibility of a playful movement between them. Creatively working with this tension is the daily work of any striving "artist of life".

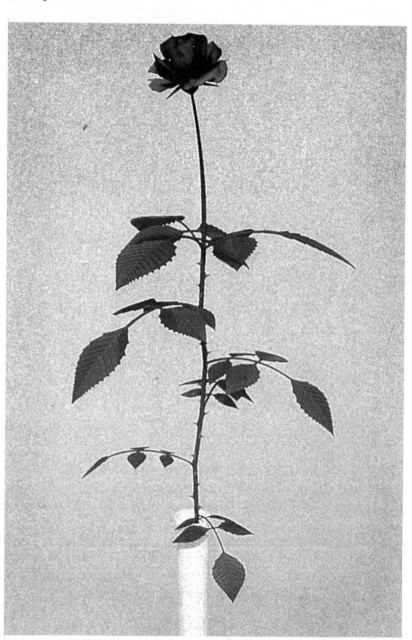

Fig. 15. Image of a rose which has been produced by a computer. Compare this with an artist's rendering of the plant on the opposite page. What attributes and qualities of plant life and of inner lawfulness and truth do these two representations of plants convey to you?

"Dead" or "Alive"

Let us conclude this chapter with two pictures of plants. One is the work of an artist, the other is a computer graphic. Look at them carefully. What attributes and qualities of plant life and of inner lawfulness and truth do these two representations of plants convey to you? Think of the activity involved in creating these two images. Can you imagine the "creative process" of the artist in drawing this picture and the activity of the computer programmer, computer and printer in producing the other image?

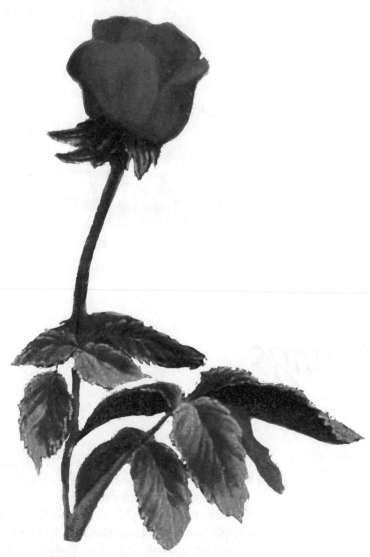

Fig. 16. Artist's rendering of a rose.
[watercolour]

2 Beginnings or Ends

Seeds and Skeletons

We are in the deep of winter – warm and cosy by the fireside, our stomachs filled with the riches of last summer's fruit. It is hard to stir, to leave the stories and the candlelight, to move this heavy body that longs for sleep and silence. Outside the sun has passed the point where days are dipped in darkness. Hope shines in the slanting rays of a cold sun floating in translucent mist. The brief daylight hours call out. Brightness and colours cast in shadows on the snow draw us away from the glowing coals, tea and cake.

Fig. 17. Winter landscape, East Lothian,
Scotland. [pen, ink and wash]

Donning layers of wool we trudge through a crusted, crisp white world, each breath forming freezing clouds as it leaves the scarf-bound mouth or nipping nostrils. Snow whiteness turns here blue-grey, there yellow in the hoary mist. Trees stand like sentinels – dark skeletons against a sky of soft-layered greys. The sun shines through the mist; snow crystals sparkling in the light look like stars shining from within the earth. Even the snowflakes looked like falling stars when they fell in countless six-membered variations, glistening in the darkness. No wonder we want to sleep so much!

The threshold between night and day seems to fill the waking hours. It is as if heaven comes closer to the earth in these brief days so full of subtle colours and stars that sparkle from below. Standing in a winter sunset is akin to being in an upturned open flower – nuances of shining petal colours fill the sky. Revelations of what was and will become stand naked in their essence – intangible; just caught in a breath of thought.

Each morning as the light moves into the sky again we are greeted by these frozen thoughts of frosty fronds or flowers fastened in ice on every window pane – revelations of invisible plant-becomings (Fig. 18). Where do they come from? Are they always there, hovering near – a heavenly plant world caught momentarily half a year before it is fixed in solid form and final physical flowers or leaves? The frost and ice still movement, catch thoughts, hold life rigid or simply stop it, even bring our musings home to rest.

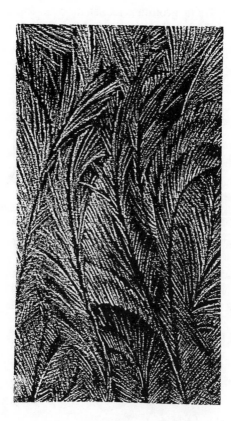

Fig. 18. Ice flowers – revelations of invisible plant-becomings? [white chalk on black paper]

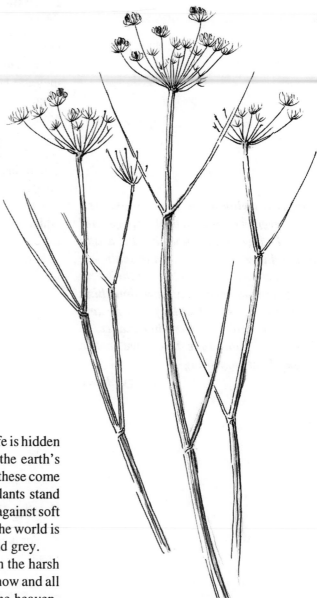

The ground is frozen hard. Nothing moves or grows. All life is hidden and the earth quiet to outer sense perception. Scattered on the earth's snow blanket are myriads of heart-shaped seeds. Where have these come from? What are they for? Sticks of grey-brown erstwhile plants stand skeletal-stiff along the wayside – rigid uprightnesses mineral against soft snow remain erect in sharp defiance of decay (Fig.19). Here the world is reduced to lines and planes and points of white and black and grey.

There seems to be such a contrast in Nature now between the harsh exactitude of black and grey sharp lines against the sky and snow and all that richness of ephemeral colour and forms that hover in the heaven-filled air. This contrast in the world outside is reflected in our inner world. At mid-winter we can dream wonderful dreams but we can also think more clearly. The snow-cleansed, frost-honed, sun-filled air allows our seeing to be more alert and sharpened by the clear contours of things.

Fig. 19. Hogweed (Heraclium). [pen]

Picking one of the grey stick nakednesses from the snow we take it home to draw, remembering the lane in summer when this hogweed (*Heraclium*) stood with massive leaves, a thick, branching, angled stem topped by flat white umbels shining lantern-like in summer evening light. *Where is this plant now*? All that is left of these great wayside companions are the grey, stiff sticks revealing in their stark simplicity structured order, exact to the last seed, as they stand at the end of their life with all their new beginnings scattered on the snow.

Drawing from Nature

A plant displaying such a clear and simple "skeleton" as the hogweed provides us with a very useful object for our first drawing "from Nature". Many people have hesitations to draw from Nature because they think they are hopeless in producing anything which has even the remotest likeness to the object in front of them. Are you one of them? Don't be afraid! It is not our aim to produce perfect photographic renderings of plants. Nor do we want to turn you into a professional artist. The aim of the following drawing exercises is to learn to see more of what is there and to sharpen our powers of perception. We will also discover our arms, hands and fingertips in a new way as we gradually transform them into sensitive tools which are capable of registering subtle nuances of that of which our heightened perception has become aware. The following introductory exercises will help us to loosen up and prepare these tools so that they become supple enough to follow that which our eyes are learning to see.

I think drawing ought to be taught seriously, even in primary schools, as a general part of education . . . not with the idea of producing a lot of painters and sculptors, but to get people to look, to use their eyes . . . If they are made to draw something they have to look at it; they may make a very poor drawing, but what matters is that for a short time they have looked intensely at something.

Henry Moore

Setting the Stage for Drawing

For these exercises you will need the following materials and equipment:

- several large sheets (ideally 600 x 1000 mm) of cheap drawing paper. Brown wrapping paper (Kraft paper), lining paper, newsprint or sugar paper will do.
- an easel and a drawing board – big enough to take your large sheets of paper. If you don't have an easel you can fix the paper on a smooth and even vertical surface such as a wall or door.
- masking tape and drawing pins to fix the paper on the board.
- soft (B or 2B) "Conté crayon" chalk or any other black chalk which comes in square sticks. Alternatively you can use charcoal sticks. They won't produce as sharp and well-defined lines as does the Conté crayon, but the more soft and brittle lines of the charcoal can help to convey an impression of the dry fragility of withered plants. Charcoal has the additional advantage of being easily erasable.

Fix your first sheet of paper on the easel or another vertical surface, with the centre of the format at eye-height. You will find that standing upright in front of the paper with your arm stretched out will help you to be relaxed and at the same time in control while you are drawing. Take a stick of Conté crayon and try to hold it as illustrated in Fig. 20. Drawing with the whole of one of the four edges touching the paper you will be able to produce sharp, well-defined lines. The intensity of the lines can be controlled by exerting more or less pressure.

To start with it is very important that you familiarize yourself with your materials and tools and with that particular size of paper in front of you. We suggest that as a first preliminary step you will *practice drawing straight lines*! You will find out that this is not as easy and perhaps also not as boring as it may sound. In any case it will introduce you to your materials and help you to overcome any initial anxiety you might experience when faced with a huge empty sheet of paper. Explore the full size of your sheet by drawing straight lines alongside the edges of the paper, creating a kind of margin: first two vertical lines followed by two horizontal lines. Draw slowly but with confidence, firmly but without too much pressure, be in control but not stiff. With each of these lines imagine that the black trace which becomes visible on your paper represents only a small visible section of a very long invisible line, extending into infinity at both ends. Four infinitely long lines meet on your sheet of paper defining that particular format which you choose to be the "stage" for the production of your drawing.

Entering this "stage" you can introduce the "players": vertical, horizontal and diagonal straight lines, each of which is being drawn in a fashion similar to that in which we created the four framing lines. Consider the addition of each new element as a real "happening" which changes the constellation and balance of elements on your paper. Stop when you feel that you have got enough lines to create an interesting and balanced composition (Fig. 21). Fill several sheets of paper with similar compositions. As a variation you might like to use curved lines instead of straight ones.

Coming back to our hogweed we first have to learn to look at it in a new way. What are the visual elements the hogweed is composed of? We see tight bundles of parallel lines at varying angles playing around the vertical. The lines are firm, allowing for only the slightest, tight curvature. These bundles terminate in upside-down umbrella-like structures with many lines radiating from one small area of concentration into an open cup-like shape.

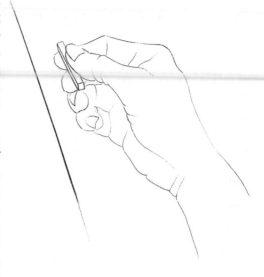

Fig. 20. Hold the Conté crayon stick like this, put one of the edges flat onto the paper and move it with slight pressure. This will help you to draw sharp, well defined straight or slightly curved lines.

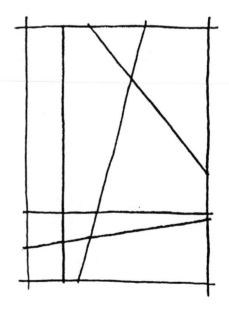

Fig. 21. Composition with straight lines. [Conté crayon]

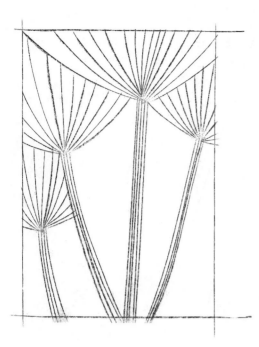

Fig. 22. Preliminary exercise for drawing hogweed. [Conté crayon]

As a further step let us practise to draw – not yet the hogweed itself – but such lines as we have just described. On a new sheet of paper define your format with four lines as in the previous exercise. Start by drawing a vertical line joined by a number of parallel lines closely following its course. Other bundles of parallel lines are added slightly diverging from the original direction. All bundles start at the bottom but end at different heights with their lines radiating upwards and outwards forming a kind of crown. Vary the thickness of your vertical bundles as well as the size of the crowns to create an interesting composition (Fig. 22). Do not hesitate to go right up to the edges of your defined area so that your lines generously fill and divide the available space. After having drawn a number of variations of this exercise your hands will follow your instructions more willingly and you will begin to develop a feeling for the picture space and for those of your compositions which are more and those which are less successful. You have begun to make this space your own! We are now ready to make an attempt at drawing the actual hogweed.

Drawing Hogweed

Allow five to ten minutes for a careful study of the plant. Touch it with your hands, feel the texture of its "bones", note its structural strength in contrast to its lightness. Become aware of the overall proportions, the relation between height and width; follow the stem from the bottom to the top, the rhythmical sequence of its divisions, the branching into side stems and the change in direction with each division. Compare the diameter of the main stem, before the division, with that of both main and side stems after the division. The side stems are always much narrower than the main one and are each enveloped by the dried remains of a leaf base. Become aware of the spaces created between main and side stem and finally study the structure of the flower heads and follow their patterns into the tiniest detail.

Then put the hogweed into a bottle and place it some distance from you so that you can easily oversee it in its entirety. Take a new sheet of paper and, as we did in the preparatory exercises, customize the format by framing it with four straight lines. To make sure that the whole plant will fit into that format trace with generous movements of your arms but as yet without a drawing instrument the main parts of your plant. Make full use of the surface area at your disposal (Fig. 23)! Then begin drawing the plant with generous and confident lines. Try to capture in each line which you draw the dry, light and yet firm character of the structure. Draw from the bottom to the top, building the plant as an architect would build a house. Keep your eyes fixed on the plant as if you were touching it with your gaze and follow the course of its growth. Of course you will also have to look at your paper from time to time to coordinate your composition of lines. For this exercise the emphasis lies on your eyes being out there on the surface of the object while your hands are recording

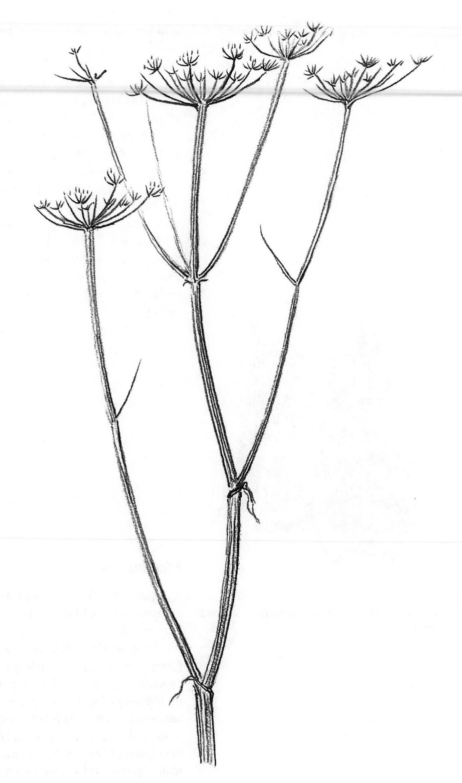

Fig. 23. Hogweed (Heraclium)
[Conté crayon]

the movements of your eyes on the paper. The aim is to be true to the plant and absolutely clear in your representation. Don't expect this to work satisfactorily the first time you try it. Practice will improve your results and give you more and more confidence.

In this exercise we tried to look at the plant "with new eyes" and to draw it as exactly as possible – *as it really is now*. Try practising this way of seeing with "cold blue winter eyes". Try looking at the world as it is in its mineral nakedness. Try to draw the same object for some days running. Watch the progress of both your ability to see and your ability to represent on paper what you see. It is easier to do this with still, dead or "frozen" plants but once you are in the habit of this "winter" way of seeing you can focus on the physical appearance of anything you like and clearly represent it in your drawings.

You will find that this is an important way of beginning to open yourself to that which lives in the world of plants. The exercise of drawing exactly what you see allows one's prejudices of how things "should" look to fall away and we experience a "cleansing" in our very process of seeing.

Fig. 24. Path into an oak wood. [pen, ink and wash]

Meeting Oak

Proceeding further on our winter walk we find the entrance through an open space into the woods. Solemn trees stand, warden-like, on the horizon. Drawing nearer we are struck by all the different shapes that form one single undulating woodland edge. A great variety of skeletal forms etched against a pale grey sky, holding naked arms in different upward, outward angles, together creating one boundary. In all the multiplicity of shapes we recognise a familiar form at once. *Oak* stands out, telling us who he is from half a mile away. *How do we "know" oak?* What is this act of recognition? Is it the trunk, the angle of the branches, the cluster of twigs at the crown? No-one taught us all the details which make up oak. In fact, the moment we start to look carefully at all these details the being we recognised as oak has disappeared! There even comes a familiar moment when we start to doubt whether it really is an oak!

Let's look at some of these details. Choose an individual tree and start by looking at it from far away, in relation to other trees round about: how does it stand in the environment in which it grew? Look from all directions. What is its overall shape? Coming closer note the proportions of the trunk's thickness to its height, of main trunk to branches. See how the branches rise, at varying intervals from the trunk bending in "elbows" of similar angles in seemingly erratic fashion. They become thinner and more numerous, still with that characteristic bend until the tiny fan-like clusters of twiglets "crown" the end of each main branch system. From a distance the whole tree seems "lobed". Remember how it was in summer leaf.

Coming nearer note the gaps in the branch system where another tree grows near. In the oak tree dead branches or scars are apparent and, underneath the tree, perhaps a mighty limb lies fallen among a multitude of tiny, many-budded twigs thrown from the crown in winter winds.

Looking closely at one of the young twigs, or even at a two to three year old tree, of which there are several in this clearing, we find a very clear pattern in the organisation of the buds on the twig (Fig. 25). There are several tiny buds tightly spiralling at the base of the year's growth. The spiral than elongates and we find the buds are sitting at irregular longer intervals along the twig until, at the tip, the buds are larger and spiral more tightly (shorter intervals). At the very tip of the twig they sit in a close cluster (five to seven buds) radiating round the fat, terminal bud. The leaves in whose axils these buds formed gave rise to that soft-lobed, densely clustered appearance at the outer edge of an oak in summer.

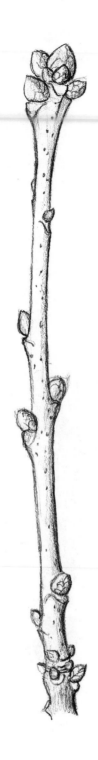

Fig. 25. Young oak twig showing one year's growth (from the rings at the bottom – the scars of last year's bud bracts – until the end buds at the tip of the twig). [pencil]

The irregularity in the placement of the buds on the twig reminds us of the irregularly-lobed mighty branches of the adult tree or even the irregularity of the veins within a single undulating leaf blade. It is as if the oak is alternately pushing outward and holding back in a rhythmical way. Comparing our young twig with a much older one we can see something of how the pattern of growth has arisen (Fig. 26). Each year's growth is terminated by (or begins with) a tight sequence of bands round the twig – the scars of bud scales. This twig shows that the direction of growth has stopped at the end of one year's growth and how the continuation of growth has moved into another direction. This is caused by the dying off of the terminal bud and a side bud taking its place. This often happens with oak after a certain age – here it happened two times in eight years' growth. Oak provides a home for more species of animals than any other native British tree. One of these insects often eats the fat terminal bud, so a cluster of side branches appears. Some of these fall off and we are left with the characteristic "oak elbow". This stemming of growth at the tip countered by a burst of new growth is a *"gesture"* that seems to belong to the being of oak. Can you follow the pattern of "oak becoming" from the young twig onwards until you *understand* the form of the mighty oak?

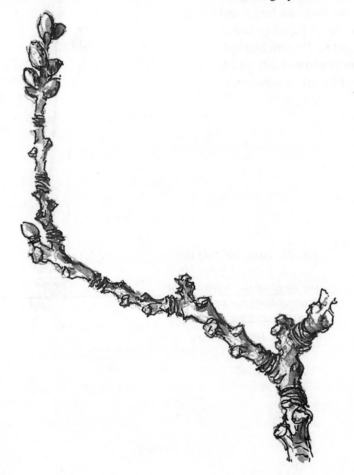

Fig. 26. Oak twig showing several years' growth. [pen, ink and wash]

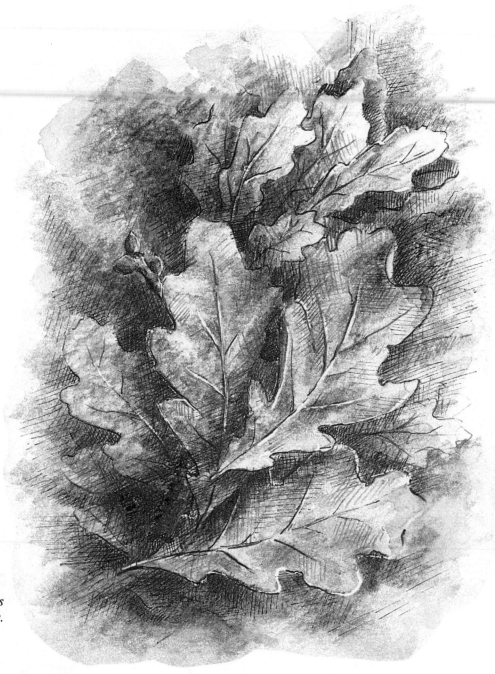

Fig. 27. Pile of oak leaves of varying shapes and sizes. [pencil and wash]

Look for a moment at the leaves scattered underneath the tree (Fig. 27) Although you will readily be able to recognise oak leaves you will never find any two having the same shape. Draw the outlines of some of them and then invent your own variations on the theme. Often the oak leaf is indented at the end lobe just where you might expect a point to be. And how is it with the acorn?

Looking at the leaf shapes further you might be struck by the irregular waves of indentations and lobes along the edge – how similar again to the irregular rhythm of branching potential in the buds along the tiny twigs, and similar as well to the lobing of the overall shape of the whole tree which is especially visible in summer. The contraction of the spiral at the top of each twig gives rise to a "flattened lobe" appearance – similar to the shape of the crown, the lobed ends of the leaves or even the acorn and acorn cup scales. "Living into" all these aspects of oak in its becoming allows us to recognise something of the rhythmical gesture of burgeoning new life and a holding back (or dying) that make oak what it is. Even the thick trunk (Fig. 28) with its deep fissures alternating irregularly with bursting mounds has something of the same quality of holding back (dying) and bursting into life. This contrast of death and life welded together in one tree was one of the reasons why the oak was sacred to the Druids in pre-Christian times.

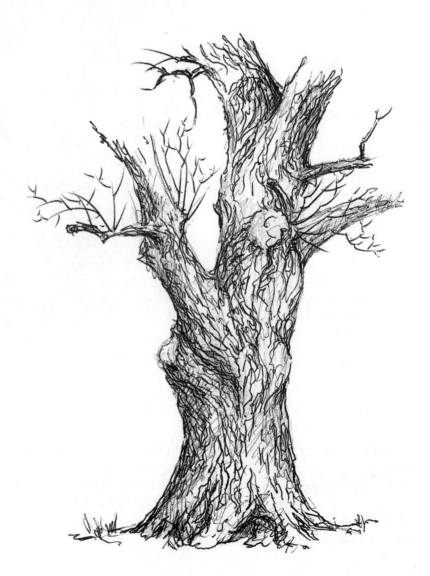

Fig. 28. Trunk of an oak tree. [pencil]

You will be aware by now that we are looking at the oak in quite a different way to that in which we encountered the hogweed. We have much more entered into the "space" or "being" of oak – rather like the way we walked *into* the wood – whereas with hogweed we remained outside, cool and objective. In doing this the bleak, open wilderness of hard lines softened to a sheltering, embracing warmth. Underfoot the ground, no longer hard and cold, cushioned our footfall with a thick carpet of leathery, buff-brown leaves atop a soft, rich, moist almost-earth. The air became thicker and softer. It is harder to think here. But in an almost dreamy way we become aware of how each undulating curve of the leaves, the bending elbow movements, the shapes of buds and acorns all have something to do with each other in an unmistakably "oaken" way. This is what we "saw" and subconsciously recognised from half a mile away. Slowly becoming aware of the "gesture" or character of oak leads to questions of how it grew, how these forms came about and what determined them with such re-cognisable exactitude. We start to feel we know *who* oak is and we are "enveloped" by oak being in our interest. We find we can "become one" with it in this inner act of recognition – rather like the way the colours in the winter skies envelop us, awaken and echo the colours within our souls.

This is the other side of winter (the opposite to those hard, exact, skeletal lines) when we experience something of the mystery and hidden depths of the beings of Nature – such as oak. The following drawing exercise will lead us into building a bridge between the hard, etched exactitude of the world and that equally apparent (although on another level) "beingness" – a bridge between fact and physiognomy.

"Only that which I can draw from memory I have truly understood."

J. W. v. Goethe

Drawing from Memory

We suggest that on one of your winter walks you look for a suitable mature oak tree which you can easily oversee in its entirety. Choose the view which you find most characteristic. After some thirty to forty minutes (if you can stand the cold) of detailed observation summarize for yourself all the observations you have made: the overall gesture, the angles, growth patterns and proportions (it is helpful to use your body, e.g. the distance between two fingers with your arm stretched out, to assess proportions). Check the facts in your mind (make notes if you like) and make sure you have as many details as possible about how this particular tree stands in this particular place. Then go home for cup of tea – and a drawing from memory! (Such an exercise of detailed observation is much easier to do and leads you to see more if done in a small group of people, each taking it in turn to describe what he or she can see to the others.)

Before you start drawing the trunk outline the overall shape of the *space* which the tree occupied (Fig. 29). This will provide you with a "mould" into which the tree can grow: starting with the main trunk, followed by the main branches dividing into finer and finer lines. Of course you cannot possibly remember each single twig. The point is that once you understand the pattern according to which they divide, the gesture in which they terminate and create that intricate network of interlocking lines in the periphery, you can reproduce, "imitate" this pattern at will to fit it into the organism of your tree drawing. Try different drawing materials: charcoal, chalk, wax crayons, soft pencils, a fountain pen, a roller ball pen or a mixture of different media. Take your finished drawing out to the tree and check if you have done justice to it.

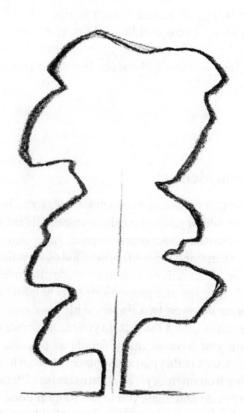

Fig. 29. Before drawing the trunk and branches of the tree first ouline the contours of the space which is occupied by the whole tree. [pencil]

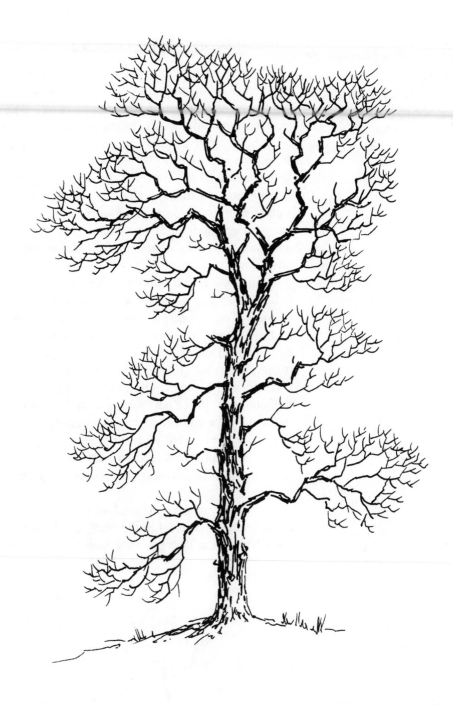

Fig. 30. Oak tree drawn from memory. This particular tree was growing along a country road in Scotland in a loose row of neighbouring trees. [pen and ink]

Re-membering a living Organism

Drawing from memory takes us one stage deeper into our capacity to experience Nature than drawing an object which we see in front of us. In order to recreate something from memory we have to have *become united with it* to a certain extent. In trying to represent from memory we become alarmingly aware of (and sometimes pleasantly surprised by) what we have seen and what we have not yet seen. Once we have noticed that which we have missed the first time we can go back to the tree in order to complete our memory picture and make yet another attempt to draw the same tree from memory. (This works even better if you have a night's sleep between looking and drawing.) The regular practice of this exercise can train our faculty of noticing and memorizing *"wholenesses"* in our environment.

You might also try drawing oak exactly as we did the hogweed. A branch is enough for such an exercise (Fig. 31). Again let go of all memory of rich experience of soul letting your eyes become cleansed. Try to draw exactly what is there and compare it with the hogweed experience. Do you notice a difference? You might find the tree more difficult to draw in this way. Hogweed was dead, mineralised, had reached its end. Oak is in a mid-stream of becoming – merely making mid-winter pause. Something of life, of new potential, of the opposite of mineral meets us in the oak. We can connect to this quality of life in an initial way by *"re-membering"* what we have seen as end parts or isolated parts of a living organism. This leads us into the activity of "membering" or echoing within ourselves the becoming of a plant between its *end* and its *beginning*.

The quality of new potential we mentioned – of "not yet become" – is particularly powerful in the buds which sit at the end of last year's growth but are at the same time new beginnings of this year's growth.

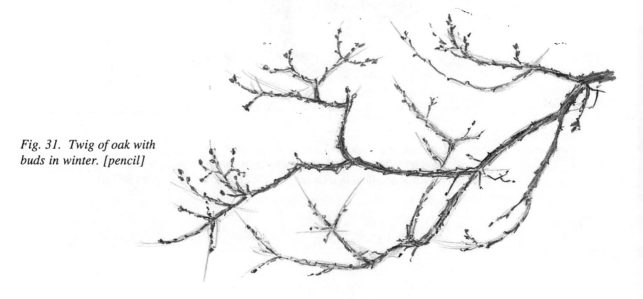

Fig. 31. Twig of oak with buds in winter. [pencil]

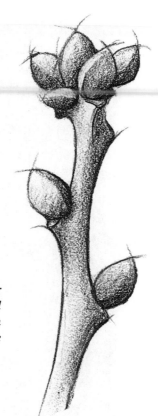

Fig. 32. Oak twig with buds. In your first sketches simplify the form and try to bring out the contrast between the convex lines of the buds and the concave lines of the twig. [pencil]

Drawing Oak Buds

Take one of the cast-off twigs which you found underneath the oak tree and carefully study the rhythm of buds along the twig and the busy clusters of buds at the end. In a number of line drawings sketch the spatial arrangement of buds, their bulging convex shapes and the way they are attached to the twig (Fig. 32). In contrast to the hogweed drawing, these lines defining the shape of the buds are encompassing an inner volume bursting with bulging life potential! Note the contrast between the convex lines enveloping the buds and the concave lines on the twig leading from one bud to the next. There is a little "pedestal" provided for each bud to sit on, and below it is the scar where last year's leaf was attached.

Once you feel confident about the form of the buds and their arrangement you might want to add light and darkness. Start a new drawing, using charcoal on a large sheet of white cartridge paper (40 × 60 cm). First indicate the twig and the buds with a few faint outlines. Using the flat side of the charcoal stick cover the sheet with differentiated, rich layers of darkness, leaving out the twig and the buds as areas of light. Keep the area around the buds slightly lighter in order to create a sense of "breathing" in the space around these bulging shapes. Eventually bring more definition and differentiation into the left-out forms of twig and buds (Fig. 33).

The use of light and darkness will help you to imbue the barren lines with a sense of life. Leaving the buds lighter than the environment can be a means of conveying an impression of the buds' bulging life potential within the darkness of winter.

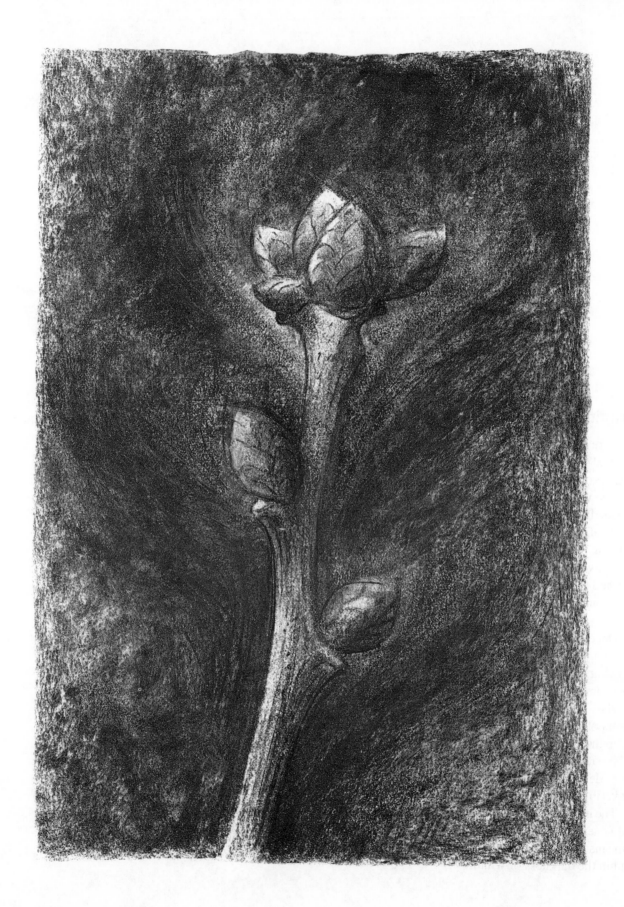

Beginnings or Ends

Ends and Beginnings

Our oak will begin to develop this year out of the ends of last year's growth – countless buds surround the periphery, bursting with new life. Once upon a time this oak began – as an *acorn*, which was the end of another oak's flowering (and thus dying). Are there truly ends and beginnings – or are there simply steps in cycles of time?

By now we are familiar with "oak curves" from the whole tree, from branch, leaf and bud. The same essence of oak curve is to be found in its own particular way in the acorn and the cup (Fig. 34). Acorn is oak in essence. The cup itself is made of many tiny scales; like miniature leaf-lobes or condensed bud bracts hardened into a shallow, woody saucer. Let's take the acorn out and look in more detail at the beginnings of an oak (Fig. 35). If you have not got access to acorns you can use any other seed in its fruit. The larger ones like almonds or hazelnuts are easier to see without a lens.

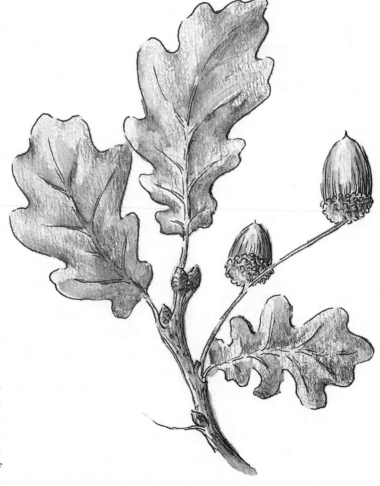

Fig. 34 (right). Oak twig in winter with acorns. [pen, ink, wash and pencil]

Fig. 33 (left). Oak buds in winter. Darkness is applied to the background in order to set off the three dimensional form of the buds and the twig. The darkness has been given some movement and differentiation; the area around the buds is left lighter in order to create a sense of "breathing" around their bulging forms which are full of future potential. [charcoal]

Fig. 35. Acorn. Fig. a shows the acorn just as it came out of the cup (see page 43) – but turned upside down. In Fig. b we have removed the hard shiny seed coat to reveal the cotyledons or seed leaves and the now-emerging radicle which will eventually become the future root. Fig. c shows the cotyledons slightly opened to reveal the embryo shoot or plumule, which is all that is there at this stage of the future mighty oak tree. [pen]

The shiny ovoid acorn glistens like a polished ancient dining table (oak, of course!). Where it was attached inside the cup we find a pale, rough scar through which the seed was nourished in the summer as it grew. At the other end a shallow indentation houses a hard pointed protrusion – the remains of the stigma of the flower. Have you ever seen oak flowers?

Breaking the shiny surface open we are surprised at an even shinier inside. The hardened coat falls off to reveal a fat, oily, yellow-white mass (this is that part which was so valuable for feeding the pigs in medieval times as they grovelled in oak groves planted around every castle, town or village). The surface shows indentations of veins from the leaf-like seed-coat. The upper part (as it sat in the acorn) reveals a small white protrusion, peeping out between that which then obviously becomes two halves. Breaking these, the seed leaves or *cotyledons*, apart we find the protrusion is actually the future root or *radicle* of this little embryo tree. The developing root pointing upwards to the sky! In the opposite direction, on the downward side (upward in our drawing) of a very delicate joint between and sheltered by the oily cotyledons are tiny little hints of the first leaves (the *plumule*), only to be properly deciphered with a hand lens.

This remarkable fact of upside-down seed development in the dark inner space of the fruit seems to belong to many higher plants. You can investigate this for yourself in any seeds you encounter in their fruits, such as avocados, chestnuts, cherries, hazel or other nuts. In chapter 6 we will go more deeply into fruit formation and its development out of the flowering process, in which case it is the end of development. Is the acorn the beginning or the end?

Beyond Beginnings and Ends

Now, having looked at an acorn in great detail you might like to draw it very exactly. You will need a hand lens. Remembering the oak we drew from memory can you fill in the gap from acorn to oak – or indeed from oak to acorn? Where is the oak tree now into which this acorn might one day develop? How does the acorn grow into that form which is characteristically oak and not beech?

In each seed, we are told, written or engraved into the genes comprising the "business side" of the chromosomes which make up the majority of the hereditary material, are the exact details in a kind of shorthand of who this being is. This highly complex script lies dormant (like a shut book) waiting to be read until the conditions are appropriate and the book is opened, the words read and translated into deed – a kind of recipe book. But who reads the script recorded within the acorn? The words of oak, this particular oak, will be reproduced and borne by every cell of every leaf, twig, branch and bud scale of the future mighty oak. Who, or what is reading them and translating them into those characteristic curves or elbow bends? Who or what makes the leaves unfurl in spring and decides where and when a branch will flower? And who wrote all the instructions into the chromosomes in the first place?

From skeletons of mineralized plants, etched by winter, we learned to see and draw exactly what is there. Learning how to memorize these facts in the context of an *invisible whole* and to reproduce them, in the light of this whole, from memory we find ourselves plunged into infinitely large questions and *almost-thoughts* that also belong to winter – thoughts as huge and fleeting as the colours of a winter sunset or the ice flowers in the warming light. Keeping these questions in our hearts let us go further and simply watch what happens in the spring, as all the ends disappear and the beginnings become something else.

"The whole plant represents only an unfolding, a realisation, of that which rests in the bud or in the seed as potentiality. Bud and seed need only the appropriate external influences in order to become fully developed plant forms. The only difference between bud and seed is that the latter has the earth directly as the basis of its unfolding, whereas the former represents a plant formation upon the plant itself. The seed represents a plant individuality of a higher kind, or if you will, a whole cycle of plant forms. With the forming of every bud, the plant begins a new stage of its life, as it were; it regenerates itself, concentrates its forces in order to unfold them again anew. The forming of a bud is therefore an interruption of vegetation. The plant's life can contract itself into a bud when the conditions for actual real life are lacking, in order then to unfold itself anew when such conditions do occur. The interruption of vegetation in winter is based on this."

Rudolf Steiner: "Goethean Science"

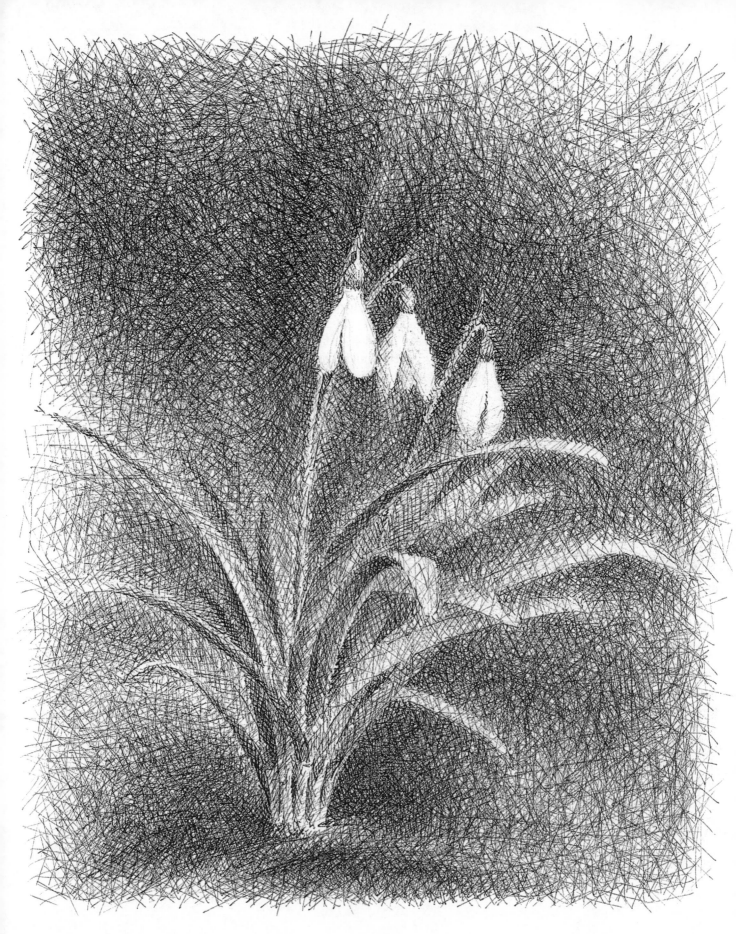

3 Plant Becoming

Early Spring Awakening

Spring is "in the air". Soft, yellow light and a hint of warmth in the wind draw us out of doors to walk amongst Nature "in the becoming". Led by subtle smells and a gentle greening of the world amidst bird song and the thrill of new life we follow the route of our winter walk only to find a multitude of new "happenings". The sticks and hard edges of the grey, black and white landscape of winter are dissolving downwards into twigs and bits of brown-grey humus-in-creation. Worm casts abound and frost has broken up bare soil. The surface of the earth is bursting into movement – into life. Amongst the final *ends* of last year's dull grey browns are bright green spikes and delicate unfurlings of this year's new *beginnings*. The tenderest of shoots – grain, grass and herb – spring upward in seeming oblivion of wild winds, storms of sleet and snow and the last of winter's frosts.

The fleeting colours of the winter skies have given way to yellows and grey-green softness; sometimes bright, white, still and glaring light – echoed in the first spring flowers of winter aconite in yellow and the pure white snowdrop. "Snow drop" – what a wonderful name for this herald of spring who will unfold bright green leaves and snow-white blossoms even piercing through the carpet of snow. Snowdrop thrives in cold and will rapidly wilt when brought indoors. How is it possible that these vibrant, dark green shoots and their nodding fresh flowers can appear so suddenly complete in our woods and gardens when all around is still dull, brown, grey decay? Where have they come from?

Fig. 36. Snowdrops in early spring. [pen]

You might have noticed them in the late autumn under fallen leaves or in clumps of round brown balls with a little white nose exposed where the wind and rain have laid the ground bare around them. During the winter months, while all was still above the ground, their roots were actively growing from a ring around the base of the bulb and, even in January, the coldest time of the year, their white noses started to push upwards turning green among the snow and ice (Fig. 37).

Such a contraction into a bulb is yet another way in which plants go through the winter. We may compare it with the buds and seeds which we got to know a little in the last chapter. This chapter will take the story a step further but first we will watch the snowdrop unfold from its bulb.

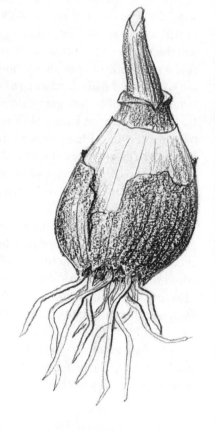

Fig. 37. Snowdrop bulb in January. [pencil]

Snowdrops unfolding

If we dig up a snowdrop in the first days of gardening, as often happens when venturing out to clear away the winter debris in early spring, we are surprised by the vitality and tenderness of the growing green shoot. By now the bulb is becoming soft and spongy under its slowly rotting brown coat as a pair of spear-shaped bright green leaves rapidly make their appearance. Folded within a rather square space between the leaves we find a pale green spike enveloping at its tip an elongated swelling which will soon release the dangling, drop shaped flower hanging from its narrow pale green stem and swollen "fruit-to-be" (Fig. 38).

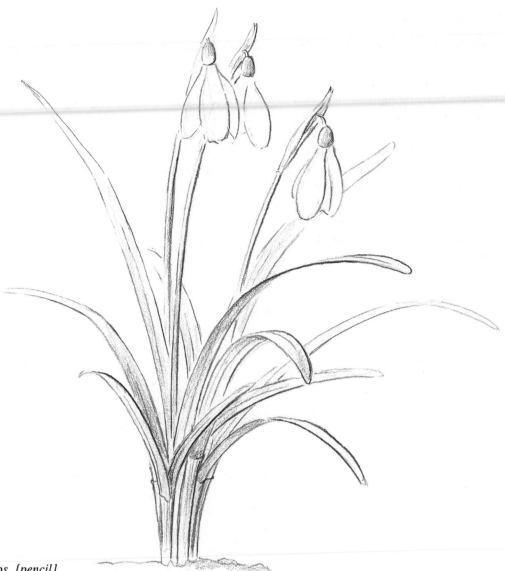

Fig. 38. Snowdrops. [pencil]

The best way to follow this wonderful developmental process is to draw it. You might like to do this for yourself either with a snowdrop or some other bulb. We have chosen snowdrops because they are so plentiful in Britain growing wild in many places as well as being a common early garden flower. If you dig up bulbs to draw and study, please do so only from places where they are growing in profusion and then replant them somewhere where they can grow on. You can also buy bulbs in a garden shop and watch them unfold in a glass or pot in the house over winter (e.g. daffodils, hyacinths, narcissi).

Drawing Development

Having chosen a plant and drawing equipment with which you feel comfortable begin by leaving plenty of space on your paper for the plant to "grow into". You can draw them larger than life size but it is essential to stick to the same scale throughout the sequence of drawings (life-size is therefore probably simplest to begin with).

Set aside a time of day, one day or certain days of the week in which you want to work and then draw your bulb as exactly as possible *as it is now*. It helps each time to look at the previous drawing first to check what has happened to all the different parts that you have been recording. You can even make a rough pencil sketch of the first stage, change it into the second and so on until you come to today's which you then draw properly. This will bring you into the process of the plant's growth – into an organic transformation in time.

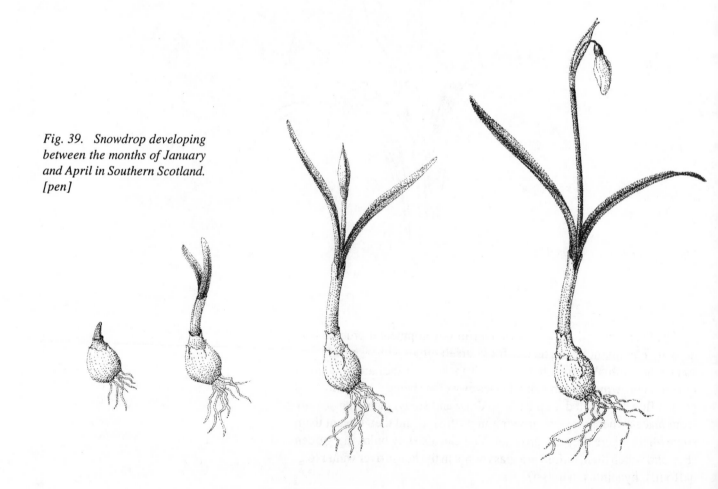

Fig. 39. Snowdrop developing between the months of January and April in Southern Scotland. [pen]

Fig. 39 shows our sequence of drawings for snowdrops developing between the months of January and April in southern Scotland. When you have finished the whole sequence with your plant (and don't forget to follow it into its dying and contracting phase) let yourself, with fluid imagination, *live into* this process of development whose continuous stream you have captured in a series of "foot-prints".

As you let yourself grow with the snowdrop out of the bulb into full flower and leaf, through fruit and beyond, can you experience a gentle stretching, expanding movement within you which becomes more and more differentiated as you approach the flower? This is then followed, after the fruit has set, by a gradual withdrawal of the plant as the now big floppy leaves wilt and die away and the bulb swells again to condense throughout the summer as a preparation for the following winter and spring. How does this feel within you?

Imaginative Thinking

If we would understand plant development more than superficially we have to use that within us which is akin to the processes of growth in Nature outside us; akin to the forces or activities of becoming and dying away. This force in us which we have just been practising with the snowdrop is the faculty of imaginative thinking. We have just followed, with the use of imaginative thinking, how the thought or "idea" of snowdrop manifests through time – first as a condensed "notion" of winter bulb, then through growth into green leaves and flower, finally to form fruit and to fade away above the ground. If we look at several snowdrops and follow through several years of development we find our *imagining* "becomes one with" the stream of becoming of the snowdrop. We can then see how the "becoming" of snowdrop is a process similar to the happenings within our fantasy life (you only need to remember how dreams – the day or night sort – develop one image out of another).

In the development of snowdrop we have recorded all the facts of progressive snowdrop becoming and de-becoming at intervals during this process. Our fantasy is, in this case, linked to a very real life situation – the physical manifestation of "snowdrop idea" into "snowdrop facts" through time. We see the facts as if frozen by our perception and drawings of different stages; but the *process of growth* we apprehend as a streaming activity through our faculty of "seeing" with imaginative thinking. This activity Goethe called *"Exact Sensorial Fantasy"*. It is a skill which we all have and use every day when we notice that someone looks tired and give them tea or that a plant needs to be watered, but we need to develop it as a conscious tool or organ of active perception if we want to study the life processes of living beings.

Buds unfurling

Let us now use this faculty to follow the process of yet another springtime phenomenon – the opening and unfurling of buds. Here we have chosen a horse chestnut bud (Fig. 40) because they are so large, but you may choose to do this with any convenient tree or bush to which you have access. If you are unable to visit a tree outside at regular intervals you can always cut a twig and take it indoors. The best, of course, is to go to your tree every day at the same time – say half an hour each morning as the birds are singing or during your lunch break you might like to sit outside in the spring sunshine with a sketch pad. Again we would recommend using the same scale for each drawing and the same materials used in as similar light conditions as possible.

Leaving space on the page for the future development, draw the bud with as much detail as possible and try to experience again the bursting potential we discovered in the last chapter. Once your bud starts to open it can develop very quickly so you may have to adjust your drawing intervals to capture as many stages as possible. Fig. 41 shows the development of a terminal chestnut bud (the one on the end of the twig) drawn at intervals from February until mid April.

That which grows out of this bud will form a continuation of the twig on which it sits. Looking a few inches below the bud we see something which looks like a rolled-up sleeve (Fig. 40). This is formed of horizontal scars around the twig which are left by the bud scales of last year's terminal bud. Can you imagine this twig at this time last year? All that growth from rolled-up sleeves to terminal bud together with the leaves whose horseshoe-shaped scars you can also see on the drawing has come out of last year's terminal bud. Throughout the spring the leaves unfurled, the stem stretched, just as this year's one is doing now, then hardened, turned brown-grey, formed new buds in the leaf axils and lost its leaves in the autumn as the new buds swelled ready to go through the winter. Try and follow the whole sequence of your twig with your imagination starting with the winter condition.

When you have followed it forwards in time you might like to try the exercise of imagining it backwards in time so that this year's growth gets packed away inside the bud as it was when you began. You can compare the difference within yourself as you accompany these two movements in time – into the future and into the past.

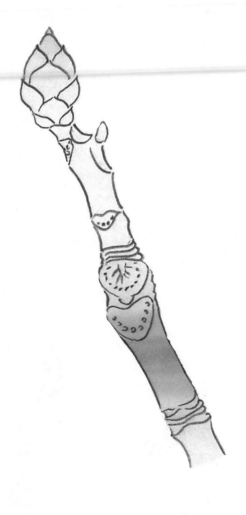

Fig. 40. Twig of horse chestnut (Aesculus hippocastanum) *with terminal bud. [pencil]*

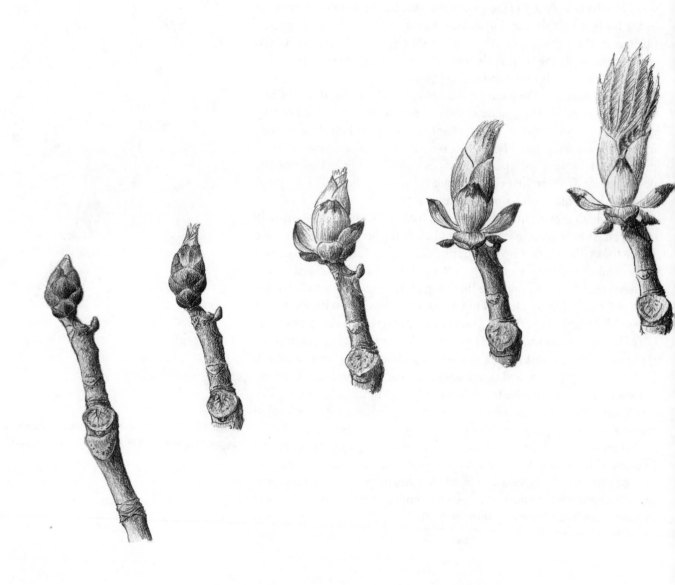

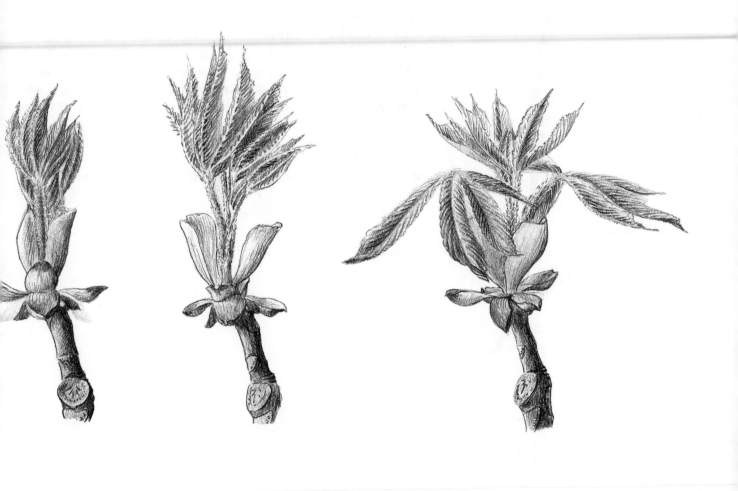

Fig. 41. Development of a terminal horse chestnut bud (in this case a leaf bud) drawn at intervals from February until mid April. [pencil]

Inside the Bud

In the winter months each bud is encased in dark brown or grey-brown bracts which are reduced and hardened tiny leaves. As the bud starts to swell in spring the smaller leaf bracts are pushed outwards and may fall off to reveal larger ones inside, the longer of which have a green and growing base (see our horse chestnut sequence, Fig. 41). Depending on which species of tree you choose you may find few or many of these in gradually increasing size, spiralling inwards towards the central stem cone. Eventually the first true leaves are revealed – at first in a tuft and then unfurling into planes, spiralling stretched along the stem as the new green growth extends from within outwards out of that which was once the bud. Can you experience the similarity between this bud unfurling and the way the snowdrop emerged from out of the bulb's brown coat?

Fig. 42. Beech buds in January. Compare this drawing with Figs. 44 and 45. [pen]

Fig. 43 (below). This drawing shows the sequence of forms of which the terminal bud of such a beech twig, illustrated in Fig. 42, consists, proceeding from the outermost bracts to the tiny feathery leaves (from left to right). Compare this with Fig. 44. [pencil]

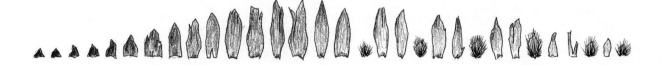

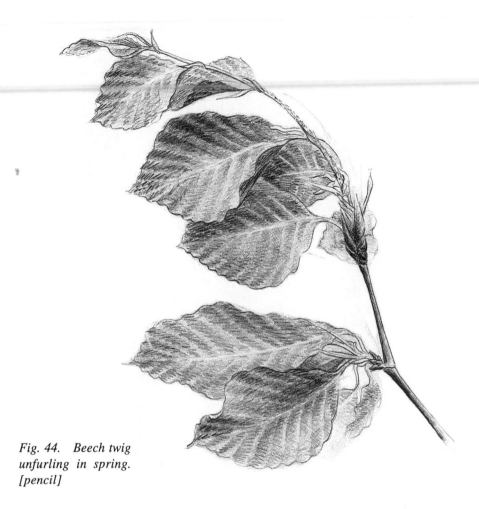

Fig. 44. Beech twig unfurling in spring. [pencil]

In the axil of each new leaf lies the potential for yet another new bud and, by the end of the summer, as our twig hardens and turns brown, next year's buds will already be forming in their leaf axils. If we open a bud in the middle of winter we find all the leaves perfectly formed and ready to come out in the sequence in which they will later unfurl along the stem. Fig. 42 shows two beech buds in January and Fig. 43 the content of the terminal bud (proceeding from outside in). Compare this picture with Fig. 44. It is hard to imagine how all of this came out of such a tiny bud – and yet it was there inside all ready and only had to stretch and swell in the spring. If we had not dissected the bud, those tiny, hairy leaves just visible in Fig. 42 would have become the equivalent of the recognisably soft green beech leaves of Fig. 44. Can you imagine this process of growth and preparation happening thousandfold on each tree every year in late summer and autumn followed by a stretching and unfurling every spring – year after year the same and yet every year slightly different – until eventually a whole tree is standing there?

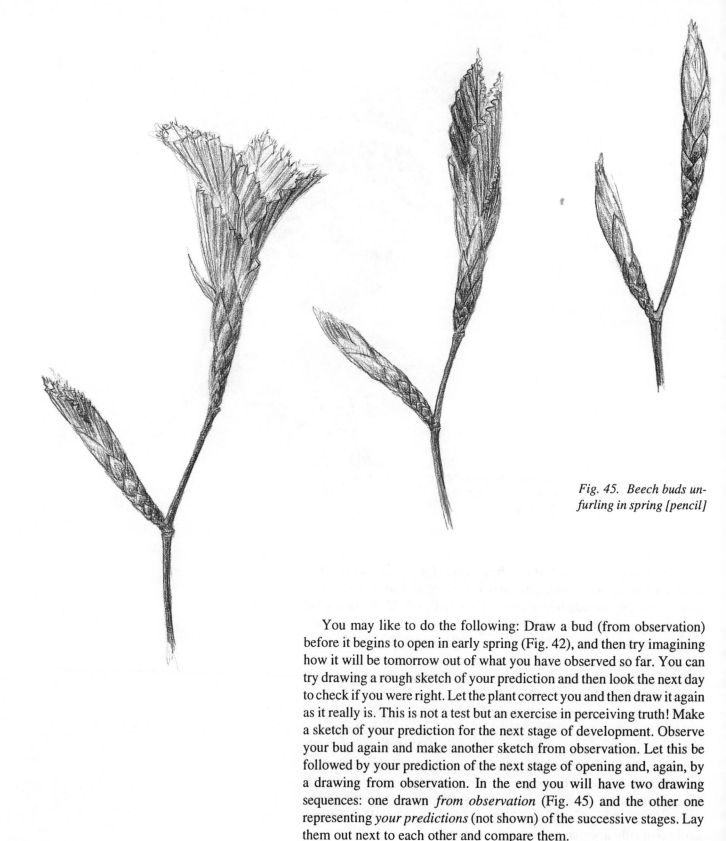

Fig. 45. Beech buds un-
furling in spring [pencil]

You may like to do the following: Draw a bud (from observation) before it begins to open in early spring (Fig. 42), and then try imagining how it will be tomorrow out of what you have observed so far. You can try drawing a rough sketch of your prediction and then look the next day to check if you were right. Let the plant correct you and then draw it again as it really is. This is not a test but an exercise in perceiving truth! Make a sketch of your prediction for the next stage of development. Observe your bud again and make another sketch from observation. Let this be followed by your prediction of the next stage of opening and, again, by a drawing from observation. In the end you will have two drawing sequences: one drawn *from observation* (Fig. 45) and the other one representing *your predictions* (not shown) of the successive stages. Lay them out next to each other and compare them.

All the exercises which we are describing here will enable you to slowly develop and train your faculty of imaginative thinking or *"Exact Sensorial Fantasy"* as an organ of perception for experiencing the processes of living beings. You will find that you start to be able to "turn on an inner light" which lights up developmental processes in your understanding just as the light within the physical eye enabling us to make mental pictures is an organ of perception for those objects lit up by the sun in the world around us.

Imagination and Water

Following our observation of growth process you might have felt like having to immerse yourself into a fluid medium in order to "swim" from one stage of development to the next, trying to experience as a continuous process that which represents itself to our perception as separate "foot-steps" in time. The comparison with water can indeed further illuminate the Nature of imaginative thinking. Picture to yourself a stream of water flowing down a slope. On the surface of the stream we see "standing waves" which remain stationary in their place. The water underneath the surface which is creating these shapes is in constant movement and never the same. This is like a picture of our imaginative activity which is able to "flow" between isolated, "stationary" forms such as our pictures of stages in plant development.

Studying water, its movements and the imprints it leaves in other media we can even find similarities to the outer manifestation of plant growth. On a sandy beach we can study the intricate shapes left in the malleable medium of fine sand by the water as it was flowing off the beach at low tide. Often these shapes resemble primitive plant forms (Fig. 46).

Fig. 46. This shape was moulded into the sand as the water was running off the beach at low tide. The water was flowing from top to bottom; yet the form which resulted resembles that of a primitive plant which appears to have grown from bottom to top. [pen]

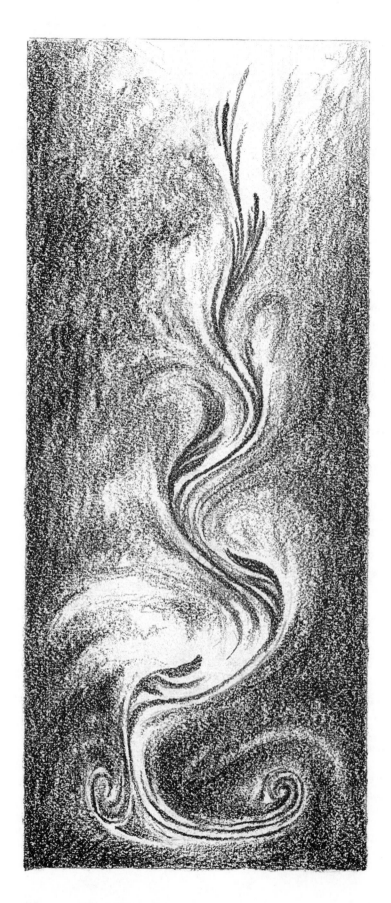

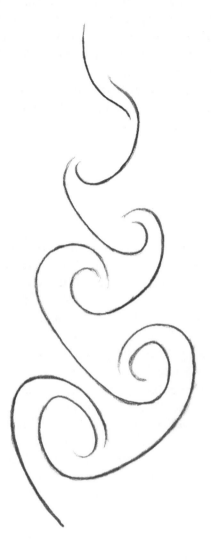

Fig. 47 (left) (after: Schwenk, "The Sensitive Chaos"). Flow pattern produced by pulling a brush through a shallow basin which is filled with a mixture of glycerine and water (as seen from above). The brush has been pulled with even and slow speed from above downwards. In this picture we can see the "embryonic" stages of development of the vortices, which become more accentuated if the brush is moved more quickly (see Fig. 48). Compare Fig. 47 with Fig. 49! [pencil]

Fig. 48 (above). Diagrammatic representation of flow pattern with fully developed vortices. This pattern is produced with slightly quicker brush movement. [pencil]

Water has the inherent capacity to *generate rhythm* once it is set into motion by an outer impulse. You can observe the forming of rhythmical flow patterns for yourself whenever you pour milk into cup of coffee or tea or when you draw a stick through a puddle of muddy water. These patterns are present in water whenever it moves – we only need the presence of an additional substance like mud in the water in order to make the movements visible.

In a more controlled fashion you can produce and observe a rhythmical flow pattern in the following experiment: A shallow basin (you can construct it with a board, four pieces of wood and a lining cut from a black plastic refuse bag) is filled with a 1:1 water/glycerine mixture (the glycerine makes the water more inert and slows down the movements). A small amount of waterbased silver or gold paint is added to this mixture. The fine metal dust of this paint will make the movements of the liquid visible against the dark background colour of the lining. Pulling with slow motion a brush or stick in a straight line through the shallow liquid will produce a rhythmical flow pattern like the one illustrated in Fig. 47.

Now compare the drawing of the flow pattern in water with the drawing of the interior structure of a tulip bulb (Fig. 49). It seems at first glance, as if similar forces and a similar capacity of movement were revealed both in the rhythmical patterns of flowing water and in these embryonic stages of plant growth where they become realized (held in form) in the fluid enveloping of one sheath out of the other.

Any bulb or bud with its tightly packed leaves is a composition of enveloping surfaces of sheaths. Water too is organised in sheaths! This you can prove for yourself in another simple experiment. Fill a large cylindrical glass jar with water and stir it vigorously, creating a circulating vortex. As the movement begins to slow down inject one drop of black ink very close to the centre of the vortex. This will conjure up in front of your eyes a beautiful pulsating organism of enveloping sheaths of water.

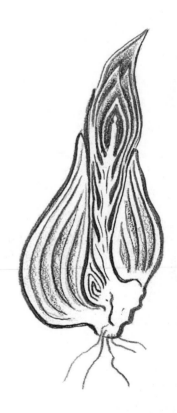

Fig. 49. Vertical section through the bulb of a tulip. Note the rhythmical growth pattern in the centre of the bulb. Each of the rhythmical articulations represents one of the developing leaves. [pencil]

Practising Fluency

Let us now practise the fluency of our fantasy (and of our hands) with the help of some drawing exercises (Fig.50). These are best done with white chalk on a blackboard or black chalk or crayons on large sheets of cheap newsprint paper so that you can practice them over and over again. Draw them with generous movements using not only the hand but involving your whole body in the rhythmical movement.

Fig. 50. Exercise of drawing rhythmical waves with increasing amplitude. [pencil]

With each line enjoy the simple and harmonious rhythms of up and down, forward and backward and in and out. Feel how your breathing is getting involved. Take care that each wave rising from below has its equal counterpart form above. Feel how the line you are drawing becomes as it were a "sensitive membrane" between above and below (Fig. 51).

Fig. 51. The line as a sensitive membrane between above and below. [pencil]

Feel how each line grows out of the previous one, enhancing its movement. Having practised this sequence of waves for some time we can proceed to combining the consecutive stages into one developing line:

Fig. 52. Combining the different stages of Fig. 50 into one continuous line. [pencil]

Here follows a variation of these wave patterns, the different stages of which we can again combine into one line (Fig. 53).

Fig. 53. A variation of the wave patterns. [pencil]

If we now combine this last pattern with the slanting tendency of the previous one we come to a form (Fig. 54) which is very similar to those flow patterns which we saw in the shallow vessel experiment (compare with Figs. 47 and 48).

Fig. 54. *Dynamic flow pattern. [pencil]*

Now allow yourself to apply in a playful way the fluency we have practised in the previous exercises by inventing your own "patterns of growth" adding one line to the other like the layers of an onion (Fig.55). This is like a variation and enhancement of our "growing" scribble from chapter 1 (Fig. 14).

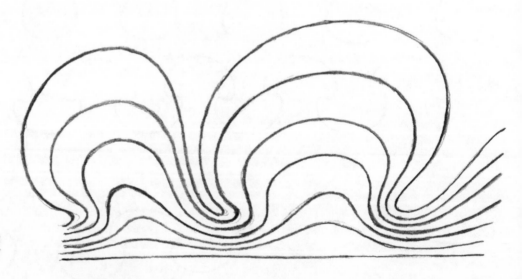

Fig. 55. *"Patterns of growth". [pencil]*

Can you experience the difference between these drawings and those we did in the previous chapter? Rather than being occupied with finished shapes and their relationship to each other in this chapter we are concerned with movement. Becoming one with this movement in drawing we can experience how *form comes about through movement.* People of olden times were more at home in this fluid realm of form-becoming than we are today. They experienced the kinship of vegetative plant growth with the element of water and expressed this in their art. Our illustration of a Greek ornament (Fig. 56) eloquently exemplifies this. It is based on a rhythmical wave movement. Spirals issue from junction points which are enveloped by leaf-like sheaths. Compare this drawing with Fig. 47!

"Motion is at the root of all growth"
Paul Klee: "The Thinking Eye"

Fig. 56. *Decorative pattern from one of the roof soffits of the Tholos, Epidauros, Greece.* [pencil]

Bud and Bulb

Let us come back to the plant, using the faculties we have gained through our drawing exercises. Having watched a bud cast off its winter garments, stretch out the new green twig surrounded by gossamer soft leafy unfurlings which slowly mirror the planes of light create by the spring sunshine, we have moved a step further in our understanding of how plants grow. Now we can look at a five year old twig and imagine (backwards in time) how each portion grew from each terminal bud, from rolled up sleeve to rolled up sleeve. We can imagine the twig tip getting younger and the tree becoming smaller year after year until we arrive at the seed with the most enormous potential (and least "fact") which the tree ever has. It is not difficult to move backwards or forwards in time with this newly gained faculty of exact sensorial fantasy and to experience the rhythms of the seasons in each plant, once we have enough facts at our disposal. But how do we bring together such a phenomenon as a bud unfurling with the becoming of snowdrop or the germination of a seed?

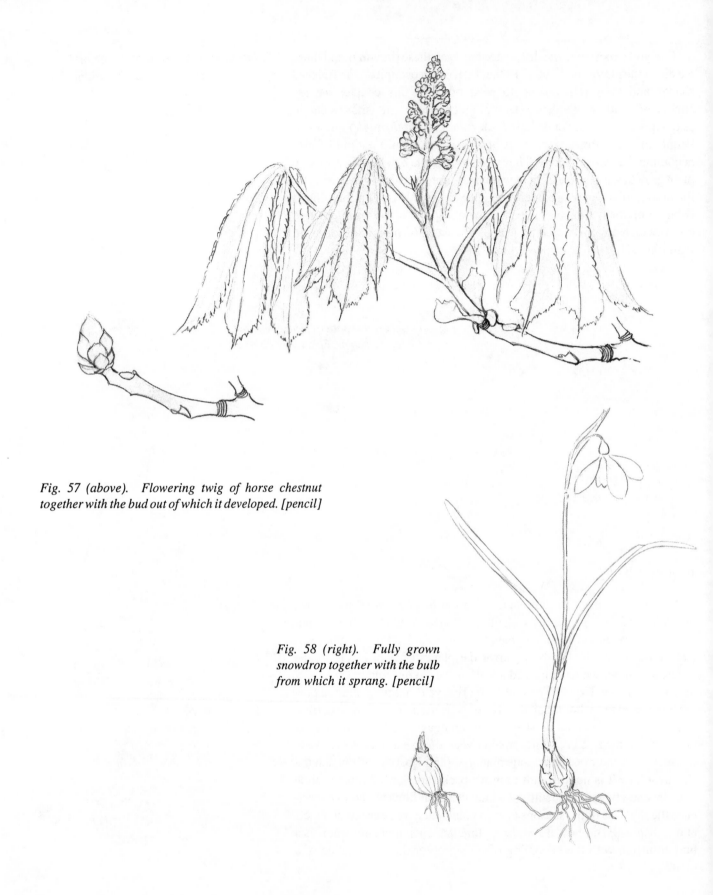

Fig. 57 (above). Flowering twig of horse chestnut together with the bud out of which it developed. [pencil]

Fig. 58 (right). Fully grown snowdrop together with the bulb from which it sprang. [pencil]

By now you will have realized that each year's new growth of a tree, contained in its winter bud, is like the equivalent of a whole new plant sitting on the branch of the tree. Some flower and some do not. Fig. 57 shows the fully developed flower of an horse chestnut together with the bud out of which it developed. Compare this with Fig. 58 which illustrates a fully grown snowdrop together with the bulb from which it sprang. Again the snowdrop bulb growing into a flowering plant is a whole plant in a certain sense also, "emancipated" from the earth (but differently from the tree bud). The snowdrop bulb is rather like a "little earth" in its own right, containing all it needs for its development in the spring (we all know how tentative the bulbular connection to the earth is and how bulbs will even grow and flower with the barest minimum of root contact with earth or water). On the other hand we might like to look at a tree as being an extension of the earth itself upon which the annual shoots are growing.

"He who understands the secret of the 'eye' of the leaf has penetrated one of the deepest secrets of Nature."

J. W. v. Goethe

The "Eye" of the Leaf

Fig. 59 shows the bulb of a daffodil cut open in vertical section. We can see the outer brown coat within which are found layer after layer of "leaves". These make up the bulb, each one sitting on a cone shaped base at the tip of which is this year's flowering shoot. In the axil of one of the leaves a new bulb is growing. This will eventually separate from the parent plant as this year's flowering part dies away and will only flower itself next year or the following one. This new bulb began to develop last summer at the base of the leaf. The daughter bulbs always form in the axil of one of the leaves of the parent bulb (see Fig. 59). This brings us to one of the profoundest secrets of Nature – the secret of the *"eye" of the leaf.*

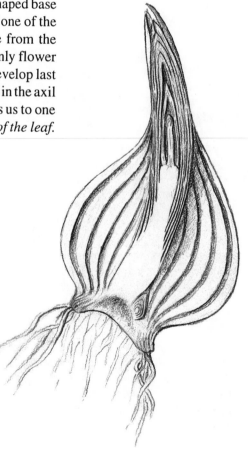

Fig. 59. Bulb of a daffodil cut open in vertical section. [pencil]

Fig. 60. Diagrammatic representation of the "eye of the leaf", the central part of the node. [pencil]

The "eye of the leaf" is that point which lies at the centre of the space between an enfolding leaf and the stem on which it sits (Fig. 60). In the case of a tree twig, the leaf scar under the pedestal upon which the bud sits shows us the mark of last year's leaf. The swollen bud is the "eye" of this leaf.

In the snowdrop or daffodil we have seen how the stem is reduced or "held back" to the cone-shaped area at the base of the bulb on which all the leaves are sitting and from which the roots spring around the lower edge. Where each leaf, or leaf-like sheath, joins the cone of the suppressed stem is an area of potential for new growth, an "eye point". From each "eye" can grow a whole new plant.

Fig. 61 shows a twin terminal bud of a horse chestnut; one of them contains a flower, the other one will only bring forth leaves. Fig. 62 shows the same buds cut open in vertical section.

We can see the similarity with a bulb (Fig. 59). All the leaves are tightly packed and ordered on a cone at the end of the stem. Between each leaf and the stem, as yet unstretched, is that point of potential where new buds will later form. In the developed chestnut twig (Fig. 57) the "eyes" of the leaves of new buds for next year are spread out along the stem.

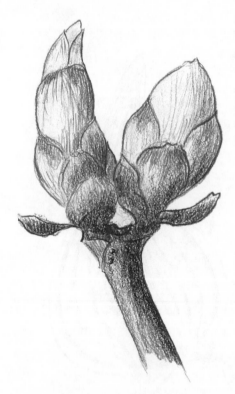

Fig. 61. Twin terminal bud of horse chestnut. The left one is a leaf bud, the right one a flower bud. [pencil]

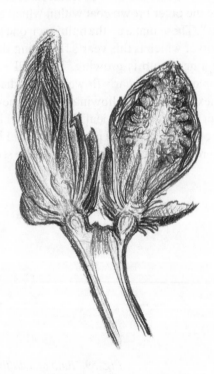

Fig. 62. Twin terminal bud of horse chestnut, cut open in vertical section. [pencil]

From this we can see that a bulb is really a special kind of bud which "does not grow up" and whose leaves stay fleshy. A bud might also be seen as a kind of bulb whose fleshy leaves have become reduced and hardened on the outside.

Both bud and bulb then have something of the seed potential we saw in the last chapter. There we saw in the acorn that the area of greatest potential was the place between the cotyledons, out of which a whole tree might potentially grow. Can you see how this area within the seed, between, beside and above the seed leaf (snowdrops belong to the *monocotelydonous* plants which have only one seed leaf) or seed leaves is like a kind of "primary eye" – a beginning place of greatest potential of each new plant. As the plant grows something of this potential is carried up the stem in the growing point and a remnant of it is left behind in each node at the base of each leaf. This is the "eye" of the leaf.

In the last drawing of this chapter (Fig. 63) we show a common weed germinating where you can see the "primary eye" clearly with its two *cotyledons* attached. Above is the tiny *plumule* which will become the upper part of the plant and below an already substantial root system which grew out of the *radicle* within the seed. We will follow the development of this little seedling on its journey further in life in the next chapter.

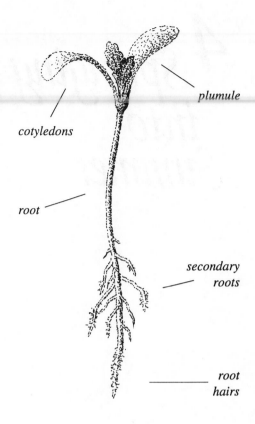

plumule

cotyledons

root

secondary roots

root hairs

Fig. 63. *Seedling of groundsel* (Senecio vulgaris). *[pen]*

4 Springing into Summer

Fig. 64. *A variety of common garden weeds displaying their early summer foliage.* [pencil]

Late Spring to early Summer

It is now late spring and, as we move into early summer Nature seems to "take off". The plant world expands into a lush, vibrant multitonal green presence. Around the trees leaves crowd forth from newly opened buds which spiral stretching stems to spread green garments over the once bare grey branches. Spring bulbs are over, their sudden burst into flower followed by lazy, leafy growth and gradual fading as the fruits set. Autumn comes for them in spring and, as the summer vegetation grows upwards, they retreat downwards under the ground preparing the new bulbs and corms for next spring's early outburst. Small seeds sown last autumn or in early spring now grow rapidly. Those which germinated early and formed rosettes last year have made a start in starred rosette form near the ground and now unwind into a wealth of long-stemmed leafy growth in rapidly changing forms before the summer flowers crown their greenery. Others, having over-wintered as seeds, now burst their hardened boundaries and grow rapidly into green and flower. We will follow the development of one of these summer "weeds" in more detail soon, but first we will look at some larger seeds beginning their growth in spring.

Growing Down and Growing Up

Having over-wintered as a seed under the snow the first thing which happens as the warmth of spring penetrates the moist earth is that the seed swells with moisture, the seed-coat bursts and the *radicle* (that little, pointed cone which will become the future root) pushes through. Its tip "explores" the soil, always directed downwards towards the centre of the earth. I'm sure you've all seen conkers or beans sown "the wrong way up" with a long white root curling round the seed until it can grow downwards (Fig. 65). There are also many experiments which one can do to demonstrate this downward direction of the root, its "positive" response to the earth, known as *geotropism* (movement towards the solid or earthly).

Once the direction of growth is established, from the *epidermal tissue* (outer thin skin) just above the root tip grow single-celled root-hairs at right angles to the main root through which a relationship of mutual interchange is created between the developing plant and the earth via the watery medium between the particles of the earth. The young plant exudes substances into the soil dissolving its hard mineral matter and helping to create a medium in which it can grow. In the other direction dissolved salts are taken into the plant from the soil in fluid form which pass in through the root hairs and travel up the plant into the stem and newly emerging leaves.

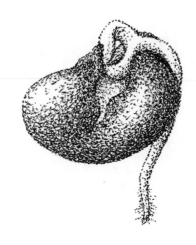

Fig 65. Broad bean germinating. [pen]

That which we refer to as root is that part of the plant which grows *downwards* from the centre of the seed. We show two examples here of dicotyledenous (bearing two seed leaves) plants germinating from seed to seedling (Figs. 66 and 67). The bean has fat seed-leaves which remain below the ground, while the sunflower carries its germination point above the ground. The cotyledons then turn green. The groundsel does the same but is much smaller and impossible to follow in this way with the naked eye.

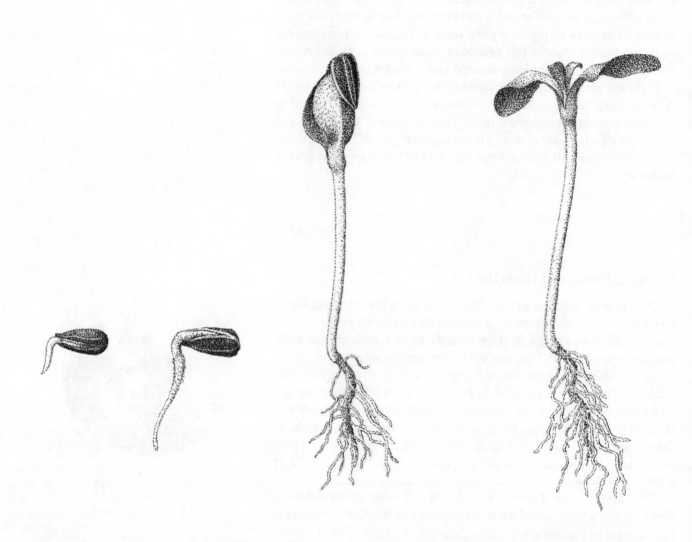

Fig. 66. Sunflower germinating sequence. [pen]

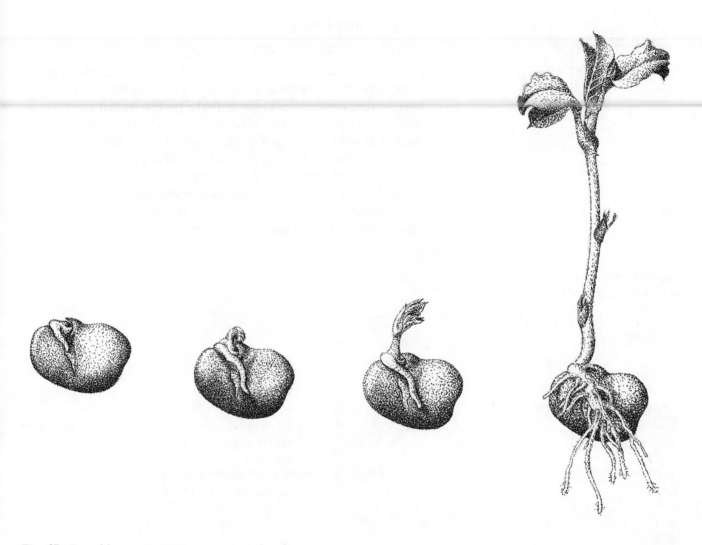

Fig. 67. Broad bean germinating sequence. [pen]

In between the points of attachment of the seed leaves is a delicate hinge or fulcral point called the *hypocotyl*. This is the centre of the new plant. From this central zone the whole plant will develop – first down and then up. The upward growth usually only begins once the downward connection with the earth has been established. The seed leaves or cotyledons hold the balance while this important beginning is happening.

Once the root has grown down and the cotyledons have spread into green planes to catch the sun, the tiny *plumule* (that feathery, pointed future shoot) (Fig. 66) between them starts to grow up and form the shoot – the opposite movement to the root growing down out of the radicle. Both growth directions begin at the fulcrum point between the seed leaves.

Leaping into Leaves

At first the new leaves form a tiny feather-like cluster – indistinguishable as separate leaves to the naked eye. As the first true leaf takes its place in the world of sense-perceptible phenomena it looks like a stretched out, long-stemmed, rather thick, green, fleshy paddle-shaped plane. At the same time the second, third and fourth are unfolding in a spiral, one after another. In our illustration (Fig. 68) this can be seen clearly.

Observe this stage of development in other plants which you see growing around you when the first true leaf is visible. We find the finished leaves unfurl and take their place within an invisible vortex form prescribed by the outer leaves. The growing point of the not yet formed plant is in the bud – the growing tip at the centre of the vortex (Fig. 69).

Fig. 68 (above). Seedling of groundsel (Senecio vulgaris). *[pencil]*

Fig. 69 (left). Groundsel seedling. As the leaves unfurl they take their place within an invisible vortex form. This drawing attempts to artistically represent the relationship between the (visible) plant form and the (invisible) configuration of the space into which it grows. [pen]

Fig. 70. Groundsel plant drawn at different stages of development [pencil].

This is a wonderful thing to watch daily in early summer when the growing and unfolding process is so active and strong. Try drawing a little seedling every day as we have (Fig. 70)) over a period of time (or watch and draw seeds germinating in the winter months). You may want to dig up a seedling in an early stage of development and plant it in a small pot which you can keep on your window sill for daily observation. Groundsels are particularly suitable as they are readily available almost everywhere and grow throughout the whole year. You can also sow seeds of your own choice and watch them germinating. Make a quick sketch of the whole plant every day or whenever you notice a change and compare each drawing with the previous one. Let yourself slip with your imagination into the gaps between the pictures and allow yourself to flow with the expanding movement of the plant as it spirals upwards and outwards into physical expression. Compare this with the rather simpler development of snowdrop. (Snowdrop is a *monocotyledonous* plant, having only one seed leaf and simpler, parallel-veined leaves. Groundsel is a dicotyledon. It has two seed leaves and a more complex net-like leaf venation.)

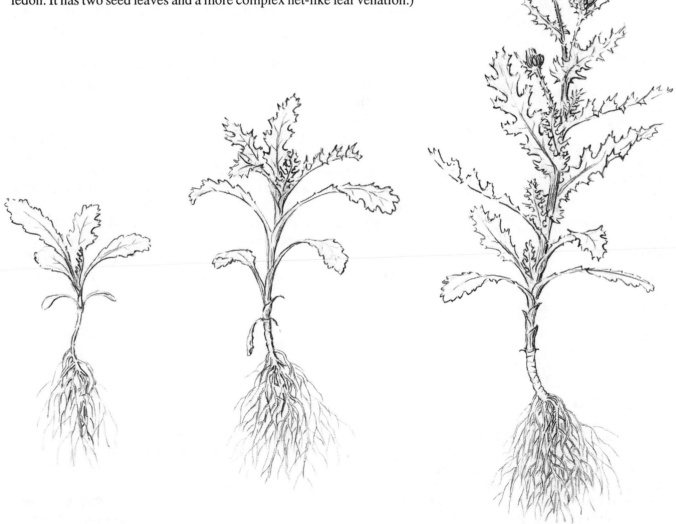

"Living into" a Leaf Sequence

Once the groundsel plant is fully grown and all the leaves are in place on the stem and are as stretched and formed as they can be (Fig. 71) we can take a further step in our studies of this part of the plant (the leafy shoot) and its development. In Chapter 1 we suggested taking all the leaves off a groundsel plant and laying them side by side in the sequence in which they grew on the plant. Let's now do this again paying careful attention as to how they attach and making sure that the whole of the leaf is removed from its wrapping around the main stem. Our illustration (Fig. 72) shows the leaf sequence of a fully mature plant.

What do you see? What is your impression as you let your eyes wander from one leaf to another? Perhaps a wave, a movement of expansion and contraction, a feeling of developing becoming more complicated and then more simple?

Try to imagine yourself being inside the first leaf. What do you have to do to change yourself into the shape of the next, and the next and so on until you come to the end? Where do you have to push or pull, to stretch or contract? If you practice this you will find it is not difficult to move through the leaf sequence in either direction.

What is it in you which "moves through the leaf sequence"? What has this seemingly innate capacity in us to do with how the groundsel plant grew? And, back to our earlier thoughts in Chapter 1: What causes it? Who is "shining the light"?

Just by practising this activity you will find that your thinking (the imaginative part) becomes more and more alive and mobile. Then you will start to realize what a wonderful tool or organ of perception your own faculty of imagination can be when used in this way. Here we are again applying what Goethe described as *"Exact Sensorial Fantasy"*. Our "fantasy" is the organ for perceiving something invisible which flowed through the plant as it grew leaving its footprints in the sense-perceptible phenomena (the leaves in this case). We can connect to this with that within us which we have in common with the invisible something which makes the plant grow.

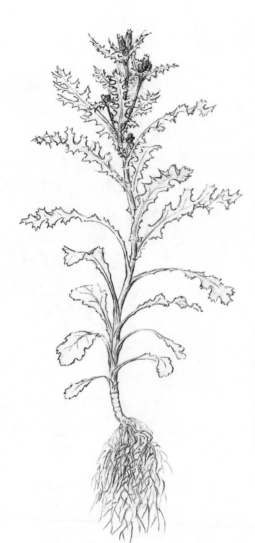

Fig. 71. Fully grown groundsel plant. Look for an example with as complete a leaf sequence as possible. Take off all the primary leaves (not those grown on secondary shoots) starting from the bottom and arrange them in a straight line or a semi-circle as we have done in Fig 72. [pencil]

" We can find Nature outside us only if we have first learned to know her within us. What is akin to her within us must be our guide."

Rudolf Steiner,
Philosophy of Spiritual Activity

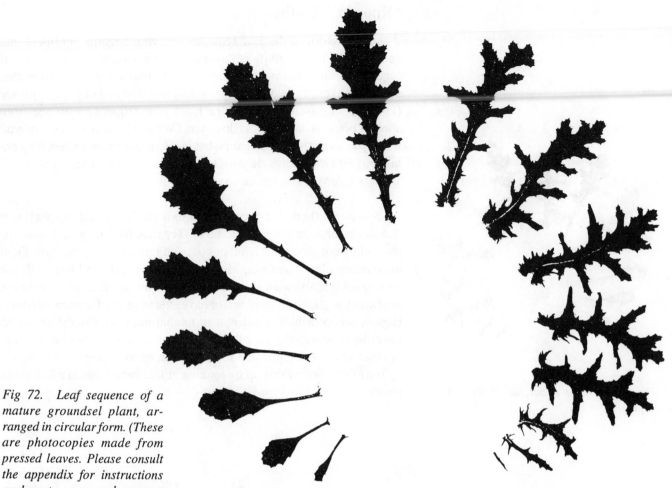

Fig 72. Leaf sequence of a mature groundsel plant, arranged in circular form. (These are photocopies made from pressed leaves. Please consult the appendix for instructions on how to press and arrange your own leaf sequences).

This "invisible something" in us is that which made us grow. You might be familiar with how difficult (almost impossible) it is to think when you are growing a broken bone, or if you are pregnant and all the growth forces are directed towards the developing child. Children themselves are only capable of developing their thinking as their bodily growing slows down.

> *"Something spiritual reveals itself in the formation and growth of the human organism. The spiritual element then appears during the course of life as the spiritual force of thought."*
> *Rudolf Steiner and Ita Wegman in: "Fundamentals of Therapy"*

This "spiritual force" is that which we are able to use to connect our imagination in a living way with the invisible process of development or life in the plant. The flowing stream of our thinking and plant growth have, therefore, an intimate connection to one another.

"Knowing" Truths

Let us return to the leaf sequence. Having become confident and comfortable in the activity of "swimming in between" or through a leaf sequence with your imagination you might like to try as a further step swapping over two leaves equidistant from either end of your sequence (Fig. 73) – or even swapping one from your sequence with one from another plant. What does this do to you? What effect does it have on you when you swap them and again what happens within you when they are in the *right* order? How do you *"know"* that they are in the right order? What is it in you that can be so sure?

You might think that because you took the leaves off the plant you "know" what order they should be in. Try muddling up your leaves (or photocopy our sequence, cut them out and mix them up) and give them to someone else to sort out. Most people, especially children, will put them quickly in the order in which they grew on the plant, whether or not they know anything about plants or have ever seen a leaf sequence before. How is this possible? What is it in us that not only has the ability to inwardly flow with the growth of plants but can also recognise the truth of inner laws of complicated form change without ever having seen it before? Let's follow this up by looking at leaf sequences in a few more plants.

Fig. 73. What about this groundsel leaf sequence?

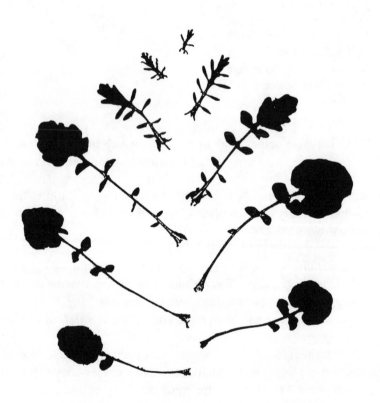

Fig. 74 (a)

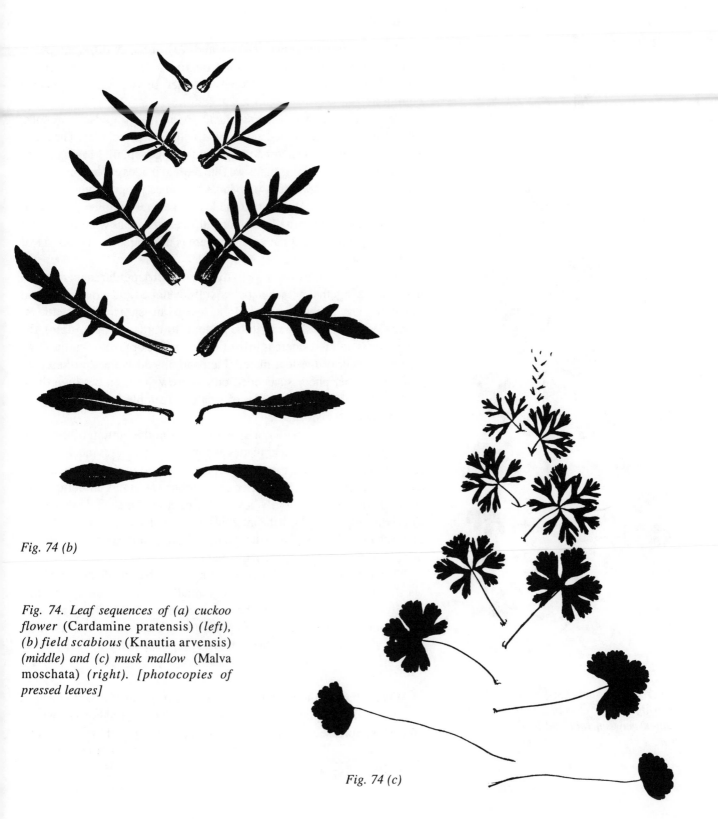

Fig. 74 (b)

Fig. 74. Leaf sequences of (a) cuckoo flower (Cardamine pratensis) *(left), (b) field scabious* (Knautia arvensis) *(middle) and (c) musk mallow* (Malva moschata) *(right). [photocopies of pressed leaves]*

Fig. 74 (c)

Leaf Language

Our illustrations (Figs. 72, 74 and 75) show 5 different plants revealing their leafy transformation from root to flower. We can see at a glance how different they are from each other. But what do they have in common?

The first leaves in all the plants are, as in the groundsel sequence, rather small, long-stemmed and simple with rounded blades. The intervals between them are short and the form changes small. Moving up the sequence of leaves on the plants we find the leaf blades expand in size and proportion as the leaf stem or *petiole* becomes progressively shorter. Alternatively one could say that the leaf blade creeps down and "swallows" the petiole, eventually joining with the leaf base as we approach the top of the plant, until at the very top there is no longer any hint of a leaf stalk (petiole).

Directly under the flower we find contracted, triangular shaped simple leaves close together with their bases well developed and wrapped around the stem. The intervals between the leaves are short. The "centre of gravity" of the leaf shape is at the bottom (towards the main stem), the periphery is pointed whereas in the first leaves the opposite was the case. There the bulk of the leaf material appeared, as it were, "pushed out" towards the periphery suspended on a narrow stalk. In between these apparently polar opposite types of small and simple leaves we find an extraordinary transformation.

You will see that in all our specimens, from the bottom of the plant moving upwards, as the leaf blades expand in size the previously simple rounded shapes begin to become indented. Their points become exaggerated and multiply at the outer edges reaching a climax in complexity somewhere around or shortly beyond the middle of the whole sequence. This is usually where both the intervals between the leaves and the leaves themselves are largest. From these most differentiated leaf shapes we can often recognize which species the plant is.

Then the indenting and differentiating of the leaf blade draws downwards towards the base. The leaves gradually become reduced in complexity and more refined at the outer edge while retaining a three-dimensionality where they envelop the stem. Finally, even the last frills disappear and we are left with a narrow, spear-shaped leaflet at the top of the stem.

What is happening here in what seems to be a transformation which extremely diverse plants have in common with one another? The whole process is expressed most eloquently in the poem by Goethe entitled "The Metamorphosis of Plants". We quote now the section on the development of the leafy region of the plant:

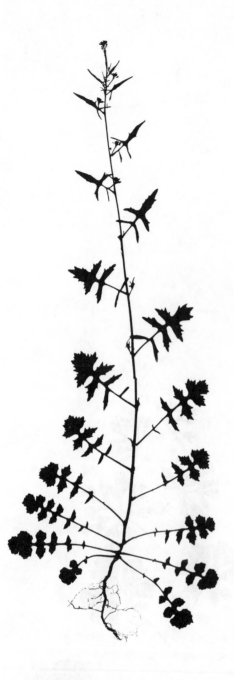

Fig. 75. Charlock (Sisymbrium officinale) *showing another example of the leaf transformation between root and flower. [photocopy from a pressed plant specimen]*

The Metamorphosis of Plants J.W.v. Goethe

"Confused may you be my beloved
By the thousandfold mixtures of flowers in the garden
You hear many names, sounding one after t'other,
With terrible tones in your delicate ear.
All their forms are alike, yet there's none like another,
The whole choir is pointing to a secret law,
To a holy riddle. Oh if only, dear friend, I could in a word
Convey to you now the happy solution!
Come, see how they grow, how stepwise each plant
Gradually guides itself t'wards flower and fruit.
From the seed it develops as soon as the earth,
That still, fruitful womb, gives it over to life,
Allured by the light, sacred ever-moving,
Tending delicate forms of the unfolding leaves,
In the seed lay this force, simply sleeping,
Foreshadow of form, enclosed in itself, in the seed-coat protected.
Leaf, root and germ, only half-formed, un-coloured,
Thus the kernel, in dryness, protected unstirring life.
Now, trusting in moisture, it sprouts eagerly forth
Lifts itself out of enveloping night.
Simple the shapes of the first things we see
Showing there's childhood among the plants too.
At once then an impulse arises, lifts itself over,
Renews, node after node, that first simple form.
And not always the same; as you see the leaves that then follow
More complex and manifold, are spread out, serrated,
Divided in points and divisions,
What formerly lay joined, unmoving below.
And so it approaches that highest fulfilment
Which in so many species great wonder evokes.
Many-ribbed and indented with voluminous surfaces,
The richness of impulse seems unending and limitless.
Yet here Mother Nature, with powerful hands, holds back
The formative force and guides it so lightly
To something more perfect.
She reduces the sap and narrows the ducts
And at once show the forms a more delicate working.
The outer extremities are quietly withdrawn
And the rib of the leaf-stem builds itself fully.
Quite leafless now the more delicate stem
Rapidly grows and shows the observer
A most marvellous formation . . . "

(continued on page 104)

What Goethe describes here as events in a continuous time stream were studied in detail and the differentiation within it described in the 1960's by Jochen Bockemühl.

Let us look at the leaf sequence again (for instance Fig. 75 or any other of our previous examples), this time reflecting on the activities we experience as we enter into the movements with our fantasy.

Laws of Leafing

At first there seems to be a stretching, pushing activity which is rather linear or unidirectional (Fig. 76a) and which then, as the leaves become larger further up the stem, is joined and overtaken by a bilateral planar expansion (b). This second activity seems to be "in competition" with one which differentiates or divides the expanding plane of the leaf blade, apparently "eating" away its substance from without (c). In the meantime a fourth activity has been pushing the blade backwards and inwards towards the stem, engulfing what is left of the linear stem of the leaf and enveloping the sides around the stalk of the plant (d). This contraction from periphery to centre reducing the leaf to a tiny spear-shape is the opposite gesture to that at the bottom (a) where we had seen an unidirectional expansion from centre to periphery. It is as if all that which swelled into and created the leaf form and substance in the first half of the sequence gradually withdraws as we approach the top of the plant – as if it was giving way for something else to come about.

Fig. 76. Diagrammatic representation of our experience of the four creative movements active in leaf formation: (a) stemming, (b) spreading, (c) differentiating, (d) pointing.

Following the terminology introduced by Jochen Bockemühl, the sequence of activities which the plant passes through and which left their imprint in the leaf forms can be summarized as follows:

a. Stemming a stretching outwards from centre to periphery as an axial, unidirectional "push".

b. Spreading a widening and spreading bilaterally into a horizontal plane.

c. Differentiating a dividing or indenting of the plane from the sides.

d. Pointing a contracting from the periphery to the centre and engulfing of the axial stretching.

The developmental movement of a plant in time resulting in the creation of such a leaf sequence can be thought of as a kind of dance performed by each plant to a universal melody. Each plant develops its own style of ornamentation but the underlying choreography follows the pattern which we have described as *four formative activities* or *creative movements*. They do not follow one after the other in an exclusive fashion but rather interweave and overlap as illustrated in our diagram (Fig. 77).

flower

root

Fig. 77. Diagram showing how the four formative activities overlap one another. Each of the four different lines represents the increase and decrease of activity for one of the four movements, going from root (bottom) to flower (top).

Pointing
Differentiating	– – – – – – – – –
Spreading	— — — — — — —
Stemming	——————————

Polarity and Enhancement – Prerequisites for Transformation

Perhaps you will have experienced how we have been engaged, in this chapter so far, in two very different activities. Reflecting on these you might have realised that they are in a certain way opposite to one another. In one we were involved in a process of entering, with living imagination, into the growing, developmental activity of the plant. We "swam" in between the plant parts (leaves or separate pictures of a developmental sequence), using them as stepping stones to "flow in fantasy" through the sequences, uniting our own thinking as nearly as possible with that stream of life through which the plant came to express itself as it grew. Perhaps you can feel the rhythm, the ever onward intention of this in Goethe's poem.

We then changed intention, stood back a little and our second activity was much more still and reflective. It involved standing apart from the plant, clarifying and classifying the experiences we had while "swimming" through the sequence – an activity of becoming conscious of the differences rather than the similarities between the developmental events of each plant. We discovered hidden laws in the leaf metamorphosis that were differently "enacted" by each species. These same differences we find reflected, or rather revealed, in a much more obvious way in the flower (see Chapter 5). In fact the whole metamorphic (meaning "changing in form") process of transformative movement in the leaf sequences has to do with the approach to the flower, "that most marvellous formation" (Goethe) We will deal with this later on in this chapter.

The so-called "leaf metamorphosis" has arisen in the tension between two opposites – in this case between the flower, where something definite and, one might say "spiritually different" is impressed into (or expressed by) matter and the ever onward living, growing root region. The continuous development of roots growing (all in a similar manner for the whole of the plant's life) and the sudden, dramatic appearance of a flower are *polar opposite* events in the life of the plant. Prolonged life and new growth cannot take place without the roots and their attachment to the watery region of the earth; whereas the flower heralds death and the end of development in a certain sense. In between these two opposites we find the leaf region of the plant.

The leaves themselves reflect this polarity, the lower ones being simple, long stemmed and somewhat root-like in their emphasis of linear or axial form. As we go on up the stem beyond the centre, we find the leaves become more differentiated, finer, more planar and hence flower-like. Between the root and the flower we have experienced something of a "journey of development". In any such developmental sequence in living organisms it seems to be that " . . . *we proceed at first from simple to more complex forms; but then we reach the most complicated stage in the middle of the development, after which it becomes simpler again while also becoming more perfect*" (Rudolf Steiner, Bern 29.6.1921).

The "becoming more perfect" is also described as an "enhancement": that which is different and unique to each plant becomes gradually more emphasised or enhanced as opposed to that which they all have in common (Goethe also described this as a "refining" of the sap). In entering into the process ourselves we sense the plant to be moving through to a deeper level of transformation and we start to experience the need to look at the plant in a new way – a way which befits the process of flowering (this will be the subject of Chapter 5). In order to deepen our experience of polarity and transformation we will now embark on some drawing exercises.

Practicing Polarity and Transformation

Let us start by exploring a simple polarity in the realm of form: How many ways are there to draw a circle?

We would like to suggest two slightly unusual and very opposite ways of creating a circle – by using only straight lines. Following our examples (Figs. 78 and 79) try to draw freehand straight lines using Conté crayon sticks or a soft pencil on large sheets of paper and try to observe the effect which the following two processes have on you.

In the first drawing we start by defining a point somewhere on the page and draw straight lines emanating from this centre in all directions (Fig. 78). All lines stop equidistant from the centre. This *measure* in relation to the *centre* defines the radius of the circle which we can imagine as an invisible curved line connecting all the end points of the straight radii.

A *polar opposite* way of drawing a circle is to start from the *periphery* moulding, as it were, from the outside, the rounded form of the circle with the help of tangential straight lines, all of which have their origin at infinity (on a line infinitely far away in all directions from your paper, i.e. on an infinitely large circle). You draw these lines, as they enter visibility on the edges of your paper and follow them as they leave on the opposite side. Each line is a tangent to the circle which gradually emerges between the overlapping lines from all around (Fig. 79). You will find that this way of drawing a circle is very exciting but demands a lot of control, in order to maintain the straightness of the tangents and to achieve an even form.

Can you get a feeling for the oppositeness of these gestures as you draw them? Consider these two polar opposite processes and the resulting forms. Can you relate them to the polarity of root and flower which we have described in the previous paragraphs?

Think of the semi-spherical shape which the roots prescribe as they penetrate the earth radiating outwards from the growing point (see Fig 70). Fig. 78 can be seen as two-dimensional diagrammatic representation of this radial, or centric principle of root development.

If we look at a flower (or indeed any developing bud above the ground) we find a hollow space formed by the enveloping planes of the flower parts (or developing leaves). This enveloping, peripheral principle can be seen represented diagrammatically in Fig. 79.

Fig. 78. Circular form created by straight lines radiating from the centre. [Conté crayon]

Fig. 79. Circular form created by tangential straight lines originating from the periphery. [Conté crayon]

In the leaves themselves we experience the linear tendency to be very prominent at the beginning and to reduce as we go up the stem. This reduction is "compensated" by the increase of a planar tendency, until the flower, which is entirely planar. Thus the leaves hold a fluid and consistently changing balance in emphasis between two form principles – line and plane. This brings us back to the polarities inherent in the leaf development itself.

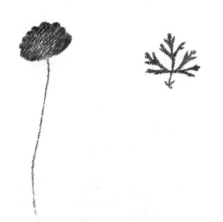

Compare the two leaf shapes illustrated in Fig. 80, taken from one of our leaf sequences, with each other. We can further highlight their oppositeness through drawing them as "negative" forms. Instead of representing the material shape as black we darken the surrounding space, leaving the leaf shape as white, "negative" space (Fig. 81). Doing this will make us more aware of the activity of the periphery. Drawing the leaf in this way we can demonstrate our inner experience of how the substance of the second leaf form seems to be impinged upon from the environment.

Fig. 80. Two leaf shapes from mallow plant leaf sequence. [pencil]

Considering the two drawings in Figs. 80 and 81, we could say: the first form is convex, bulging outline is the result of its "ex-pressing" itself into the surrounding space; the second form is concave, indented outline results from it being "im-pressed" upon by the environment. But we can also come to a different, equally valid experience of the two shapes: we can picture the first one as being drawn out, sucked or called forth and taken in by the surrounding space. Consequently it would also be possible to read the second shape as an active withdrawal or inward suction and a concentration of forces.

Considering these two readings of the pictures which give inner and outer, form and space both active and passive parts to play provides us with a richer and more living picture of the formative process.

Putting our observations and experiences into a wider context, we find we can also relate this interplay of polar opposite inner and outer forces to the cycle of the year – to the polarity of spring's expansion into growth as opposed to autumn's withdrawal of forces. That which is there enacted on a grand scale we find echoed in our leaf sequences.

Fig. 81. Drawing the "negative" can heighten our awareness of the activity of the space surrounding the shapes. Through varying the intensity of the darkness we can emphazise where we experience more or less activity of the peripheral forces. [pencil]

This rhythmical breathing in and out of Nature seems to have inspired Greek sculptors to carve ornaments like the one illustrated in Fig. 82. Here we see two plant-like gestures alternating with each other to form a kind of circle-dance. Compare the two plant-like gestures with each other. They are polar opposite in almost every aspect: one is contained and concentrated like a bud, the other one is more open, radiating out and receptive at the same time; one has positive edges, the other one concave grooves carved into its lobes. Observe how they emerge from spiralling movements: one is spiralling out, the other is spiralling in.

Fig. 82. Detail of ornamental frieze, from the Erechteion, Acropolis, Athens. [pencil]

We can find many variations of this rhythmical ornamental pattern revolving around the architraves and column shafts of Greek temples and holy shrines. Going from one form to the other, can you experience a process of breathing in and out similar to that which we described before?

Reversing the use of dark and light surfaces (Figs. 80 and 81) we have become aware of the mutual interaction between inside and outside, between form and surrounding space. We may now ask ourselves: what are the inherent qualities of light and darkness and how can we work with them artistically in a way which echoes the polarities we encountered in the leafy region of the plant?

Fig 83. Inner and outer form with reversed use of dark and light surfaces. Compare the two inner circles with each other. Do they have the same diameter?

Darkness and Light – Media of Metamorphosis

Look at our illustration (Fig. 83). Compare the two double circles with each other. Are the two inner circles of equal diameter? The white circle in black (on the right) seems to be slightly bigger than the black circle in white (on the left). In fact their diameter is exactly identical. (You can check this by measuring or you can cut your own circles out of white and black cardboard and glue them onto a sheet of medium grey cardboard). This apparent difference in size is a known visual phenomenon which is due to the inherent tendencies of light and dark surfaces. A light surface tends to *visually expand* if set off against a dark surface; a black surface seems to *visually contract* if seen on the background of a white surface.

We can develop this polarity of white and black surfaces into a sequence of drawings by adding in-between steps and transitional tones between black and white (Fig. 84). What do you feel as you move with your inner experience through the sequence from one side to the other?

Fig. 84. Light and darkness transformation sequence. [charcoal]

We suggest that you draw such a sequence for yourself. You need five square pieces of white cartridge paper (250 × 250 mm minimum) and a thick stick of willow charcoal which you break into pieces approximately 40 mm long. The best is to begin with the middle drawing which is covered with an even layer of medium grey. Put the piece of charcoal flat onto the sheet of paper and move it across with very gentle pressure. Slowly cover the whole paper with successive layers of light grey, alternating horizontal with vertical and diagonal movements in order to achieve an even cover of medium grey. From this middle drawing you may proceeed to the two sides, taking one step to the left, one to the right before finishing the sequence with the two outermost pictures. Note how the even cover of grey of the middle drawing becomes more and more differentiated towards the left and right. Towards the left the centre of the drawing becomes increasingly lighter while the darkness is gathering in the periphery. Towards the right the polar opposite process is taking place. Try to balance the amount of darkness and light created on the two sides with each other. As a help you can imagine that for each drawing you have the same quantity of dark "particles" at your disposal. Hang the drawings in a row so that you can see them together and check if you need to make some final adjustments.

Contemplate the finished result. Compare the two ends with each other. How would you describe this polarity? Can you experience contraction/expansion, warmth/coldness? Move through the sequence from one end to the other and backwards: which side feels more like a beginning, which like an end? What kind of a process is this? Can you relate it to anything we have observed in Nature, perhaps the cycle of the year – or day and night? What happens in the middle of this sequence? How do the opposites meet?

Using light and dark surfaces and all the in-between tones we have created a simple metamorphic sequence of drawings leading us from the periphery to the centre, from light into darkness, from expansion into contraction. In the middle drawing all these opposite tendencies meet and balance each other, creating an even, neutral surface.

You might like to take these exercises further into a drawing process which combines our experience of polarities and enhancement in plant development with that which we have just explored in the realm of darkness and light. How does this polarity manifest in the plant itself?

Perhaps surprisingly, the roots which penetrate the darkness of the earth are the lightest part of the plant. At the "opposite end" of the plant we find the dark seeds – hidden within the fruit – that organ of the plant formed closest to the sun.

In growing from the earth towards the sun the plant becomes "lighter" (it grows *up)*; but also more full of matter – more dense and hence "darker". Towards the flower it is less dense (lighter) but more formed – darker from another point of view. The following drawing exercise will allow us to explore these opposite qualities of light and darkness.

Take a new sheet of cartridge paper (approx. 450 × 300 mm) and fix it with masking tape in a vertical orientation on your drawing board. With the charcoal stick give the paper a first light layer of darkness all around the periphery, leaving out an oval or slightly egg-shaped (with the wide part at the top) space in the middle. If you are careful to create transitions between the darker and lighter areas you will notice that soon the centre of the drawing will appear as if filled with light. Imagine that this light is *expanding upwards,* pushing the darkness towards the periphery.

Light is insubstantial, it does not have any weight (the adjective "light" can denote lightness as well as the lack of weight). Light can only exist where there is no opaque material substance. Darkness on the other hand is bound up with the nature of matter. Solid matter is (usually) impermeable to light; it excludes light from its interior. It also creates the darkness of the shadow opposite the source of light. You might already have experienced that dark surfaces in a drawing have an inherent sense of weight. (Perhaps you noticed in your drawings of the previous exercise that you had to make quite an effort to keep the distribution of darkness even on all sides as the darkness tended to concentrate at the bottom of the paper).

In this drawing we shall allow the darkness to follow its inherent tendency to *contract downwards* into gravity. As the light expands upwards from the centre, waves of darkness stream downwards and gather towards the bottom centre, creating between them a seed-like concentration point (Fig. 85).

Between the streams of darkness coming from both sides, small vertical channels of light are created, which extend downwards into the darkness just as the roots of the plant reach downwards into gravity. At the same time the upper light space can be experienced as inviting, calling forth a form to grow upwards out of the darkness. Allow the concentrated darkness of the seed point to "breath out" in rhythmical waves into the open light space.

Fig. 85. First stage of growing process using light and darkness [charcoal].

For the following growth process it is of importance that you simultaneously develop all the parts of the drawing, the centre as well as the periphery, the bottom (earth) as well as the top (heaven). As the inner dark form grows rhythmically into the light space, the darkness of the periphery gently moves in towards the growing form, providing a kind of mould into which it can grow. Further above, the dark material, which is streaming upwards, takes on lighter and finer consistency. At the same time the darkness of the periphery becomes more active, defining from the outside the leaf-like forms which, from dark shapes growing into the light, have metamorphosed into light shapes in a dark surrounding.

Springing into Summer

This darkness gently presses in from the periphery, bringing to a halt the surge of upwards growth. This upper darkness has a very different quality from the "heavy", material darkness below. You might like to imagine this as the firm forming quality which we find at work in the flower and the upper leaves – that force which brings distinction and differentiation to the ever onward rhythmical growth process.

Leave some light in the upper part of the drawing to convey a sense of the possibility of future development and don't forget to further darken the lower part of the drawing and to define the "roots", anchoring the form in the lower darkness.

Fig. 87. Musk mallow (Malva moschata) *in its first year of growth. [photocopy from pressed plant specimen].*

Who shines the Light?

If every dicotyledonous plant passes through such a complex sequence of events during its expansion into green and subsequent contraction (and so far it seems they all do) – why is it happening? What is the force active behind this highly differentiated time process that seems to be universal and at the same time individual? Or in other words: who is shining the light? To come closer to an answer to this question we have to consider the leafy region in the context of the whole plant.

We have repeatedly mentioned the journey between the hypocotyl and the flower. Something rather obvious that all the plants looked at so far have in common is that they are flowering. Our illustrations (Figs. 87 and 88) show a common mallow plant in its first year of growth beside a flowering second year plant. You can see how similar and simple the leaves in the first year are and how the transformation of the leaves only starts to happen in the dramatic way we have been observing when the plant receives or expresses the impulse to flower. So the leaf development actually heralds a future event, the advent of the flower! Try and observe this for yourself in first year rosettes watching what happens when they flower.

Fig. 86 (left). Completed drawing of growth process. Note how in the process of growth from below upwards, light and darkness, inside and outside reverse their relationship: The first "leaves" appear as dark shapes in a light surrounding. Further above, this changes to light shapes which are fashioned by darkness from without. [charcoal]

Fig. 88. The same musk mallow plant in its second year progresses towards the flower and displays its characteristic complex leaf sequence [photocopy from pressed plant specimen].

> *"Once you have learned to decipher the letters you can read them all over though the writing may vary."*
>
> *J. W. v. Goethe,*
> *The Metamorphosis of Plants*

How can the flower, while still invisible, intangible at the time the leaves go through their process of transformation, exert such an influence upon the development of the leaves? It is as if the flower is like an "idea" working into the present from out of the future. It seems to pull the leaves towards it through an apparently archetypal sequence of events which is expressed somewhat differently in every species, as we have seen, and also differs within a species according to the environmental circumstances.

Perhaps we could say that each flower is like a light which shines into the plant from the future and casts shadows into the past of the plant's present circumstances: its physical substance and life conditions. Each flower is like a star and its star-light is a reflection of the one sun's light, experienceable in the universality of the process they all go through.

Leaf Language or Universal Language?

Is the expansion into complexity and contraction into simplicity which we found in the leaf sequences and practised in the drawing exercises peculiar to flowering plants or does it, as Goethe hints at in his poem, apply to other aspects of life on earth?

Let's think about our own lives. Picture the undifferentiated, rounded form of a baby and its undeveloped potential. We grow and expand to become more and more *ourselves* in the middle of life after leggy teenage and fleshy twenties seeking to expand in all possible directions and learning to live within inner and outer constraints. "Life begins at 40" they say – because we've become master of ourselves, somehow in charge of all that which was often a problem in burgeoning youth. But at the same time there begins a contracting and dying process in middle age of our physical capacities and life forces – a contraction into the essentials, often a release of refined soul/spiritual capacities and finally a withdrawal outwardly into frail physicality which is nevertheless the other side of deep wisdom. Think how important "the old ones" are in all so-called primitive societies – of the influence of your grandparents or other wise old people you have known in your life. Often just one sentence of an old person can go on echoing in and influencing your life even long after they have died. Such wisdom is not accessible to us in youth when we are full of boundless physical energy. We have to go on a long journey of expansion into ourselves and into the world followed by a contraction, after years of practice, before this spiritual "flowering" graces us.

Consider this while dwelling upon one of the leaf sequences, such as the groundsel in Fig. 89.

In the spring of each year Nature shoots forth sending leggy stretching growth aloft. Each early (or not so early) morning we get out of bed and stretch into our limbs before the day begins. We then partake of liquid refreshment and breakfast expanding ourselves into life in order to begin the day's real work. We feel fresh and full of force in the morning hours – rather like the growing and expanding leafy greenness in early summer which follows the rising of the sun in spring. By late summer everything in Nature is flowering and then starting to fade; has become differentiated but is dying away. So do we each day as we have completed the day's tasks and settle down for evening rest – rather like the leaves towards the top of the stem have withdrawn into themselves and sit close to the stem. Finally they transform into another world (the flower) as we do each night and as Nature does each year as she prepares for winter in the forming of the fruit.

Comparing and relating all these experiences and observations to each other we can be amazed at how the cycle of human life is indeed a metamorphosis of the cycle of the year and of the day – and how these, in turn, are moving pictures of what we meet, frozen in form, in the plant itself!

Fig. 89. Leaf sequence of groundsel (Senecio vulgaris) *[photocopy of pressed leaves].*

5 The Flowering of Summer

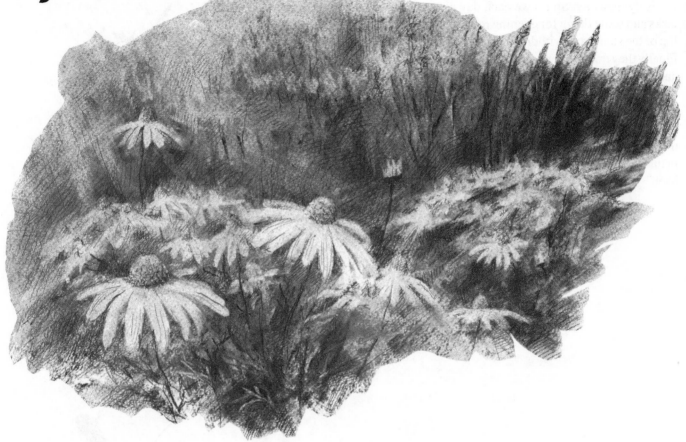

Fig. 89. Patches of chamomile in a summer meadow. [charcoal]

The Fullness of Summer

Ask any English person of their image of an ideal summer – it will probably be full of flowers, their brightly-coloured faces turned up to a warm, but not too hot, sun in a clear blue sky studded with fluffy white clouds. Perhaps a field of waving corn – barley or wheat – as it turns from green to gold full of patches of brilliant red poppies; corn flowers and chamomile beside the way – intensely white, yellow and blue against the deep green of the wayside herbage.

In such a picture it is clear that we are no longer so concerned with the individual plants as we were in spring when they appeared one after another. Now we have a huge backcloth of colour, differing shades of green against which it seems as though God and his angels have painted swathes of complementary reds or pinks, shining white or blue and the occasional stunning yellow. The impressions which delight us are in the pools of colour created naturally or in our gardens throughout the country – one block of colour against another, multitudes of flowers en masse or mixed lightly. What is it that gives us such pleasure in these gardens? Why does the heart light up and the soul almost overspill with joy at the sight of poppies in a wheat field, heather on the hill, hedges full of honeysuckle or a cottage covered with clematis?

Compare the early summer morning experience of awakening to birdsong, leaping out of bed with a longing to be out of doors (instead of going to the office) with the effort involved in leaving the daytime hearth in winter. At midwinter we remember a dragging of feet; a longing to linger by the fire; the need to pile on extra clothes and reluctance to move at all. Now, at midsummer, we find a sense of joy and delight at what grew in the short nights and the bright light draws us out all day. Those with gardens can barely turn themselves indoors for meals. Picnics become the order of the day – and where better than in a meadow full of flowers, smiling faces turned towards the sun echoing the gesture of the flowers? Often we do not even look at the flowers but simply delight in the atmosphere they create around themselves – bathe in that scent surrounded by the hum of bees, or pick them in armfuls to adorn the house or person.

Let us dwell for a moment on the polarity between summer and winter.

Seasonal Metamorphosis

Thinking back to those days of winter darkness with the watery sun filtering through a freezing mist and casting coloured shadows on the snow, when everything was reduced to the barest of essentials, we remember how hard it was to move but how easy to think – to dream great shining pictures. How far away then were the summer experiences of now – days so full of matter, of colour, of scent and sense impressions. We cannot think clearly at midsummer – we expand outwards, longing to move, to walk, swim and extend our limbs. We do not notice detail so much – there's too much of it – we bathe rather in the soul moods of plants and places. Winter's clarity and light-filled dreams have become summer's facts and filled with matter. How has this come about?

Can you experience the polarity of winter and summer – not only in Nature outside but also in your own soul? Between the opposites of the darkest and the lightest season lie all the events we have been describing in the life of plants so far and between mid-summer and the winter time lie all the events we are going to deal with in this chapter and until the end of the book.

Taken as a whole the year is a *metamorphosis in quality of season*. We call it the "cycle of the year" and it has its own laws just like those we found hidden in the cycle of leaf development in a single plant. What is this word *"metamorphosis"* which keeps cropping up? It means literally "the act of changing form". From winter until now the plants have been changing very rapidly. As they change in the world outside as the year moves on and the sun moves through its zenith, so do we metamorphose in our inner world. Our own souls seem to undergo an inner transformation of mood, which is intimately embedded in the cycle of the year.

Metamorphosis and Archetype

The word "metamorphosis" was first used in Greek times to describe the transformation from the larval state of animals into the adult form, e.g. caterpillar to pupa to chrysalis to butterfly. Carl von Linnaeus, the great Swedish naturalist, was the first person to use it to describe the transformation from leaf to bud to flower and called this "Metamorphosis Plantarum". Two hundred years before, in Italy, Cesalpino had stated that all plant parts have a common origin. Although Linnaeus "saw" metamorphosis because he was very religious (and God created all the plants and animals at once as descibed in Genesis), he could not allow himself to "experience" evolution or development between organisms. His energy went into a wonderfully strict classification of all the organisms which still bear his name (e.g. *Delphinium elatum (Linn.)*). Goethe, on the other hand, was able to build on Linnaeus' efforts and enter into the "relationship between" organisms, just as one can do between organs (leaves) within an organism (plant). In doing this he laid the foundations for an evolutionary or developmental way of thinking about life. Only now, 200 years after Goethe, do we begin to appreciate the real meaning of this and of how Goethe was able to transform these thoughts into a "way of seeing" highly appropriate for the study of life.

Remembering our leaf sequence from Chapter 4, you might have remarked that none of the leaves of a plant are ever the same and yet, there *is* something within them all that is "of leaf" by which we can recognise not only that each leaf is a leaf, but also that each leaf is related in form to every other leaf on the plant – by an "invisible something". It is as if the invisible something makes a leaf, withdraws, makes another leaf, withdraws and so on. With each withdrawal and return to leaf-making something has changed. So also with any metamorphosis or transformation of this nature one could say that *something stays the same and something is always changing*. We can represent this with the following diagram:

"Everything is metamorphosis in life – in plants, animals to man and in him too."
J. W. v. Goethe

"What he – Linnaeus – sought forcibly to keep apart had to strive for unity in accordance with the innermost need of my being."

J. W. v. Goethe

"Something" stays the same

"Something(s)" is (are) always changing

ONE contains/is contained by MANY

We saw, in Chapter 4, how, although we could recognise what all the plants had in common as they "danced" through their transformative process, there was also an instant recognition of how different and unique they are – how each plant dances its way through its symphony of the seasons (embedded in the leaf sequence) in its own particular style.

The sequence of stemming, spreading, differentiating and pointing *is the same* in all the plants we have seen but the *way* each plant species *goes through* this sequence is *different*. The differences or styles which contour the leaf sequence are as much part of the expression of the "being" or "essence" of who a plant is, as are the flowers which crown the whole process. But they are also all plants – dicotyledonous flowering plants. Thus, all the plants we have looked at so far are different manifestations of plant "beingness" just as each leaf as we know it inwardly is a kind of archetypal expression for that which all the leaves on the plant have in common. This is a "one" that is never physical, but which nevertheless contains and is manifest within the "many", which are physical!

Just as each leaf is one expression among many on the whole plant, so each plant is one expression of the many different plants within the "wholeness" of the Plant Kingdom. So also is each moment of the year one glimpse of a wholeness which is the cycle of the seasons.

Goethe, on his way to Italy, had crossed the Alps and experienced plants there which looked very different, but somehow similar, to the ones with which he was familiar in his home country near Weimar in Germany. Then, along the coast, beside the sea, he saw others looking even more different and yet still recognisable as belonging to certain known groups. He started to get a glimpse of the "eternal plant Oneness in numerous manifestations revealed" (J.W.v. Goethe: "Parabase").

PARABASE *J. W. v Goethe*
"For many years, with great delight
The spirit eagerly did strive
to discover, to experience
Natures's own creative life.
It is the eternal Oneness
In numerous manifestations revealed.
The great is small, the small is great
And everything after its own kind.
Always changing, but retaining itself
Near and far, and far and near
And thus forming, reforming itself –
To wonder at it am I here."

In the Botanic Gardens in Padua Goethe was dwelling on the different forms of leaves on one plant and, on May 17th 1787, he wrote to his friend Herder:

> *"It had occurred to me that in the organ of the plant which we ordinarily designate as leaf, the true Proteus lay hidden, who can conceal and reveal himself in all forms. Forward and backward, the plant is always only leaf, so inseparably bound with the future germ that we cannot imagine one without the other."*

And:

> *Moreover, I must tell you confidentially that I am very close to the secret of the creation of plants, and that is the simplest thing one could imagine. The archetypal plant will be the strangest creature in the world, which Nature herself ought to envy me. With this model and the key to it, one can invent plants endlessly which must be consistent – that is, if they did not exist, yet they could exist, being not some artistic or poetic shadows and appearances but possessing inner truth and inevitability.*

EPIRRHEMA *J.W.v. Goethe*
"In the study of Nature
You must always consider
Each single thing as well as the whole
Nothing is inside, nothing is outside;
For what is within is also without.
So hurry onwards and try to grasp
The Universally-open Holy Secret.

Rejoice in this true illusion
As well in the serious game;
Nothing alive is ever a one
Always is it a many."

The inner experience of "truth and inevitability" is what allows us to "know" when something is "right" or "belonging". Such an experience of inner truth can happen when we live ourselves into the connections between the many and the Oneness.

We have found that everywhere we look in the plant world – or anywhere in life for that matter – there is a fundamental "Oneness" that is in "numerous manifestations revealed". The leaves and flower parts are all part of a single plant oneness, the variations on the theme of each species are another and all the plants within one plant family or even the whole plant kingdom represent an even more comprehensive oneness. Goethe called the oneness that unites all plant being, the *"Archetypal Plant"* (the *"Urpflanze"*)

Now let's come back down to earth and midsummer matters and look at a plant who is a herald of this time of year and reveals a *"universally-open holy secret"* (J.W.v. Goethe: "Epirrhema").

Fig. 90 (above). Goethe's sketches of "leaf-like" organs, from the cotyledons (left) to the upper leaves.

Fig. 91 (left). "The Ideal Plant" by P.J.F. Turpin – an attempt to represent in sense-perceptible form something of that archetypal nature of the plant which Goethe strove for and realised can never be perceived with the senses – and yet which is within every living plant.

Peering at Peony

Fig. 92b on page 103 shows a peony (*Paeonia sp.*) which is known throughout Europe as the 'Whitsun Rose' – 'Rose' in recognition of its very special nature and 'Whitsun' referring to the time it blooms.

This particular version is a "field" variety of the wild peony which is rather more simple and common in low, mountainous areas of Southern Europe.

In Fig. 92a we show all the parts of a peony laid out in the order in which they occurred on the stem together with the upper leaves. Let's "live ourselves into" what is happening here in the same way as we used our "exact sensorial fantasy" with the leaf sequences in the previous chapter.

Moving towards the flower from the last true leaves can you feel the blade of the leaf being 'sucked down' into the leaf base, which itself expands laterally and gradually becomes tinged with colour? This process continues until there is nothing left of the original green leaf and its stem but a tiny point in the outermost edge. Lastly we even find a notch where the leaf was in the by now brightly coloured petal – a sort of "minus" leaf! How different is this experience inwardly (and outwardly) from that of "swimming through" the leaf sequence of the shoot!

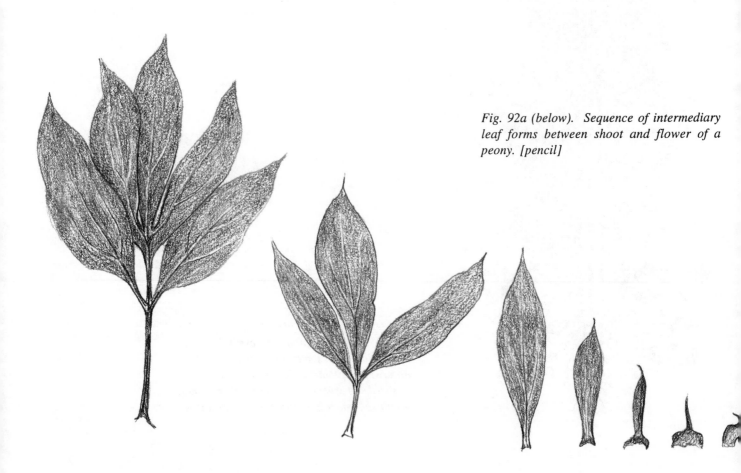

Fig. 92a (below). Sequence of intermediary leaf forms between shoot and flower of a peony. [pencil]

There we had an expansion into fleshy green complexity and then a gradual contraction into tight, green pointed spear shapes. Here the contraction of green leaf substance goes even further until it (the green leaf on its stem) disappears entirely – "down the notch" at the edge of the petal – and is replaced by something new. We experience an expansion of this new principle that was already hinted at in the enfolding gesture at the end of the leaf sequence described as the activity of "pointing". Now, in the growth of the petals the leaf base expands even more laterally and symmetrically excluding (or squeezing out) the central rib. The pale edges take on colour, the tissue becomes finer and finer as it expands itself into fully formed petals, which together create " . . . *that most marvellous formation . . .* " (Goethe in "The Metamorphosis of Plants"), the "crown" of the plant, its *corolla* .

Fig. 92b. Peony (Paeonia sp.). *This bushy plant delights us with its lushly filled, dark red or pink flowers every Whitsuntide. [pencil]*

In the following lines you can read how Goethe describes this himself in the second half of his poem "The Metamorphosis of Plants" (the first half, you may remember, we printed on page 81).

Quite leafless now the more delicate stem
Rapidly grows and shows the observer
A most marvellous formation.
Round in a circle, numbered and numberless
The smaller leaves take their place next those they resemble.
Clustered round axis, the calyx unfolds itself
Revealing that wonderfully-formed and beautifully-coloured corolla.
Thus shows Nature wealth of blossoming growth
Built layer upon layer in a series.
You wonder a new each time the flower climbs on its stalk
Over the delicate framework of leaves. This wonder of glory heralds yet
 new creation.
Yes, those coloured leaves feel the touch of God's hand,
Quietly withdraw themselves, the most delicate forms
Twofold, strive forwards, destined for union,
Trustingly standing together; sweet couples
In well-ordered numbers surrounding the holy Altar.
The nuptial God nears and splendid, sweet, life-giving fragrance
Fills the surrounding air. Now each seed starts to swell,
In countless numbers, tenderly held in the womb of the fruit.
Here Nature closes the eternal force ring
And at once a new cycle links to that of the past
That the chain will continue through Age upon Age,
And the whole be alive, like each one of its parts.
Turn your gaze now, my beloved, to the many-coloured hosts
No longer confusing before your mind's eye.
Now each plant bears witness of an eternal law.
Each flower speaks louder and clearer with you.
And once having learned to decipher the letters
You can read them all over, though the writing might vary.
The grub's creeping crawl becomes butterfly's haste.
Man himself then must change and creatively shape.
Oh think then too, how the seeds of acquaintance
Gradually grow into shoots of our habit,
How friendship, with strength, grew revealed from our hearts
And how love, at long last, led to flower and fruit.
Think how varied the forms that in silent disclosure
Nature has lent to our feelings.
Rejoice in the day! Holiness of love
Strives ever upward towards the supreme fruit:
Kinship of spirit, a like-minded view of all things.
That lovers unite in harmony of wonder
To find themselves in a higher world.

 J.W.v. Goethe: "The Metamorphosis of Plants"

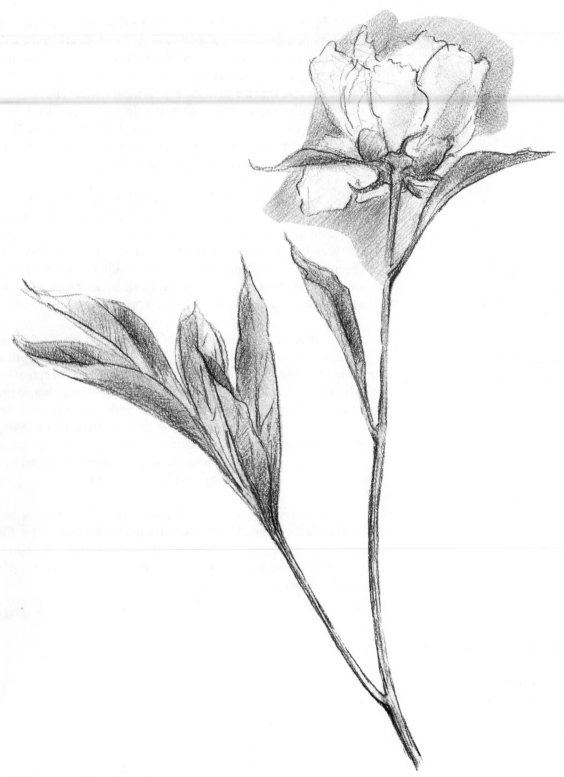

Fig. 93. Peony; upper part of the stem with the flower showing the gradual simplification and contraction of the leaf forms towards the flower[pencil].

Going further inside the layers of the flower we find another, quite new type of contraction which we will deal with shortly. First let's dwell upon this exchange area between leaf and flower for a few more moments.

Looking at the place where the upper leaves were attached to the top of the stem we find the stem to be at its most slender and fragile. Where the "leaves" which are half petal, half ordinary leaf are attached the stem has started to swell horizontally into a kind of pad. Here we find all the other organs of the flower attached in one inward moving spiral, but all "on one level" so to speak (Figs. 94 and 95).

So, summarising, we find at one and the same time the leaf stalk disappearing in the leaves themselves as they spread bilaterally, and the upward movement in the main stem of the plant stopping and spreading out laterally into a radially symmetrical pad. That principle which we described earlier as "unidirectional" or "axial" (and which belongs to the earth and to darkness) has been replaced by an expanded, bilaterally symmetrical, planar principle – its polar opposite – belonging to the light!

Dwelling on this for a moment we can allow ourselves to be filled with an experience of awe and wonder at the fading away of one principle or formative force accompanied by the rapid development of another, obviously related, yet at the same time absolutely new "happening": the flower. Something that was there before and now disappears is "compensated for" by something new. This is quite a different kind of metamorphosis than that which we have met so far. When one principle disappears altogether and a new one appears, it is in the "in between" that we realise (are revealed) the something which is common to both.

This "crossing over" of two polar opposite principles is almost tangible in the peony, but it is hidden in most other plants. It is one of the *"universally open holy secrets"* which Goethe refers to in *"Epirrhema"* one of his aphoristic poems accompanying *"The Metamorphosis of Plants"* poem (see page 100).

Fig. 94. Vertical section through flower of peony. [pencil]
b. flower base or receptacle
l. leaves, transitional forms
p. petals
st. stamens

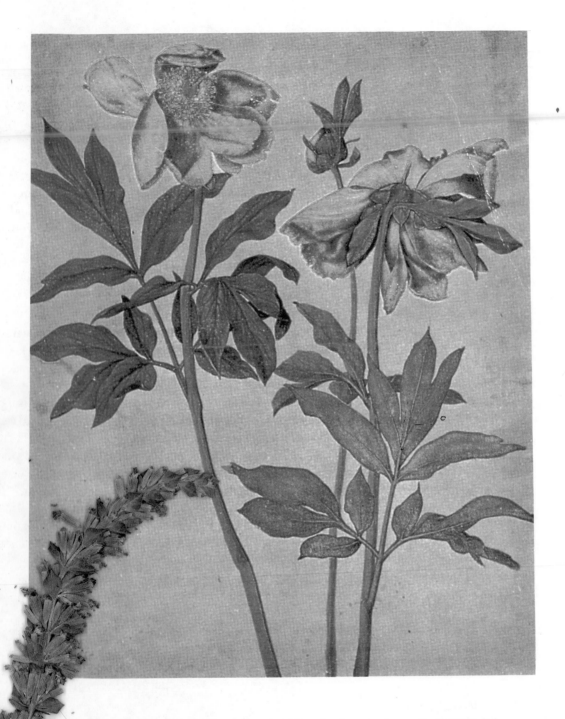

Fig. 95. *Peonies; watercolour by Albrecht Duerer. As early as 1503 the German painter Albrecht Duerer seems to have been intrigued by the secret of the peony flower. This carefully observed study clearly shows all the transitional leaf forms at the base of the flower.*

The "Flype" – an Inversion Metamorphosis

Such a "crossing over" between two worlds as we have just experienced at the balance point between leaf and flower at the top of the stem we have also met rather briefly in the previous chapter when we were examining another area of the plant. Between the downward-growing root and the upward-growing shoot at that pivotal point where the cotyledons are attached the plant turns "upside down and inside out". Fig. 96 shows a vertical section of this area in a sow thistle. Look carefully and follow the vascular bundles from the central core of the root through the hypocotyl into the stem. Imagine you are inside the root and travelling along the vascular bundles down towards the root tip. If you then want to get to the shoot region you have to turn upside down to go upwards and you then find that what was the central core and orientated centropetally downwards in the root becomes, in the stem, peripheral threads or strings around the outside of the stem and orientated upwards. You have, in effect, turned upside down and inside out.

Compare this very physical expression of an upside down and inside out metamorphosis in the root/shoot region with the rather less tangible, but perhaps even more obvious, turning upside down and inside out of the shoot/flower transformation.

To describe this activity, where one principle seems to disappear only to be replaced by something else which is its opposite and yet closely related, and which appears as if from nowhere we would like to use the word *"Flype"*. This is an old Scots expression which literally means "the act of turning upside down and inside out" (for example when you turn your gloves inside out). One could also describe it as an *"inversion metamorphosis"*. There exists a simple two-dimensional form which in the most concise way epitomizes this kind of transformation. Let us explore this form and thus deepen our experiences of this transformation through our own activity of drawing.

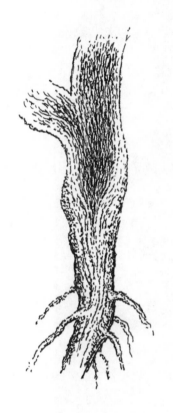

Fig. 96. Vertical section through hypocotyl area of sow thistle (Sonchus oleraceus). It is clearly visible how what was the central core in the root becomes peripheral strings around the outside of the stem. Also note the very different kind of attachment of the first leaf compared to that of the root hairs: the leaf "sheathes off" peripherally from the stem whereas the root hairs "push" their way out from the central core through the outer layers of the root.

Living in Lemniscates

Draw the following forms (Fig. 97 a–e) on large sheets of paper (preferably in vertical position) with generous movements using charcoal, Conté crayon or wax crayons. Get involved with the whole of your body. Let us, to start with, return to the wave-like movement which we have been practising in Chapter 3:

a.

Characteristic of this form is the "interlacing" of an outward with an inward impulse perfectly balancing each other. What will happen if we allow these two impulses to penetrate further into each other, allowing the lines to cross over?

b.

Drawing these consecutive stages of transformation you will notice that, without having to alter the conduct of the movement, you can arrive at a new form, the lemniscate or figure-of-eight. This figure seems to arise quite naturally from the wave-motion. But perhaps we should say: the wave form is the result of a lemniscatory movement which has been drawn out and released into an ongoing motion. What is it that lies at the bottom of both the lemniscate and the wave-movement? Let us, again through drawing, explore this apparently simple form of the lemniscate and discover some of the secrets it has in store for us (Fig. 97 c – e).

Figs. 97 a – b. Exercises with lemniscates. Draw these forms on large sheets of paper (preferably in vertical position) with generous movements using charcoal, Conté crayon or wax crayons. Get involved with the whole of your body!

 c.

 d.

 e.

Fig. 97c – e. Exercises with lemniscates. In Fig. 97d you may want to use different colours for the two lemniscates. Fig. 97e can be drawn in one go; note how you have to constantly adjust the size of the lemniscate loops. Where do these movements take you?

What exactly is a lemniscate? One might say that it is similar to the circle in that it is based on a continuous, self-contained movement, a movement which links up with itself. It always takes you back to where you have started and allows you to continue travelling on forever. Unlike the circle, where, travelling along the circle line, you never have to change your relationship to centre and periphery, to inside and outside, the lemniscate "turns you inside out and upside down" each time you go through the crossing point. Remember how in drawing (Figs. 95d and e) you found yourself alternating between inside and outside. Imagine walking along a imaginary lemniscate on the floor with your right arm stretched out. One moment it will point inside, after passing through the crossing point it will point to the outside. This crossing-over point marks a significant experience on the lemniscatory journey: here you *meet yourself* in that you cross over your previous path. This can be a moment of awakening. But here you also have to pass through the "eye of the needle", a point of utmost contraction, to emerge as a transformed person on the other side.

Having discovered something of the profound secrets of the lemniscate which give us a lot to ponder about, we are not surprised to find that the lemniscate as a form, or the "lemniscatory experience", has often been used in art. There are numerous examples where the lemniscatory form has been applied either as a symbolic form or as a compositional principle where artists wanted to hint at a transformative process or to portray the transformation from one level of experience to another. The lemniscate is also the form used by mathematicians to symbolise infinity (∞).

Look at our illustration Fig. 98. This is a beautiful example of a "lemniscatory composition". Note the difference in treatment comparing the upper and the lower part of the picture: although quite realistically painted the three upper figures are clearly designated as belonging to a different kind of reality by their defiance of gravity and the unearthly white of their garments. Compared to the quiet togetherness of the three upper figures the relationship in the lower part of the painting are much more dramatic and full of tension. Note that there is an in-between realm: lying on a kind of flat plateau we see three of Christ's disciples. Although belonging to the 'lower realm' the composition betrays how they nevertheless, at least with part of their being, participate in the happening above. What a fitting use of the lemniscatory principle for this theme!

Fig. 98. "The Transfiguration of Christ" by Raphael as an example of a "lemniscatory composition".

Fig. 99. Translation of the lemniscatory experience into a composition using light and darkness. [charcoal]

We can now enrich our experience of the lemniscatory transformation by proceeding from lines to surfaces. Fig. 99 shows one possible translation of the lemniscate into a light and darkness composition which takes our experiences further into a differentiation and amplification of some of the polarities which are inherent in this form: above and below, inside and outside, centre and periphery. A polar opposite use of light and darkness is applied to the upper and lower parts. In the upper part the centre is left light, creating the impression of light expanding into the periphery. Below, darkness is concentrated in the centre, giving this part a sense of contraction from the periphery towards the centre. You might already have noticed that this is like a combination into one composition of the two opposite ends of our light and darkness sequence from chapter 4. There we were moving from one pole to its opposite through a sequence of discreet steps, the middle of which showed a complete mixing and neutralization of the two tendencies (Fig. 84). Here we find the expansion into light and contraction into darkness brought together in one picture which suggests a lemniscatory transformation of one into the other.

Try drawing your own version of this light and darkness composition. We suggest that you use charcoal on white cartridge paper as we did in Chapter 4. Choose a slightly elongated format and fix it in vertical orientation on your drawing board. On one half of the paper you can start with darkening the periphery, graduating towards lighter shades in the centre. On the other half of the paper you could start with a concentration of darkness in the centre, leading towards lighter shades in the periphery. If we say "half" here, this is not meant literally, as part of the exercise is for you to find *the right measure*, i.e. the right proportion between light and darkness: how much contraction of darkness is needed at the bottom to balance the expansion of light at the top? This will not be a matter of outer measuring but of an artistic *"feeling judgement"*. In addition to defining the two parts and balancing them with each other you will have to blend the two parts together in the middle, allowing a flow of movement to come about between them, transforming centre into periphery, upper into lower, inside into outside and vice versa. This demands a slow, careful and *simultaneous* building up of tones in layers in both parts of the drawing. So don't get stuck in one part, but rather try to work alternately on the two halves.

Fig. 100 shows a variation of Fig. 99. Here both light and darkness are differentiated into successive "waves". This adds the element of *rhythm* to the expansion of the light and the contraction of the darkness. Try drawing this for yourself as a further step. You may picture to yourself each of the rhythmical articulations as a fine "cloud" of darkness which is either giving way to the expanding light (in the upper part) or gathering towards the centre of darkness (in the lower part). Special care has to be given to the differentiated gradation of shades within each of these rhythmical "clouds". You can give them a *direction* by concentrating the darkness either on the inner or the outer side and thus direct the experience towards expansion or contraction.

Fig. 100. Light and darkness composition
with rhythmical "waves". [charcoal]

Pause here for a moment and look at the results (Figs. 99 and 100). How would you describe your experiences in the upper and lower parts of your drawings? How do you move between them, crossing the "threshold" between "lower world" and "upper world"? Can you begin to feel how these two polar opposite experiences actually *belong together and complement each other* (as do day and night, summer and winter etc.)? Can you relate these experiences to the transition from shoot to flower?

We suggest that you make an experiment with your finished drawings. Turn them upside down and look at them again. You will see two very different images in front of your eyes. How does it feel to see the light expand at the bottom (into the earth, as we might say) and the darkness contract at the top (out of heaven)?

Our last drawing in this sequence will take these experiences a step further towards differentiation. In it we will attempt to incorporate something of the "upside-down" and "inside-out" light/darkness experience which we have just described. For this drawing we suggest that you start on a new sheet of paper laying out a composition similar to that of the previous drawing (Fig. 100). Keep the first layer very light and leave a small space of light in the centre of the contracting waves of darkness at the bottom. This will allow you to incorporate into this drawing the "reverse process" of bringing light into the darkness (in the lower part) and bringing darkness into light (in the upper part) (Fig. 101).

From the first layout we proceed by darkening the periphery in the upper part in such a way that the light is becoming more differentiated. It is as if the previously round "sphere" of light is given more contour and definition by a gentle forming activity from the surrounding darkness, allowing the light to "unfold" in turn. You have to take care not to "imprison" the light by forming hard borders. Where this happens, the light "freezes" and loses its expanding, "breathing" character. The task of the darkness in the upper part of the drawing is to *make visible* and to *give shape to the light*. At the same time the darkness below also increases, although in a very different fashion. Here, darkness *gives shape to itself*, condenses into a more tangible form while at the same time encapsulating the light left in its centre. The light which is being condensed, crystalised here in the midst of darkness, will have a very different character from the luminous light above.

Having come this far in preparing a kind of "vessel" of light and darkness, can you experience how something is still missing which will give the drawing an individual "physiognomy", something which summarises in very concise form the whole process? The centre part of the drawing is "waiting", as it were, for this "something" to make its imprint and thus individualise the drawing. Finding the appropriate gesture – it might just be very little, a few movements with the charcoal – is a matter of waiting for the right "inspiration" to come and then having the courage to do it – for better or worse. Compare your experiences during this exercise with those when you were engaged in the exercise on page 92 in Chapter 4. Can you feel how the activity itself is a metamorphosis of the previous one?

Fig. 101 (left). Further differentiation of the light and darkness composition. This represents the stage before the final individualisation, which we do not illustrate here. Only you can find it – the right gesture or "signature" to complete your particular drawing. [charcoal]

With this practical experience in the background we can now have another look at the peony. Coming from the green leaves below, following their gradual withdrawal, we arrive at a kind of a threshold, a moment of outer rest but utmost inner dynamic, as we prepare for the entry into another world, the world of the flower. On this threshold the peony performs an exceptional display of transitional forms which make visible to our eyes that which otherwise is hidden in the non-spatiality of the crossing-over point. The transformative process, which in the lemniscate is condensed into the single moment of crossing through, here appears spread out into a series of gradual steps. We can witness one principle giving way in favour of another; a slow transition of something coming down to and transforming something earthly.

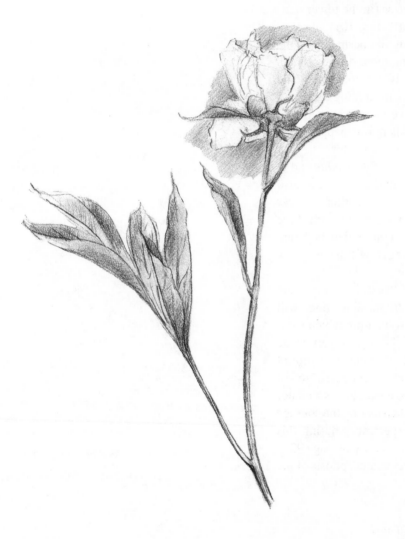

Fig. 102. Branch of a common dog-rose (Rosa canina) *showing the typical "bow" habit of growth. The shoots are topped with various stages of rose buds, open flowers and early fruits. [pencil]*

Foliation of Flowers

Now that we have been turned thoroughly inside out and upside down we are ready to enter the flower proper. What better subject to choose than the rose. We have taken a common dog-rose *(Rosa canina)* as an example. They are abundant in the hedgerows all over the British Isles – soft scented, pale pink five-petalled gossamers of glory adorning summer greenery in rising and falling cascades.

Along the hedgerow we follow that self-same walk we took in Chapter 2 half a year ago. Now, instead of colour in the winter light and shadows on the snow, we find ourselves mesmerised by a thick, green wall of hedge plants, humming with insects, dripping scent and falling petals. Rose and bramble vie for five-fold place where hawthorn, only weeks before, had led the way hot on the heels of sloe (blackthorn). Even the wild raspberry finds a place here and there between the bramble thicket down below, honeysuckle dripping scent above, while heavenly pink and white waterfalls of wild roses cascade down.

Looking closer we find the characteristic "bow" typical of rose habit and, growing upwards from almost every node of last year's leaves, a new shoot topped by one after another of unfurling rose buds, open flowers and early fruits (Figs. 102 and 103).

Fig. 103. Shoot of a common dog-rose. [pencil]

Taking a flower which is fully open and following the thin, pale stem upwards from the last leaf, with its expanded stipules at the base, we find a hard green swelling surrounded by 5 leaf-like bracts, the *sepals* forming the *calyx*. These are situated on the edge of a swollen cup like five brothers all the same – or are they?

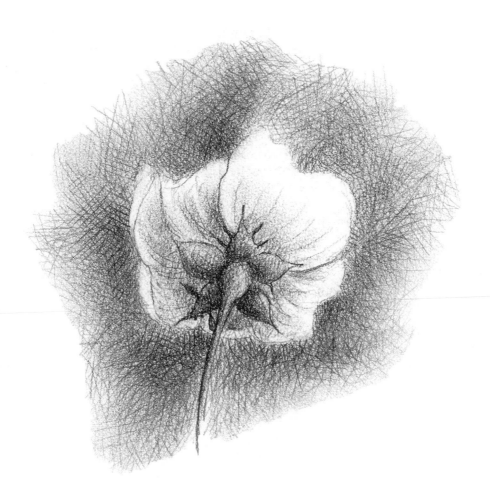

Fig. 104. Flower of dog-rose, seen from underneath. [pencil]

More careful examination reveals that the five sepals are in fact all different (Fig. 105). Furthermore we find that there is a progression from more complicated to more simple forms – an echo and last remnant as it were of the simplification of form which takes place in the leaf sequence towards the flower. The striking thing now is the arrangement of consecutive forms in the calyx. To proceed from the most complicated to the most simple form we always have to move in a clockwise movement, leaving out every second sepal. Thus we find ourselves travelling along the path of a pentagram. Again this is an echo of the spiralling pattern of leaf attachment in the lower region of the rose. It follows a very exact law (written in botanical shorthand as 5/2, meaning that after having followed five consecutive leaf intervals on the shoot you are again facing the same direction of space – having spiralled twice around the stem. In the shoot, where life is still unfolding, the angle between each successive leaf approximates to 137.5°. In the flower, where the upward movement has come to rest, the angles are 144° and fixed. That such order and exact mathematics should be "written into" the seemingly haphazard leafy zone of a plant and become expressed in picture form on the threshold to the flower can only give rise to wonder.

Coming back to the calyx we find that what the sepals *do* have in common is that their underside is convex, dark green and lightly flushed with red. The upper concave side is a soft, pale grey-green silky surface which (before the flower-bud opened) was the lining of the inner space in which all the other organs of the flower were developing. They grew protected within this inner, dark, warm space. Scientists have found that in some plants (e.g. *Pulsatilla*) the temperature inside the bud can be up to 10°C higher than that of the surrounding air.

Fig. 105 (a) Calyx of a dog-rose. What is the secret of these five "brothers" and their peculiar arrangement?
(b) If we proceed from the more complicated to the more simple forms we find ourselves travelling along the path of a pentagram!

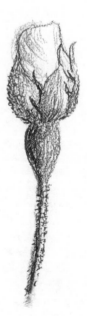

Fig. 106. Rose bud. When the rose bud is closed the sepals are enfolding all the other organs of the flower in a protected, warm space. [pencil]

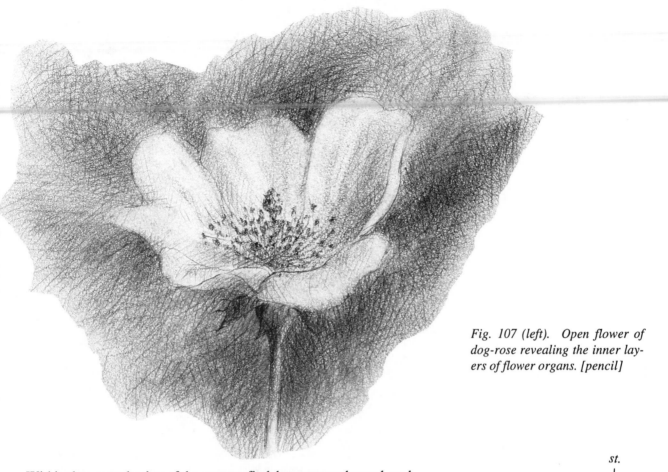

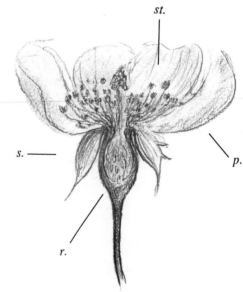

Fig. 107 (left). Open flower of dog-rose revealing the inner layers of flower organs. [pencil]

Within the opened calyx of the rose we find, between each sepal, and also attached to the ridge at the top of the cup-like *receptacle*, five delicate, heart-shaped *petals*. From a tiny yellow point they swell into a sweetly smelling soft pink silken surface. Gone is all earthiness. Their sheer transience seems to make them all the more heavenly. The petals form the most expanded part of the flower, the crown or *corolla*, which expresses most clearly to us "who" that plant is. Many plants can only be identified through the petal form and colour in all its fleeting simplicity.

After the crowning glory of the corolla can only come contraction. Indeed, the next organs we find when we move inwards towards the centre of the rose are highly contracted, doubled yellow lobes covered with a fine dust and sitting on top of fine, thin filaments. These are the *stamens* with their pollen-bearing two-fold heads, the *anthers*.

Fig. 108. Vertical section through flower of dog-rose. [pencil]; r. receptacle; s. sepals; p. petals; st. stamens

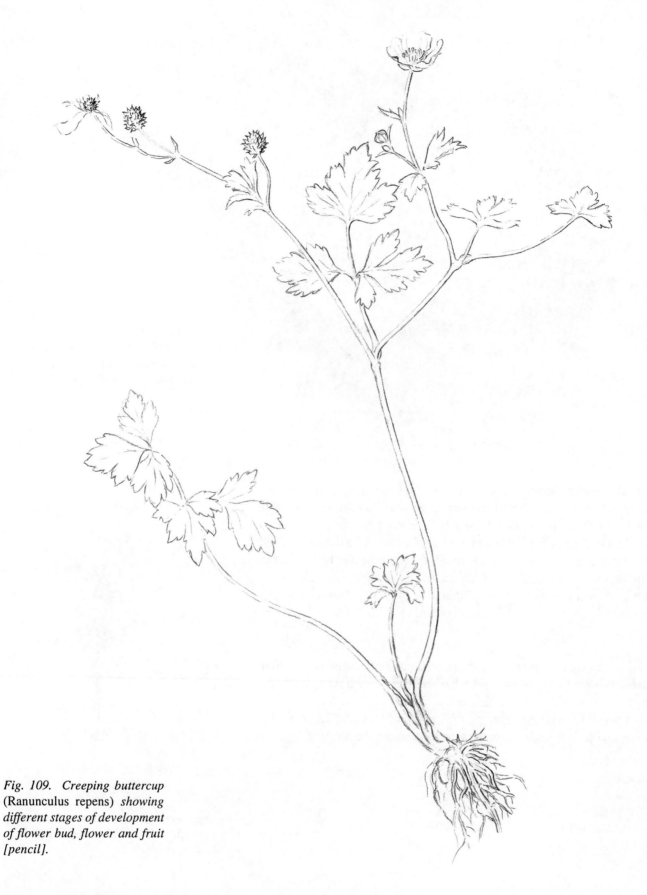

Fig. 109. Creeping buttercup (Ranunculus repens) *showing different stages of development of flower bud, flower and fruit [pencil].*

a.

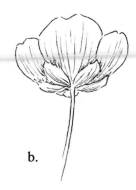

b.

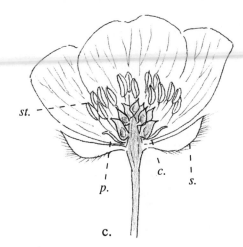

st.

c.

p. s.

c.

Fig. 110. Flower of buttercup at different
stages of development [pencil].
(a) flower bud, (b) flower seen from below,
(c) vertical section through flower, (d) petal/
nectary, showing nectar pocket (n).

c. carpels
st. stamens
p. petal/nectaries
s. sepal/petal

d. n.

In some plants we can find another organ between the corolla and the
androecium (the name given to the totality of all the stamens). Just beside
the hedge in clumps along the way are creeping buttercups (Fig. 109),
invading all the areas where passing traffic, horse and human, have
disturbed the ground. Their bright yellow, upturned flowers provide us
with an example of what the rose, in all its purity, does not have.

Fig. 110 shows a buttercup flower at different stages of development.
We can see that the outer layer of "leaves" are more petal like than in the
rose. They are in fact part sepal, part petal in nature. You can see this from
the way they turn yellow and are of a more petal-like texture compared
with true sepals of other plants. The next layer, the corolla, is made up of
leaves which are also not simply petals. At their lower tip where they join
the receptacle at the top of the stem we can find an extra lip forming a kind
of pocket. This pocket contains the nectar, which you can see being
collected by a variety of insects. This is one of the "gifts" of the plant
world to the insects.

Many relations of the buttercup such as delphinium, winter aconite, columbine (Fig. 111) or Christmas rose have *nectaries* specially built as separate flower organs (in which case one of the outer two layers of organs is either sacrificed or doubles up as sepal/petal).

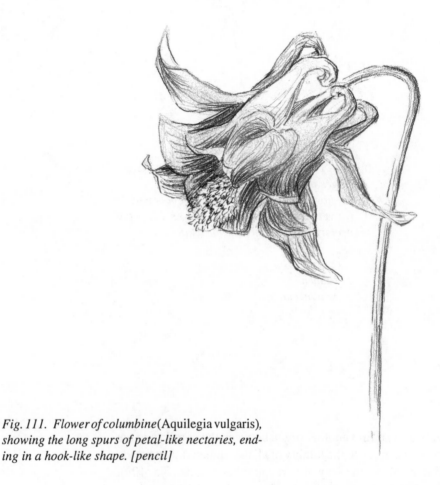

Fig. 111. Flower of columbine (Aquilegia vulgaris), *showing the long spurs of petal-like nectaries, ending in a hook-like shape. [pencil]*

If we consider now all the flower parts we have met so far (the organs to be found in the hidden green centre of the flower are actually part of what is going to become the fruit and will be considered later) and summarise them with a sketch and simple drawing of their "function", starting with the outermost or lower ones, we find a wonderful four-foldness of expanding and contracting parts (there are very few plants which have all four of the organs):

organ (diagrammatic representation of typical shape and approx. size):	**form-tendency/function:**

sepals (calyx)

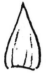

contraction in comparison with the leaves of the shoot, but expansion from the top of the stem; containing the developing flower in inner warmth.

petals (corolla)

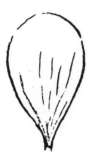

expansion into air and light with colour and scent flowing outwards.

nectaries

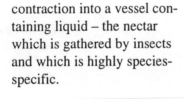

contraction into a vessel containing liquid – the nectar which is gathered by insects and which is highly species-specific.

stamens (androecium)

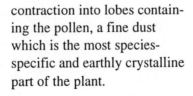

contraction into lobes containing the pollen, a fine dust which is the most species-specific and earthly crystalline part of the plant.

Fig. 112. The parts of the flower – form and function.

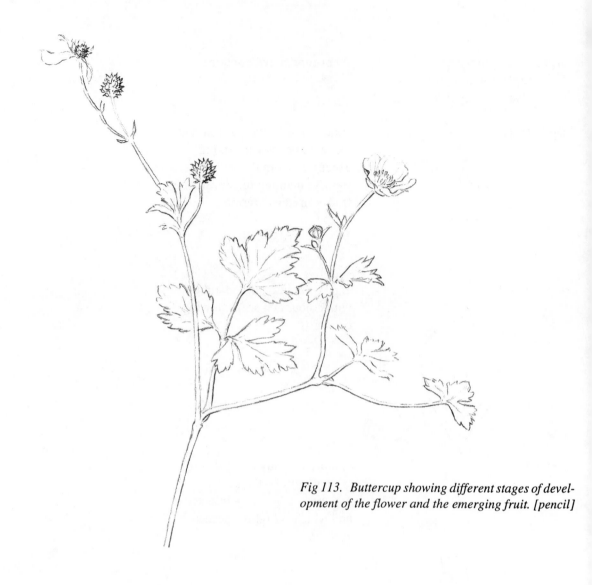

Fig 113. Buttercup showing different stages of devel-
opment of the flower and the emerging fruit. [pencil]

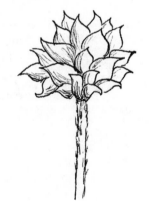

Fig. 114. Fruit of buttercup
made up of many sickle-
shaped carpels. [pencil]

The Heart of the Flower

Looking more closely at the buttercup by comparing different stages of development of the flower (Fig. 113) we become aware of something new gradually emerging from the green centre of the flower once the petals and stamens begin to fall off. This central part which consists of many, tiny, sickle-shaped green blobs is hidden by the stamens when the flower opens and only starts to reveal itself when the pollen has gone and the stamens start to disintegrate (Fig. 114). We can also see how different in its attachment to the stem is this central part, the *carpel*, compared with the other parts of the flower.

Fig. 115 shows a vertical section of a rose at a similar stage of development. We see all the flower parts very close together in decreasing circles round the rim of the receptacle. Within this cup-like swelling of the stem are sunk all the little green carpels covered in silvery hairs.

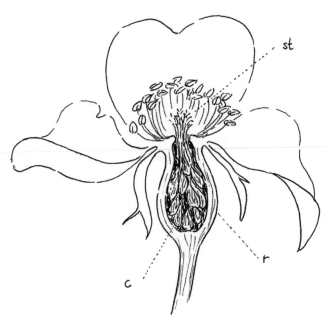

Fig. 115. Vertical section through rose flower. [pen]
r. receptacle
st. stamens
c. carpels

These are the equivalent of the sickle-shaped blobs which with the buttercup were sitting on the top of the stem on a kind of extruded pad (the *receptacle*, see Fig. 114).

In both plants it is quite clear that these organs, the carpels, are very different from the true flower parts. The carpels (together forming the compound organ called *Gynoecium*) are very firmly attached to the top of the stem, swollen at the bottom and tapering towards the periphery. Compare this with the stamens with their tentative attachment to the top of the stem and those large, hanging anthers – a double weight at the periphery of the organ. The carpels, contrary to the other flower organs, are nearly always green and are left behind when the other parts fall off, only to swell as they become the future fruit.

The carpel is indeed the beginning of the fruit – a new and fourth stage of plant development with the embryonic seed hidden within – which we will consider in the next chapter.

The "heart of the flower" in another sense can also mean that which we experience inwardly when we truly meet a flower; that which touches our hearts so deeply and which is, at the same time, the heart of expression by the flower of the being of a particular plant. Before diving into the development of fruits we will stay for a few more pages in this delightful and transient realm of flowers and what they have to tell us.

The Language of Flowers Speaking

We have followed our scientific curiosity by dissecting and examining in more and more detail the organs of the flower, their arrangement and order; the relationship of the different parts to each other. We have been stunned by the lawfulness and wisdom by which all these parts are assembled together to form a whole. And we should remind ourselves that it is this *whole*, this complete *picture* of the flower which speaks to us when we first look at it. And isn't it a very real experience when we say that flowers *speak* to us? Each flower speaks to us in its own very special way, a rose differently from a buttercup. What do flowers speak about? Do they only speak about themselves or do they have something to say about us and the world in general?

A help with this question might be to think about what flowers mean to us. When do we "use" them? What for? Perhaps a rather obvious use is when we give red roses to someone we love, lay lilies on a coffin or pick daisies for a child's room. It is almost universally accepted that red roses are a symbol or a picture for that feeling which we experience as love. Roses seem to say something about the expression of that feeling in a very pure and simple way which we cannot adequately convey in words. Other plants say quite different things. We certainly would not give a loved one

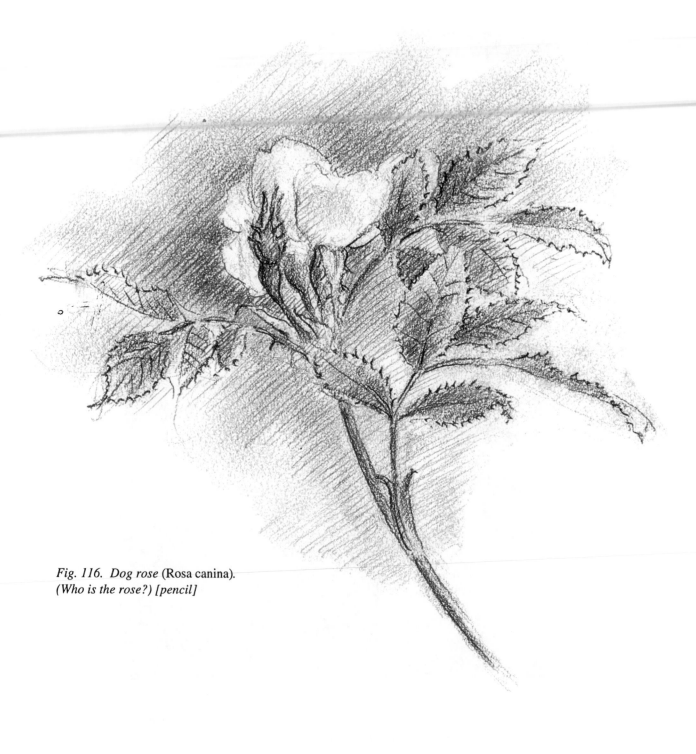

Fig. 116. Dog rose (Rosa canina).
(Who is the rose?) [pencil]

Fig. 117. Rose from the Nativity panel, Isenheim altar piece, by Mathias Nithart Grunewald. This is one of the many examples of the association of roses with the nativity.

hogweed or groundsel flowers or even buttercups – would we? It is even less likely that we would resort to roots or lower leaves of any plant to convey messages of our love!

You can think of many qualities of soul which we can convey to one another with the means of flowers – shyness in violets, simplicity in daisies, awe with an orchid and so on. In each flower we can see an *outer picture of a quality of soul* which we can also find hidden within ourselves. But whereas within our own souls the realm of emotions and desires is often of a confused and turbulent or even animal-like nature, plants present us with pure and universal pictures of soul qualities. This might give a clue as to our delight in certain flowers, as to why we surround ourselves with this or that variety, colour or form of a particular flower to suit certain aspects of who we are ourselves.

We looked at this aspect of plants in Chapter 2 when we met oak and in chapter 3 when we met snowdrop. Every plant being seems to express a gesture of soul which modifies the universal (or archetypal) plantness in a particular way. Oak had a wonderful tension between dying and abundant growth. Snowdrop showed us her demureness. Rose goes brittle and woody after a year of greenness and produces sharp thorns. What is a thorn but an expression of intense suffering? Those delicate, ephemeral flowers all over the top of its ebullient growth of leaf are like a picture of the defiance of this pain and an expression of the sweetness that comes through acceptance of suffering. Does this perhaps explain why the birth of Christ in old paintings is often accompanied by roses (Fig. 117)?

The "Christmas rose" (*Helleborus niger*) is another of those plants, closely related to peony, which reveals a "universally open holy secret". It flowers at midwinter – over Christmas – a herald of the coming of the Christ child to earth in the darkest time of the year. Another, more distant relation of peony is our common buttercup.

Buttercups have quite a different story to tell – of childhood, certainty of light, of safety, of fields in summer and of the year always being the same whatever happens; simplicity, security – like a warm embrace from the dairy maid when you've fallen and hurt your knee in the yard!

You might want to try it for yourself, whilst on a tour of your garden or a stroll along the hedgerows and over the summer meadows, to enter into a *"conversation with a flower"*. First get to know the plant as we have done by going where it grows, studying its environment, its habit of growth and its parts until you really feel "friends" with it. Have your sketchbook at hand and make quick line drawings of the whole plant, its parts and especially the flower. You should have a clear idea of how it grows and how it manifests in the different seasons. Fig. 118 shows the notes taken during such an encounter – making friends with a sow thistle.

"Just as, when you look into the eyes of another human being you get a glimpse of their soul . . . so also when you look deeply into the heart of a flower you get a glimpse into the soul of the earth."

Rudolf Steiner

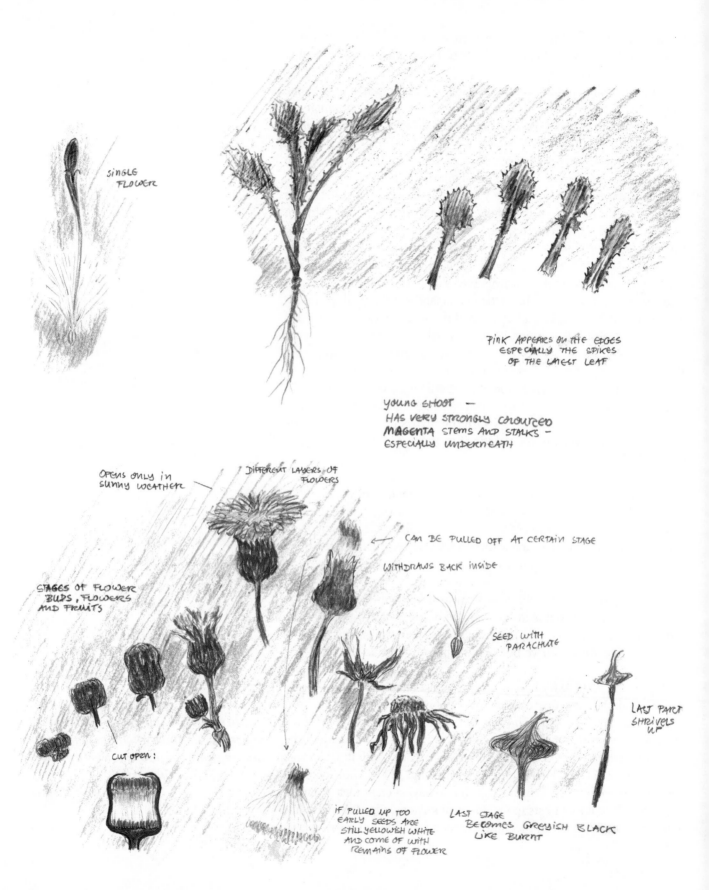

SINGLE FLOWER

PINK APPEARS ON THE EDGES ESPECIALLY THE SPIKES OF THE LATEST LEAF

YOUNG SHOOT — HAS VERY STRONGLY COLOURED **MAGENTA** STEMS AND STALKS — ESPECIALLY UNDERNEATH

OPENS ONLY IN SUNNY WEATHER

DIFFERENT LAYERS OF FLOWERS

CAN BE PULLED OFF AT CERTAIN STAGE

WITHDRAWS BACK INSIDE

STAGES OF FLOWER BUDS, FLOWERS AND FRUITS

SEED WITH PARACHUTE

CUT OPEN:

LAST PART SHRIVELS UP

IF PULLED UP TOO EARLY SEEDS ARE STILL YELLOWISH WHITE AND COME OF WITH REMAINS OF FLOWER

LAST STAGE BECOMES GREYISH BLACK LIKE BURNT

132 *The Flowering of Summer*

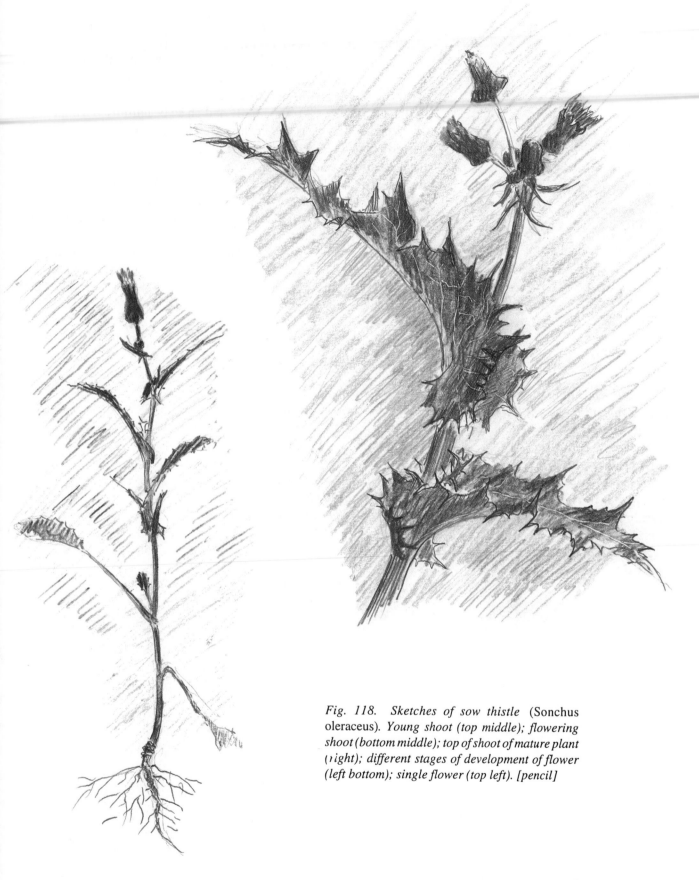

Fig. 118. Sketches of sow thistle (Sonchus oleraceus). *Young shoot (top middle); flowering shoot (bottom middle); top of shoot of mature plant (right); different stages of development of flower (left bottom); single flower (top left).* [pencil]

During the course of "making friends" with this plant you might gently broach the question "who are you?" from time to time. If you manage to do the appropriate preparatory work and make sure all your "fantasy" is based on "exact sensorial" experience then, if you're lucky, your friend will answer and one day her being will speak within you – she will have flowered – oh so briefly and oh so beautifully – within you.

When this happens there is no mistaking it. It is something you will never forget. This is the experience of truth embedded in meaning – not something that you have to prove or disprove but simply the very real self evidence of a reality faced in essence. When a flower speaks within you or a tree reveals the nature of its being you really meet that being and it is a deep spiritual experience the nature of which we have all glimpsed at some point or another in our lives. This journey we have been describing is a way to help you to have such experiences yourself; to grow more confident in your own essential meetings and, thereby, to become more intimately involved (like the Little Prince) with the world around you. Enjoy it!

"What is the meaning of 'taming'?" The Little Prince asked the fox.
"That is something people have all but forgotten about" answered the fox. "It means: 'to become familiar with'".
"To become familiar with?"
"Yes, indeed", said the fox. "Now you are but a small boy for me, similar to thousands of other small boys. I don't need you and neither do you need me. For you I am just a fox, similar to hundreds of thousand other foxes. But if you tame me we shall need each other. You will be unique for me in the world . . . "
"I begin to understand," said the Little Prince. "There is a flower . . . I think that she tamed me . . . "

Antoine de Saint -Exupéry:
The Little Prince

Fig. 119. Conversation with a flower . . .
"The Virgin and her Garden", painting by
Mathias Nithart Grunewald

6 Autumn Fruits

Dying and becoming

Autumn has come. The first frost has hovered in the air around the reddening trees. Leaves transform from dull green to gold, orange, amber and flaming fire reds before they fall and crinkle or soak to brown in a carpet for the damp earth. As the leaves fall the trees emerge in that grey, skeletal form which we met last winter. On each twig in the axils of the erstwhile leaves the new buds are revealed, sitting proud above each leaf scar. These contain all the leaves (and sometimes flowers) ready formed for next spring's growth.

Fig. 120. Apple tree in autumn. [charcoal]

Fig. 121. Beech twig in autumn. [pencil]

Fig. 122 shows a beech twig similar to the one which we studied in chapter I nearing end of its season's growth, casting its curling brown leaves; bearing the buds prepared for winter sleep. Here they will sit until spring draws them into the tender pale unfurling planes we witnessed earlier in the year (Fig. 123). Compare these two drawings. Try to imagine how the buds in our autumn twig will go through winter into spring; how the leaves inside will unfurl and stiffen into dark green planes through the summer. Imagine the summer days of stillness and intense activity within the leaves, day and night until autumn draws near. In each leaf axil slowly grows the new life potential (in the buds) as the leaves themselves gradually fade, curl and fall.

Always in dying is hidden new birth. Each seems to need the opposite. Let us follow the dying process of a horse chestnut leaf.

Fig. 122. Beech twig with
buds in winter. [pencil]

Fig. 123. Unfurling beech
twig in spring. [pencil]

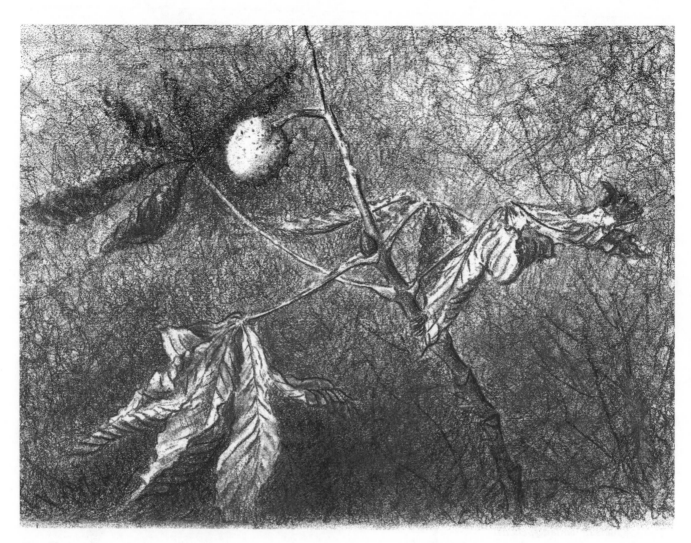

Fig. 124. Horse chestnut twig in autumn. [charcoal and chalk]

Experiencing the Death of a Leaf

In Chapter 3 we observed and drew the unfolding of a horse chestnut bud (Figs. 41 and 57 – Fig. 57 is repeated below as Fig. 125). Fig. 124 shows what has become of the flowering horse chestnut bud in the autumn. The flowers have long since disappeared. In their place a single fruit has formed sitting on the vertical stalk which once bore many small flowers in an inflorescence. The round green fruit formed from the centre of one of these florets during the summer and its prickly outer coat has begun to turn from green to brown, now harbouring the smooth, hardening conker inside. The leaves have lost their green vitality, the edges already have a tinge of brown and begin to fold inwards. Soon the autumn winds will blow them off and toss them around in the air until they fall to the ground, adding to the carpet of fellow leaves under the horse chestnut tree.

We are not normally inclined to look at this composition of withering, decomposing, dying vegetation, but once we overcome an initial resistance, we might be struck by the fascinating array of varying shades of brown to black, of curled up, contorted shapes and the variety of dry, paper-like textures. That which we encounter here on the ground bears little resemblance to those generously unfolding, fleshy green, five-fingered horse chestnut leaves which we have come to know. It seems as though, before their final disintegration, they still have to undergo a dramatic transformation of form, colour and texture.

Let us follow the destiny of one of the fallen leaves with keen interest, feeling participation – and a drawing instrument! Drawing the different stages of withering and dying will help us to experience more deeply this "coming to an end" aspect of autumn.

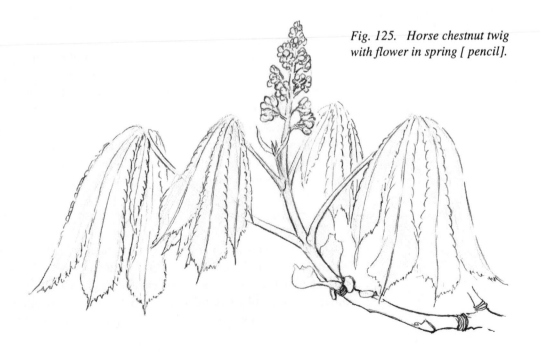

Fig. 125. Horse chestnut twig with flower in spring [pencil].

Fig. 126. Four stages in the withering of a horse chestnut leaf. [charcoal]

Using charcoal and a large sheet of drawing paper, sketch the different stages of withering of a horse chestnut leaf or any other autumn leaf (horse chestnut leaves are especially suitable) until its eventual disintegration. Concentrate on drawing the most obvious lines, such as the outer contour and the veins which become more prominent as the surfaces between them shrink. At each stage try to adjust your lines to the increasing tension, as the relaxed, expanded, open planes of the leaves begin to curl inward and to contract into ever more tightly spiralling curves, before finally "collapsing" and disintegrating into even smaller segments (Fig. 126).

By applying less and less pressure, the use of charcoal will help you to give your lines the feeling of increasing brittleness and drying up (especially if you use a rough-textured paper which will pick up the charcoal only on the heights and thus create a "broken" line). Think of how charcoal is made: charcoal is created by charring willow twigs. It is thus itself the result of a kind of "dying process" – a controlled fire process burns up part of a living organism leaving behind mere mineral carbon.

Having completed your drawing sequence of dying leaves you might like to enter into it in the same way as we did with our developmental, growing sequences in Chapters 3 and 4 such as the drawings of the horse-chestnut bud opening or the snowdrop unfolding or the groundsel growing. Using the same faculty of imaginative thinking which we practised then, try entering into one picture after another and "live yourself" into the dying process.

You might have noticed that the process of withering takes its start from the outside edge of the leaves. The colour changes also start from the periphery and proceed in ever deepening waves of colours towards the centre. Looking at the whole tree one can often observe that it is the leaves on the outer perimeter of the tree which first change their colour. (Inside the tree may still be in fresh spring green!) All these observations point to a movement which proceeds from *outside inwards*.

But we have to consider another aspect. In curling up each single leaflet for a moment creates its own *inner space*; a hollow, empty space, enveloped by a fragile, paper-like, life-less material. In doing so it also isolates itself from the living context of the whole, withdraws into its own contorted shape. This last, very dramatic "going into form" can only be followed by rapid and complete disintegration.

Compare this with the reproduction of the famous Greek sculpture of Laokoon (Fig. 127). This dramatic sculpture represents the moment the priest Laokoon and his two sons are overcome and fatally bitten by two snakes. From another point of view this piece can also be seen as an *end point*: it is considered as being the last and technically most accomplished example of Greek art and culture before that culture disintegrated and before that which remained was "recycled" by the Romans.

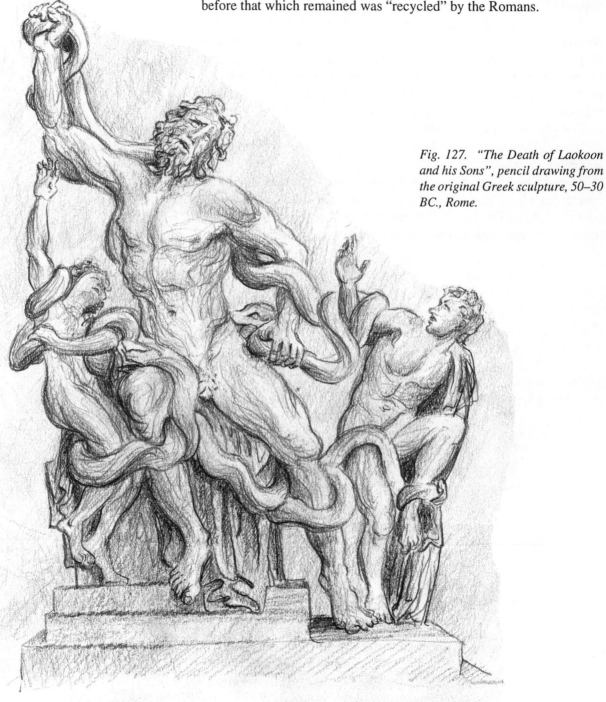

Fig. 127. "The Death of Laokoon and his Sons", pencil drawing from the original Greek sculpture, 50–30 BC., Rome.

Fall and Spring

Just as in human cultural evolution, in the dying of one civilisation is hidden the birth of a new one, so we find in all natural developmental processes (whether on a small scale, or on a larger evolutionary one) that within the dying is always hidden the source of a new beginning. From a certain point of view the dying of the leaves in autumn really represents an end; whilst hidden at the very point of dying – next to the *abscission* layer between each leaf stalk and the twig, is the bud, a new beginning for next year.

It is an interesting exercise to compare the two polar opposite processes – to enter into a growing, developmental "spring-time" plant and then to compare this with its (or another) "autumnal" dying process; and to quietly let them reverberate in your soul. You might like to pay attention to that which rises up within you at each "season" and compare this with the outer gestures of autumn and spring.

In autumn, as we conduct the traditional "clear-out" and "burning of dead wood", new creative ideas rise up in us, like seed points (or buds) as plans for next year. They are mulled over through the winter and may finally take effect beginning in spring. In spring we shed our outer wrappings, like leaf scales, spring clean, make new our homes and selves like the trees in their Easter-tide adornment.

And, as the buds are born out of dying leaves, so we also find, within each season of the year, something of the opposite one. In the colours of the leaves turning in autumn we are often reminded of spring; tones of soft yellow spring green mingle with autumnal fire reds and browns. In the "dying" season we see an echo of the "growing" one (and vice versa: the first shoots of spring often have a tinge of autumnal red as they emerge). In the mid-winter stillness the skies often hold a herald of summer in intense heavenly colours and in mid-summer the death and hardening of the vegetation is reminiscent of the winter's frozen sleep.

Something similar to this seasonal time process is happening in space between the two hemispheres of the earth. While we in the northern hemisphere celebrate Easter they, on the other side of the earth are surrounded by golden autumn leaves. So our Easter is a balance in space to the opposite fall, our Christmas to the opposite mid-summer. Our spring needs our fall in time as a preparation and the fall of the other side of the earth as a balance. Wherever we look in Nature we find such opposites and apparent contradictions. Even the sun and the moon mirror one another in their movements in opposite seasons. Through the winter the moon is as high in the sky as the sun in summer and vice versa. In autumn and spring they hang in balance.

Fruit and Seed

The interpenetrating cycles of life are even more profoundly experienced if we look at something like the apple tree in our opening drawing (Fig. 120) in all its autumn activity. We see the final culmination of this year's growth hanging in heavy, ripe apples and falling as pale golden-yellow leaves. A few inches away all that which is going to grow next year is already developed in the new buds. Even the number of leaves for each twig and the potential flowers are tightly packed inside the two different sorts of buds. (Remember our beech buds from Chapter 3 !)

Fig. 128 shows an apple twig with both leaf and flower buds. The larger, more rounded, fat buds will develop into flowers and bear fruit next year. The thinner, more pointed ones will become vegetative, long, leaf-bearing shoots and no flowers or fruit.

If you look at our drawing – or better still at a fruit-bearing tree outside at this time of year you will be able to "live into" the whole cycle of the year since last autumn as it has unfolded for this tree. Let the buds rest all winter in your imagination, swell and burst in spring into that soft apple-green rosette of rounded leaves surrounding the flower bud which then opens into blossom – white with a tinge of pink. Imagine the insects humming around the flowers, pollinating the carpels and the subsequent setting of the fruit. At the same time the leaves are growing, the long shoots form, twigs thicken, new buds form and fruits swell. Eventually autumn tinges the leaves and fruit with gold and yellow and red and finally we arrive back where we started – one year; one cycle of time later.

Try living with these thoughts for a moment while contemplating the apple twig. A feeling of gratitude might awaken in you for all that led to the final culmination of growth, the fruit, which the plant offers to the world. The tiny seeds which the fruit harbours within itself, as well as the tightly-packed buds, can awaken in us a sense of hope and anticipation for all that will develop and come to fruition in the coming year.

We realise with thoughts like these, how time is never still, how life is always changing and transforming itself. Opposite and contradictory processes (the seasons, dying and becoming) and places (the two sides of the earth) work continuously hand in hand. As Goethe says: *"What has been formed is immediately transformed again, and if we would succeed, to some degree, to a living view of Nature, we must attempt to remain as active and plastic as the example she sets for us"*.

We have to learn to hold the polarities of dying and becoming together inwardly at one and the same time – just as the earth bears autumn and spring together at once out of inner necessity – if we would understand the development of the plant – or anything alive for that matter.

Fig. 128. Branch of apple tree. [pencil]

From Bud to Fruit

What does this mean in practical terms for the development of fruit and seed? Let us follow one of our autumn buds onward into spring and through the summer, until it arrives at its autumn process of fruit formation. We have chosen the wild cherry or Scottish gean *(Prunus avium)* which flowers in May before the unfolding of its green leaves. Fig. 129 shows the development of a flower bud of wild cherry until the formation of the fruit, drawn at intervals throughout the year.

After months of quiet preparation through the winter the flowers burst forth from their buds and adorn the cherry tree with a cloud-like mantle of delicate white blossoms. This white glory is short lived in the May breezes and fills the air with fragrant confetti. Soon the ground beneath the tree is covered with a shower of pink-tinged white petals. But the death of the flower and the falling away of its parts are accompanied by the coming into being of the fruit.

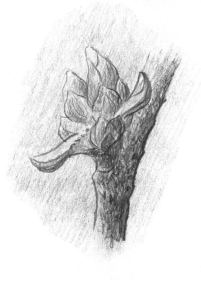

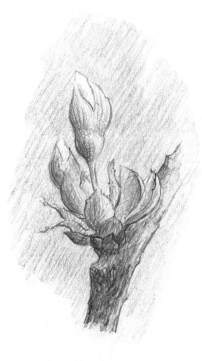

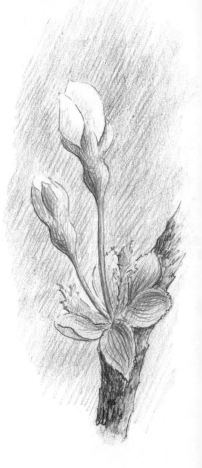

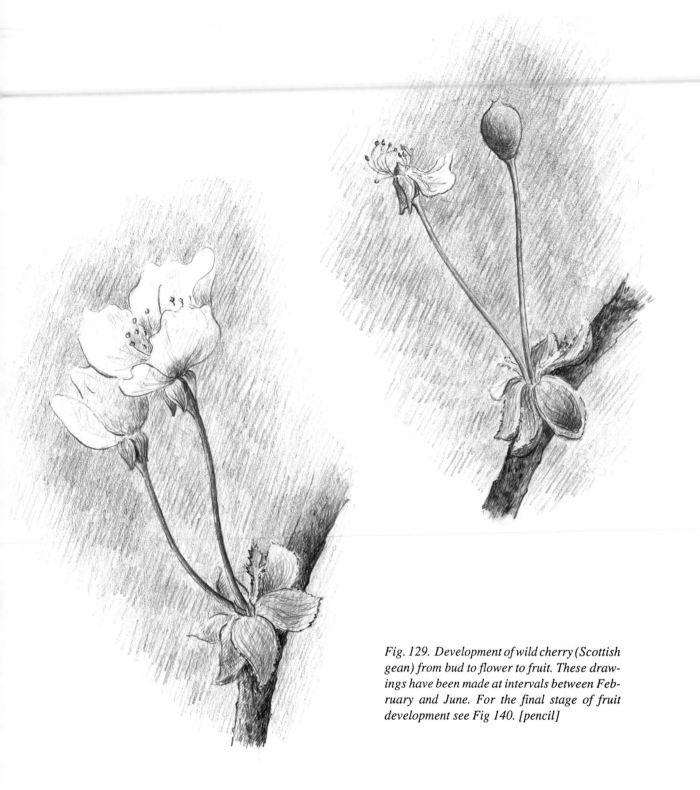

Fig. 129. Development of wild cherry (Scottish gean) from bud to flower to fruit. These drawings have been made at intervals between February and June. For the final stage of fruit development see Fig 140. [pencil]

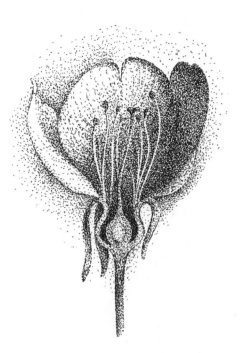

You can try this for yourselves – it's a rather longer time sequence than those we have done so far but it is well worth the effort. The beginning of the process can be observed by Christmas if the twigs are cut in November – St. Barbara's Day – and kept indoors. You won't get fruit formation and the flowers will be small, but they will reveal the complete perfection of forms held within the bud from autumn onwards. (And it is wonderful to have cherry blossom in your home at Christmas!)

Fig. 130 shows a section of a cherry blossom. We can clearly see how the flower parts are all organised on the rim of a kind of cup. As they wither and fall off, the hard, shiny green ball-like *carpel* (the future fruit) starts to swell in the centre of the flower cup (Fig. 131). In the cherry the outer layers of the *carpel* or "fruit-leaf" expand as the fruit ripens while its inner layers contract and harden to form the single stone inside, condensed around the embryo seed.

Fig. 130. Vertical section of cherry flower [pen].

Fig. 131 (below). Fruit development of cherry [pen].

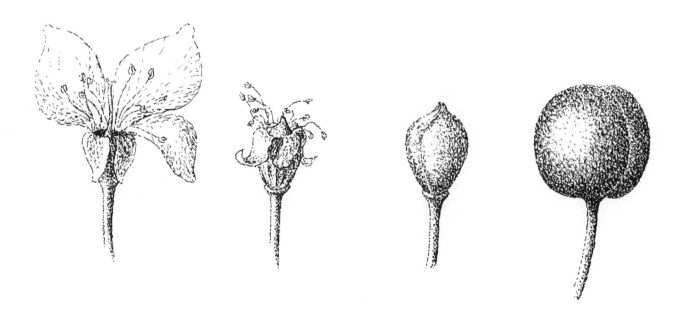

The Fruit "Leaf"

If we compare the two innermost organs of the flower – the *stamens* growing on the innermost layer of the rim of the cup and the *pistil* in the very centre with each other – one could hardly imagine two more polar opposite forms (Figs. 132 and 133). Think about their function and the same applies. Inside the anthers, that pair of swollen heads at the top of the filament of the stamens is formed the pollen. Pollen "dust", as it is often called, is the hardest, most "crystalline" part of the plant. It can endure, undamaged for thousands of years. The pollen forms inside the "rolled-up leaves" of the filament head (the pollen sacs of the anthers). One might look upon it as being a kind of dehydrated, distilled, earthy essence of the plant species. We can identify plants readily by the shape of their pollen grains. Pollen analysis used in archaeology rests on the durability and carved crystalline nature of this part of the plant. One might say that it is in a certain sense "the end of the road" for the plant. There is no-where else for the plant now to go (or grow) other than to fly off into the cosmos as the anthers disintegrate. The pollen substance is dispersed by insects or wind which can even take it as far as into the outer layers of the earth's atmosphere!

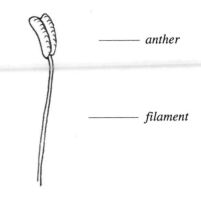

Fig. 132. *Diagrammatic representation of stamen.*

— anther

— filament

If we imagine the polar opposite gesture to that which has just been described it would be something that stays near to the earth, is soft, round, not desiccated and formed but hydrated, soft and malleable. This is exactly the nature of the *pistil*, the last organ of the plant, the future fruit, which we have not until now considered.

Through its position at the centre of the receptacle on the top of the stem it maintains a firm connection with the earth. Goethe has said:

> *"Forward and backward, the plant is always only leaf, so inseparably united with the future germ that we cannot imagine one without the other."*

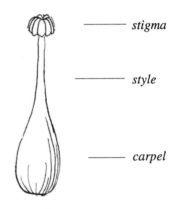

Fig. 133. *Diagrammatic representation of pistil.*

— stigma

— style

— carpel

We have seen the truth in this for the stem leaf united with its bud. Now imagine a simple "leaf" form folded in half (continuing the wrapping round gesture of the leaf base round the bud) and "sewn up" along its edges leaving a hollow space inside. We end up with something like the carpel or "fruit-leaf". The embryo seeds grow from the ends of the veins attached to the seam, known as the *placenta.* In real life we can see this clearly in a simple plant from along the wayside of our walk, the common vetch.

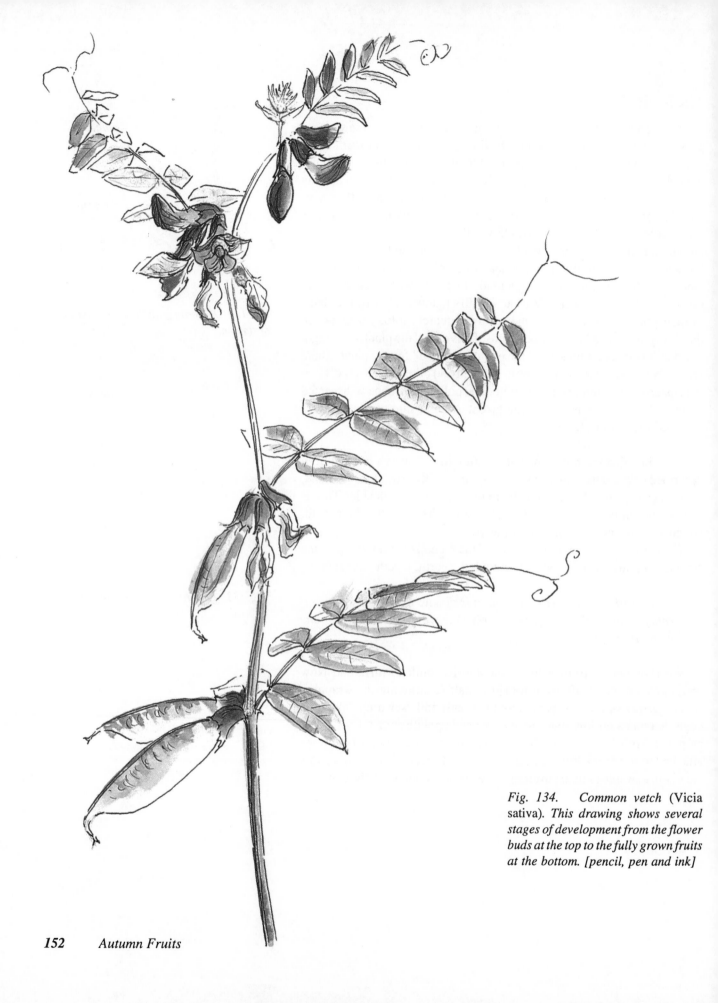

Fig. 134. Common vetch (Vicia sativa). *This drawing shows several stages of development from the flower buds at the top to the fully grown fruits at the bottom. [pencil, pen and ink]*

Fruit Formation

Fig. 134 shows a common vetch *(Vicia sativa)*. At the top of the plant we see the flowers in which the future fruit is entirely hidden. As the flowers open the *stigma* become visible during the course of visitation by insects. Some insects bearing pollen from other vetches touch the sticky stigma as they brush by with their hairy coats and the pollen grains adhere to the stigma surface. There then begins a process which we cannot see without a microscope and without cutting open the *style*. The pollen grain actually begins to digest the cellular substance of the pistil, grows down the style and in through a tiny hole at the bottom of the already prepared plant embryo sitting inside the *ovule* or innermost coat of the carpel.

The two sets of chromosomes from pollen grain and ovule unite and cells start to multiply. This is the beginning of the development of the new embryo plant within the seed. (If you want to follow this you will need to consult a modern plant anatomy book with highly magnified pictures.)

Let's go back to what we can see with our eyes, following the visible stages of fruit development, as we move down the vetch plant (Fig. 134). We see the parts of the flower fall away as the pod (the carpel, looking like a folded leaf) expands and grows. We can still see the remains of the style and stigma at the tip of the pod, a central vein down the ventral (lower) surface and a larger, more seamier vein along the dorsal (upper) edge. As the pod develops the venation across the pod becomes stronger leading from the upper seam (known as the *placenta*). Situated inside the pod, firmly attached to this seam, we can see swollen bumps (Fig. 135), which – as we open the pod along the vein – turn out to be the developing seeds. They sit firmly attached, alternately on each side, to the double vein, the placenta, on little stalks (Fig. 136). In our example only some of the potential seeds are fully developed.

This may remind you of the familiar house plant, the succulent bryophyllum *(Bryophyllum daigremontania)* – also known as "The Goethe Plant" – shown in Fig. 137, which regularly reproduces baby plants along the edges of its leaves, at the tips of the veins. Such phenomena enabled Goethe to see the reproductive potential of the leaf:

> " . . . *Forward and backward is the plant – always only leaf, so inseparably bound with the future germ that we cannot imagine one without the other.*"

placenta

Fig. 135. *Pod of common vetch. The stronger vein along the upper ridge of the pod is the placenta. Along this vein several bumps reveal the shapes of the seeds which are developing inside. [pen]*

Fig. 136. *Opened pod of vetch. If you want to open the ripe fruit, you have to insert a finger nail or a sharp knife exactly in the middle of the double seam in order to see what is illustrated in this picture. [pen]*

Fig. 137. Bryophyllum daigremontania. *[pencil]*

It is not difficult to imagine one of these bryophyllum leaves folded over with the baby plants tucked inside and covered with a seed coat. In reality both developmental and evolutionary steps from such vegetative reproduction as is displayed by bryophyllum – and indeed by so many plants which can reproduce themselves in this way from leaf cuttings – to the true fruit development is enormous (and the subject of another book). The usual way of doing things (leaf production) has to be brought to a culmination (in the flower), a certain death, and new birth (in pollen and ovule). The new beginning (seed development), the production of something that is absolutely new, takes place in a dark inner space closed off from the world – the outer world within which the rest of plant development so far has been intimately embedded.

But for now we have seen how, naively speaking, the fruit is truly a kind of leaf folded together to form a double seam, the placental vein, where the "would-be" edges of the "fruit leaf" come together. In our example of the vetch the double seam has a row of seeds sitting alternately on each side (Fig. 136). A pod fruit may have one or many seeds inside. In some plants, such as our familiar buttercup, each fruit contains one seed (Fig. 138). The fruit does not swell into a pod but stays small and dry as a thin coat around the seed. (This is known as an *achene*.)

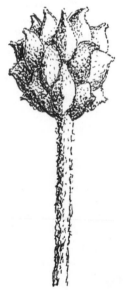

Fig. 138. Fruit head of buttercup, showing the arrangement of many flat fruits which do not swell but stay small and dry as a thin coat around the seed. Each fruit contains one seed. [pen]

Stages of Fruit Development

Returning to our cherry at the beginning of its development we can see the similarity to both buttercup and vetch. Buttercup has many fruits each containing a single seed clustered together in the green, cone shaped "cushion" in the centre of the flower. Vetch has one fruit in each flower, each containing many seeds. Cherry has one fruit with one seed inside. Looking carefully we can see in the early stages the remains of the stigma at the top of the cherry and a slight indentation running down one side. This is the placenta (Fig. 140). If you cut open a ripe plum, cherry, peach or nectarine along this seam you will find that here is the toughest flesh upon which the stone or seed coat sits containing the embryo. In the case of the cherry it is as if part of the "fruit-leaf" swells, becomes fleshy, watery and forms that part which we can eat, whereas the innermost layer of the "fruit-leaf" hardens to form the "stone" surrounding the seed (Fig.139).

Fig. 139. Vertical section through cherry fruit. [pen]

Fig. 140. Branch of cherry with fully developed fruit. [pencil]

Dwelling on the fruit formation for a few moments let's see if we can come to a picture of the whole process and relate it to that which we have met before in the other parts of the plant.

We will consider the whole journey of fruit formation which follows after the fertilisation of the ovule by the pollen. The first thing which can be observed is a new surge of growth from below. The placental vein is strengthened and the embryo begins to grow. The renewed connection to life-giving energy from the earth below is also revealed in the fact that many plants show a surge of new growth in their vegetative parts coincidental with the setting of the fruit. This is a kind of echo of the first burst of spring growth we observed in Chapter 3 and reminds us of the activity of *"stemming"* in the leaf metamorphic sequences.

Following rapidly after this renewed stem/vein development is a stage of swelling of the fruit. Pods increase in size, become more voluminous; the cherry expands filling up with watery substances. At this stage there is no great differentiation. The fruit swells in green, occupies space. It is like the *"spreading"* process in the leaf sequence, or the general expansion of plant growth into green.

The next stage is the equivalent of the "flowering" process – in sketch form in the fruit itself – a differentiation into all these wonderful sugars, aromas, colours and textures that allow us to recognise each variety and to distinguish between one and another. This process is akin to the *"differentiation"* in the leaf metamorphic sequence, where we also found we could distinguish one species from another.

The final stage of fruit formation is "ripening" when the fruit is completely formed, full-grown and able to exist independently of the parent plant. This stage of rounding off and ripening of the fruit is very dependent on outer warmth. It is the fruit equivalent of the *"pointing"* activity in the leaf sequence – where we also saw the beginning of a movement into three-dimensionality as the leaves wrapped round the stem.

So you can see how we have moved through phases of development in the growing fruit that are like a "summing up" in sketch form of all the previous stages of plant growth from the root-like connection to the earth, through the burgeoning watery swelling into green to a flower-like, fine differentiation into smell, taste, colour and texture and, finally, a ripening or rounding off into independent existence.

Now the fruit is finished and with it the plant for the first time has achieved *full three-dimensionality* and, at the same time, independence from the earth. What does this mean?

From One to Two to Three Dimensions

If we pause for a moment and look back at the whole of plant development from the seed to the fruit we can ask ourselves: what has been the journey of the plant into space?

In a simplified manner we could summarize this journey as follows: the plant starts its life as a *point* (the seed) and continues as a *line* (root and shoot). At rhythmical intervals the lines spread into *planes* (leaves) which tend to become more three-dimensional as we approach the flower. The flower is made up of individual planes which have lost their lines (stalks). The flower is already approaching a complex three-dimensional configuration with a briefly enclosed inner space created out of the planes of the petals and sepals. But it is only in the fruit that the plant achieves its final goal of creating a self-contained and *fully three-dimensional "body"* containing a dark central space within which something new can grow.

Let us for a moment dwell on these simple elements of point, line, plane and three-dimensional body.

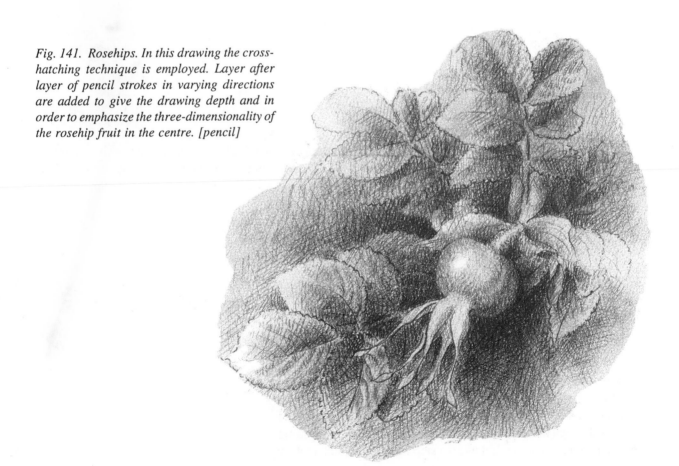

Fig. 141. Rosehips. In this drawing the cross-hatching technique is employed. Layer after layer of pencil strokes in varying directions are added to give the drawing depth and in order to emphasize the three-dimensionality of the rosehip fruit in the centre. [pencil]

Taking a Point for a Walk

What is a point? It is the smallest possible element we can imagine. Actually we can only think it, because, the moment we start drawing it with even the most carefully sharpened pencil – it no longer is a point. The "ideal" point has *no dimensions*, is infinitely small; it represents utmost contraction, concentration; pure potential or essence resting in itself.

Here the point has "gone for a walk" from one place to another, creating a line and with it the *first dimension*. How do we draw a line? We move the (less than ideal) point of the pencil across the paper leaving a trail of graphite dust behind us. *"A line is the trace of a movement"* Paul Klee stated. As we proceed from point to line we encounter the elements of activity, direction and movement in time.

What has happened here? The journey has taken the point back to its origin on a kind of circular walk creating an enclosed configuration. Looking at this drawing we become aware of something else:

A new element has emerged – the area encompassed by the line appears as a *two dimensional surface*. It is as if the moment we become aware of this enclosed surface, we no longer experience the line as a movement but as the outline of a fixed, static shape. As we proceed on our way through the dimensions the elements are gradually getting more concrete and tangible. Let us go a step further and add another element:

Fig. 142. "Taking a point for a walk". [pencil]

A second line creating another enclosed surface has been added. What do you actually see? With a little effort of our imagination the flat picture transforms into the *three-dimensional* image of a bent surface creating a hollow, bowl-like shape inside. This mental transformation involves our unconscious completing the image by adding what we cannot see:

This observation makes us aware that as we proceed from two to three dimensions we come to a realm which, in spite of being more "real" and tangible also confronts us with a profound mystery: We can never oversee a three-dimensional form in its entirety from one point of view. There is always something hidden from us which we can only discover when we change our point of view. And from every point of view the three-dimensional object presents us with a different sight.

If we want to represent a three-dimensional form on a flat piece of paper we have to resort to all kinds of "tricks" in order to create the *illusion* of the dimension of depth. These "tricks" include the use of linear perspective and light and shadow which have been "discovered" as artistic means by artists of the Renaissance and have been employed ever since.

This picture shows the final transformation which our point has gone through on its journey. The addition of light and shadow take us a further step into three-dimensional reality by conveying a sense of substance and weight. We are reminded of the fact that solid materials usually are three-dimensional and impermeable to the light. Their opaque surface *reflects the light*; their solid shape *casts a shadow*. The phenomena of light and shadow are intimately bound up with solid, three-dimensional matter.

Autumn Fruits – End or Beginning?

Autumn is the time of harvest, of reaping the fruits of the earth (and the heavens). It is an ancient tradition to celebrate this at the harvest festival with lush displays of harvested fruits and vegetables on the church altars. Imagine such a colourful display of big, rounded, juicy apples, pears, grapes, marrows, tomatoes, nuts of all kinds and other fruits of the earth piled up on a table. Such a richness of bulging three-dimensional forms with their contrasting shapes, colours and textures have inspired artists at all times to portray them in a "still life" composition (Fig. 143).

'Still life' – what does this actually signify? A still life portrays life, which has come to a rest. The ever changing and developing life of nature has been arrested for a moment in the artist's picture. In the still life as in the fruits the natural process has come to an end – or has it? Isn't life only held back, retarded and waiting, like the small seeds within these bulging fruits, for a new beginning? Is the still life "still alive"?

Another name for still life is the French "Nature Morte", which means "nature which has died". Having been taken from their living context in nature, aesthetically arranged on a table or in a bowl and illuminated by the light of an indoor space these fruits of the earth have become *objects* which in the artist's composition assume a new, human meaning. They appeal to our aesthetic sense as well as to our hungry stomachs (in which they would also assume a new meaning!).

The creation of every work of art implies an act of destruction or death and at the same time the building of a new context or whole. In a similar fashion also the process of human digestion is, to start with, a process of gradual destruction of the food substances which we take in. This process ultimately serves to sustain new life within us and to allow us to perform new deeds.

It seems fitting that in many still life paintings we find fruits, those parts of the plant which have achieved the most three-dimensional and independent existence and represent the final accomplishment, the "end product" of plant life – the final stage of evolution as food for humans. In fact, most of the parts of the plants that we eat have become "held back" and swollen at an earlier stage of development. They have become "fruit-like"; remember the potato – a swollen stem, cauliflower is held back swollen flower, fennel swollen leaf bases on a supressed stem.

Fig. 143. Still life with fruits by Caravaggio (1573–1610). This painting shows a basket overflowing with a harvest of autumn fruits. The artist skilfully represented the tactile richness of the various surfaces. Note the contrast between the bulging forms of the fruits and the withering leaves.

Drawing a Still Life

Let us complete this chapter with our own celebration of the three-dimensional richness of the fruit by composing some of them into a still life drawing. Collect some fruits of the season and arrange them into a composition which is pleasing to your eye. Try to have a variety of different shapes and sizes at your disposal and take your time to arrange them in an interesting way. You will need between three and five fruits. Don't attempt to draw more than that; it is easier to create a consistent composition with fewer elements.

The next step is to make a first outline sketch of the composition (Fig. 144), just using a few firm lines (pencil or Conté crayon) to outline the shapes of the fruits, their proportions and their relationship to each other. It is helpful to begin with the outline of the whole composition and then to proceed to the borderlines of the individual fruits (just as we did in Chapter 2 when we were drawing the oak). Pay special attention to the overlapping of forms, i.e. where part of one form is hidden by another. Always try to inwardly complete the parts which you can't see. If you pay heed to this and draw the outlines of your fruits with energetic, tight curves these first line drawings will already have a three-dimensional appearance. Don't hesitate to make several sketches of the same composition until you feel secure with the shapes, proportions and until your lines begin to convey something of the juiciness of fruit.

Fig. 144. *Still life composition. Start by outlin-ing the whole composition with a few faint lines. Then draw the contours of the fruits with a few generous lines. You might like to try out several different compositions, changing the fruits, their relationship to each other and the way you fit them onto your format. [Conté crayon]*

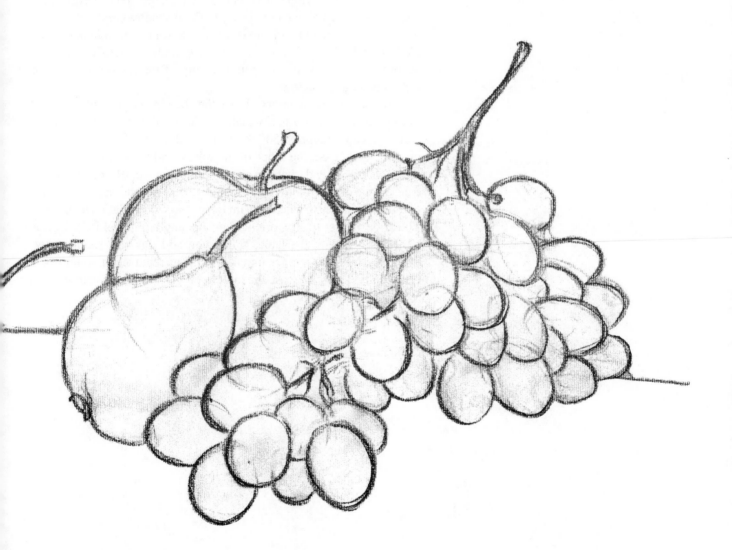

In the next step we shall enrich our drawings with the use of light and shadow and thus try to enhance the three-dimensional effect of the drawing. We suggest that you first practise this with a simple object such as a sphere. You may also use one of your fruits which has a simple spherical shape, for instance an apple. Put your chosen object onto a table near the window and observe how the sunlight illuminates it. The part of the object facing the window will appear light, the opposite side dark, with a more or less defined borderline separating areas of light from areas of shadow. Observe how the shape in which this line appears on the object depends on your point of view. It will change when you move. On the table you can see a second shadow which is cast by the object. If your object is a perfect sphere, this shadow will appear in the shape of an ellipse. Which is the darkest area in this arrangement? It will be that part of the cast shadow in the table which is "tucked away" underneath the object.

It is useful to do the same experiment in a darkened room replacing the sunlight with the light of a mobile electric lamp. You will find that the electric light will give more clearly defined shadows and harsh borders between the light and dark areas. Move the source of light and you can study how both the shadow on the object and the cast shadow change accordingly. This will give you a feeling of the relationship between light, object and shadow.

After some careful observation of the phenomena you might like to try to draw from memory that which you have observed. Take a sheet of cartridge paper (approx. 500 × 350 mm) and start darkening the background, leaving out the shape of the sphere and the surface of the table. Next you carefully darken the shadow on the object. Remember that the exact shape of the shadow will depend on where you imagine the source of light to be and also where you imagine yourself in relation to the object. The same applies to size, orientation and length of the ellipsoid shadow which is cast onto the table. When you add this cast shadow, try to experience what difference it makes to the appearance of your drawing. Can you feel how the cast shadow "grounds" the object and gives it a feeling of weight (Fig. 145).

Fig. 145. Sphere. This drawing showing the effects of light and shadow on a simple form was done from memory. [charcoal]

Having practised the use of light and shadow on a simple object we can now proceed to apply what we have learned to our fruit still life composition. Take a new sheet of paper and once more sketch with a few faint pencil lines the outline of the composition. Then begin to slowly fill in the various shades of light and darkness following the direction of the light. Start by giving the background a layer of middle gray, leaving out the fruits themselves. Then slowly work your way from the background towards the foreground giving each fruit its accompanying mantle of shadow. Finally you can add the cast shadows and strengthen and differentiate the darkness of the background where necessary.

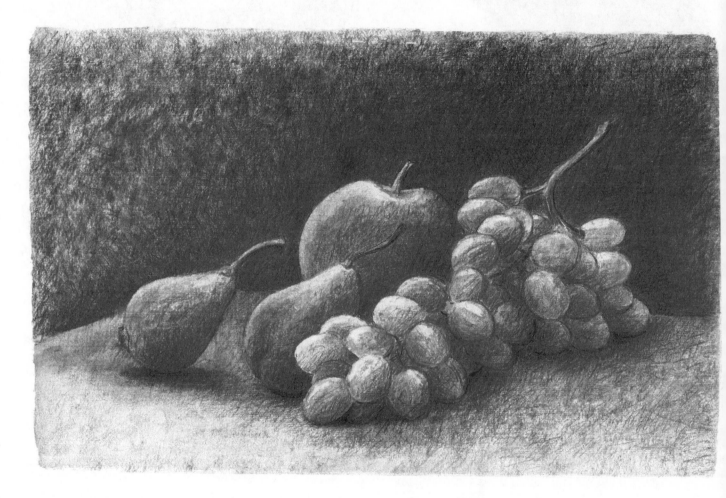

Fig. 146. Still life using light and darkness. Several layers of darkness were applied by using the flat side of the charcoal stick. You will find that after several layers it becomes increasingly difficult to apply more charcoal without actually removing some of the previous layers. In this drawing clouds of whirling lines, which were produced with the tip of the charcoal stick were added in the end in order to create the darkest areas of the background and to add some texture. [charcoal]

Apart from following the laws of shadow casting the success of your drawing will also depend on the proper use of *contrast* and *transition*. In order to spatially separate one fruit from another one behind it, there has to be sufficient contrast on the boundary between them. That means that you have to handle the "rules" with some flexibility and strengthen or lessen the darkness according to how much contrast is needed in order to set off the fruits from each other. If your fruits look like flat discs it probably means that the surfaces need more differentiation of tones, a more gradual transition between the darker and lighter tones.

This drawing will take you some time. Working slowly towards darker and darker tones has the advantage that for a long time you can change and adjust the different tones in relationship to each other and even change and move the contours of the objects. Don't be afraid to get darker – especially in the background. The richer the darkness, the more full-bodied your fruits will appear – provided you leave enough light on the fruits.

Have a look at the result (Fig. 146). Through the use of light and shadow the fruits in our drawing have become true "inhabitants" of three-dimensional earthly space as we know it. They have become imbued with a sense of substantiality, fullness, weight, juiciness. They are almost tangible in their three-dimensionality. If we manage to render the relationship between light, object and shadows in a fashion which is confirmed by our sense for truthfulness, completing such a drawing can be a very satisfying and "grounding" experience.

In the light of what has been said above you may now understand why working with the effects of light and shadow on solid objects is one of the exercises recommended by Rudolf Steiner to be used in the classroom for children entering puberty. At the time when the children make their final, often dramatic effort of growing their bodies, struggling to make themselves feel at home in this earthly vessel, they are given the chance to practise the same process outwardly in an artistic exercise which involves the "embodiment" of an object into three-dimensional earthly space.

7 New Eyes for Plants

Fig. 147. Branch of blackberry (Rubus fructicosus) showing different stages of development from flower bud to fruit. [pencil]

The Journey and Beyond

Now let us look at the journey we have taken together during the course of this book and reflect upon which "new eyes", if any, we have managed to develop during our wanderings through the seasons with their rich variety of plants encountered on the way.

If you remember, we began in winter when, "with cold blue eyes", we saw things *exactly as they are* in all their bare, grey, black and white winter nakedness. There was something mineralized in the way we drew and in the things we saw – grey stone-like skeletons of beech and hogweed sticks and seeds. Meeting them was much akin to meeting the earth itself or naked rocks – hard to penetrate, rejecting and separating. And yet, at the same time, we found we had, in the winter dreams and heavenly imaginations, a glimpse of the wonder and glory hidden within the things – a memory of last summer's white flowering hogweed lanterns and the lobed summer forms of oak and, at the same time, a foretaste of the future.

In Chapter 3 we sprang into spring-time and "flowed with" the growing movement of developing plants. The emerging leaf region itself showed us how to "tune into" and "swim with" the rapidly unfolding myriad of forms, each a transformation of the one before. In order to enter into this realm of plant development we found we had to "dream a little" compared with our winter way of looking, which kept us very much wide awake. We had to use our *imagination* to fill the gaps between the facts.

You might be reminded here of the first drawings we did in Chapter 1 – the "telephone pad scribbles" shown here again in Fig. 148. In the first one we were in the crystalline, wide awake winter world and in the second we entered more livingly into the imaginative world of metamorphosing forms – more reminiscent of plant growth than crystal formation.

In Chapter 4 we moved on from the dreamy, flowing, transforming nature of the growth process and began to analyse something of the gestures of the "creative movements" experienced in the shoot region, particularly in the leaves of dicotyledonous flowering plants. We discovered these transformative movements, although similar in all the samples we saw, were distinctly contoured by the "being" of each plant. We could recognise a plant by the way it "danced" its way through the leaf metamorphosis, each in its own distinctive style. A new "mode of observing" entered our experience as we started to recognise the patterns inherent in each plant. We had glimpsed something of this already in our first meeting with oak in Chapter 2.

Fig. 148. Exercises with straight (above) and round (below) lines from Chapter 1. [pencil]

This gave rise to a new kind of "awakening" – an excited awareness of the immense order in nature – of the wisdom behind the created world. Goethe called this way of seeing *"Seeing in Beholding"* (Anschauende Urteilskraft), sometimes translated as *"seeing with the eyes of the spirit"*. We all know the everyday side of this experience when we see something *as if for the first time*, and are able to say "I see" or "I know". In this is a true recognition of someone or something *other than oneself*.

Something within us has been able to resonate with something in the other and *re-cognise* that which we always knew and yet were unaware of. We glimpsed something of this in our first meeting with oak in Chapter 2.

We can find a comparison here of our own inner journey towards a revelation in consciousness. In the "becoming aware of", or "flowering" of the essence of an-other in oneself, we can see a similarity to the way the plant itself moves on its journey towards the flower. All the wonderful transformations in the leaf region are incomprehensible (or even unnoticed) until the plant flowers and then, in retrospect, their meaning is so obvious. Similarly the journey of getting to know someone or something is often like this. Again and again we reach a moment of recognition of the other for what it or he or she is which flowers in us again and again until at a certain moment there is the experience of inner union, of *"being at one with"*.

It is a state of being, of intimate union, known and described by artists, lovers and mystics – no less by scientists:

"The state of feeling which makes one capable of such achievements is akin to that of the religious worshipper or one who is in love."
Albert Einstein

Here you will feel we have moved beyond the flower into the fruit, to a new experience of "becoming one with". These move naturally from one into the other if we allow the experience to come to fruition. It involves a lot of preparatory hard work, just like the early stages of plant development, and then a certain state of surrender or sacrifice, like the flower, to allow something of a higher nature to be born within us.

We encouraged you to go on this journey for yourself in Chapter 5 with a flower friend by the wayside. One needs then to open one's soul to the other and trust in the communion that can result from such a quest. Having come this far, and allowed the grace of experience to speak from flower to inner soul, you will find you can never forget these moments. They bear fruit for the rest of one's life. In our everyday speech we are more than aware of these moments when we say that something like an idea "flowers" within us and "yields fruit" for the future.

"Fruits" of the Journey – Inner and Outer

In our journey through the plant world, as it is embedded in the cycle of the year, we came at last (in Chapter 6) to that season of mellow fruitfulness – to autumn, when the cycle of plant development comes to a certain end, bearing new beginnings hidden within. The fruit might be likened to a tangible picture in the outer world for the culmination or turning point of this inner cognitive human journey. It is no surprise then that the true fruits are the most perfect food for human beings In *eating* fruit we actually "become one with" the plant or it with us. In our digesting of the fruit, a new seed is born within us – for creative action in life. Without food we cannot function. It is our fuel for the future on a daily basis.

Fig. 149. Sketches of the cherry
blossom journey. [pencil]

In the autumn of the year we gather in the harvest which, stored, distributed and used throughout the year allows us to unfold our lives. In the autumn of our lives we gather in the harvest of life's fruits and prepare for a longer journey – a new life. In our journey of "getting to know" (science of every day), the fruits of our experience are food for our deeds (in daily art).

One might ask what is the point of all this? We have made a nice story and have shown, we hope, how the journey of discovery through the outer world of plants leads us into something of their "inner secrets". These are at the same time embedded in the cycle of the year in the outer world and also aid us in our own inner journey of "seasonal" transformation.

We might sum this up in the following picture:

fruiting	Fire/autumn	In the fruit we "become one with" the plant or whatever we study.
flowering	Air/summer	Flowering in the plant is like a revelation or lighting up of the essence of the being of things within ourselves.
shooting	Water/spring	The shooting of the leafy realm shows us the way to imagining development and a fluid swimming in-between the facts.
rooting	Earth/winter	The seed taking root in the soil is an activity similar to our "wintery" sense perceiving of the earthly element (the sense perceptible world of facts).

Fig. 150. Diagrammatic representation of a dicotyledonous plant. The whole plant becomes a picture of its (and our) dance through the seasons (and our seeing). [pen]

So the journey of plant development apparently has something in common with the journey of "getting to know" generally – of *"doing science"*. If we proceed along it we are granted gifts for being *"artists in life"*. In autumn we gather in the harvest of the year, take stock and plan, out of what we have experienced so far. The yield of the year gives a foundation for new seeds to germinate within us through the winter. We plan in autumn – design and organise in winter ready to *do* in the spring. The fire of autumn warmth nourishes us throughout the winter to be kindled by the spark of spring sunshine for new creations.

Art or Science?

It may by now have become obvious to you that the boundaries between art and science are not as clear as they were at the beginning of this book. We are all artists (of life) and we are all scientists (in life). The art or science of being human is to find a balance between these two inherent tendencies within us. We all study and we all are creative. Our striving in life's journey, one might say, is to take a little of the creative fountain of art into every scientific investigation and to allow science and the quest for true knowledge to nurture every artistic deed, whether it is painting a picture, making a sculpture, cooking lunch or answering the telephone in a busy office. Every experience of truth or inner lawfulness we have about the world will allow us to perform our daily tasks in life in quite a new way.

Apart from helping us in our daily lives, Goetheanism can play a major role in the life and work of professional artists and scientists. In the next section we will introduce in sketch form a few examples of the fruits of Goethe's science in our time. In our booklist are examples of how to take this further.

A New Sort of Science

In a 1992 Newsletter of the Scientific and Medical Network (No. 47) Willis Harman, President of the Institute of Noetic Sciences, Sausalito, California, writes:

> *"There is increasingly widespread agreement that science must somehow develop the ability to look at things more holistically. The 'separateness' assumption that underlies modern science is in a way an artifact of the history of Western creation"*

He goes on to argue for the development of a "Wholeness Science" for the future:

> *"'Wholeness Science' would include and emphasize more partici- patory kinds of methodologies; it would assume that, whereas we learn certain kinds of things by distancing ourselves from the subject studied, we get another kind of knowledge from intuitively 'becoming one with' the subject. In the latter case, the experience of observing brings about a sensitization and other changes in the observer. Thus a* willingness to be transformed *himself or herself is an essential characteristic of the participatory scientist."*

Goethe's way of science is one answer to this need that today is felt by many scientists. One could say that it is a kind of ideal way of doing science for which many people strive today. We cannot yet do it but Goethe has shown us the way. As Henri Bortoft (author of "Goethe's Scientific Consciousness") says, this way of doing science is *"an accomplishment yet to be achieved"* . (This statement was first made of the science which Galileo introduced to the world when he first attempted to quantify knowledge about things). Each attempt to use the method helps it on its way.

Finding the Order in Nature

One of the major contributions of Goethe's methodology to science has been in taxonomy – the science of understanding how plants and animals are organised into groups of "belonging togetherness" or wholes. The first attempts at an objective taxonomy took place in the 16th century when scientists and philosophers began to try and justify or rationalise the, until then, intuitive grouping together of different sorts of plants and animals. Many attempts were made throughout the following centuries until the Swedish naturalist Karl von Linneaus, out of an innate intuitive feeling for the connections between organisms together with a very exact capacity for observing and describing exactly what he saw, arrived at a system of classification which is still used today. The aim of *taxonomy* then (as now) was to classify and order the things of the world into comprehensible wholes. The individuals in the group may all be quite different but they have something in common which makes their "belonging togetherness" quite recognizable.

We have already discovered in Chapter 4 that in any metamorphosis something is consistent and something is changing. In the case of the metamorphosis of the leaves on the stem of the plant and into the flower it is quite clear that the "something" which stays the same is that particular plant and its potential to make leaf-like organs. This can be represented by the following diagram:

"Idea" of leaf ("Urorgan")

Leaves on stem and flower parts

If we now look at a single plant species, different examples of which have grown in widely varying habitats, we see that the "something" which stays the same is no longer an individual plant but the plant species, for instance yarrow (*Achillea millefolium*), and that which is changing is the form of the different plants which are influenced by the weather and by varying soil and light conditions (Fig. 151). We can illustrate this diagrammatically as follows:

Plant species

Plant individualities in different habitats

Fig. 151. Yarrow (Achillea millefolium) growing in two different habitats a few metres away from each other: in a sheltered hollow in the sand dunes, and on top of the sand dunes. [photocopies from pressed plant specimens]

a.

b.

Perhaps a little harder to comprehend but no less certainly also forming a "wholeness" are the various species or "cousins" of a plant within a wider grouping than species, the *genus;* e.g. *Senecio vulgaris* (groundsel), *Senecio jacobea* (ragwort) and *Senecio squalidus* (Oxford ragwort) are all different species within the same genus *(Senecio)*:

Senecio

Senecio vulgaris Senecio jacobea Senecio squalidus

Groundsel of the genus *Senecio* and yarrow of the genus *Achillea* are rather more distant relations within the family *Compositae* which are characterised by having a kind of "super flower" which is composed of very many tiny flowers in a "basket" (Fig 152).

Fig. 152. Section through a marguerite (Chrysanthemum leucanthemum). This compound flower is composed of many tiny flowers in a basket. The two kinds of flowers, (a) ligulate and (b) tubular, are shown enlarged on the left of the flower. [pen]

The *Compositae* is the largest plant family and represents a kind of culmination in the evolution of higher plants. Groundsel is one of the most common species in the largest genus within this family:

Compositae	Family
Senecio *Alchemilla*	Genus
Senecio vulgaris *Senecio jacobea* *Senecio squalidus*	Species
	Sub-species or plant individualities in different habitats (not the same thing)
	Leaves on stem of one plant

You can try looking out for members of the *Compositae* family in your garden and along the wayside! Can you recognize them as belonging to this family? You might find other cousins, brothers and sisters and will certainly experience wonderful changes in form from place to place. As you do this, allow your memory of previous encounters to reverberate in your soul. You will find that you are developing "new eyes" or organs of perception on a variety of different levels.

If you then try to encompass buttercups or roses, snowdrops or oak, you will find much larger gaps in the relationship. The *Compositae* have a clearly defined and recognizable "wholeness" which we describe as "belonging to the same family". It is both a strong *inner* experience and an *outer* means of classification, which excludes members of other plant families. You might like to try experiencing this for yourself with the buttercup or rose family once you have got to know them.

Fig. 153. Metamorphoses within the Brassica family : a. Brussels sprouts; b. cabbage; c. kale; d. cauliflower; e. kohlrabi.

Playing with Brassicas – an "Archetypal Experience"

You will find that "living into" any group of plants such as the *Compositae* (above), or now some members of the cabbage family *(Brassica),* that the quality of the gaps between the members will show you the nature of the relationship – as an inner as well as an outer experience. The laws of Nature (out there) start to be revealed on the (inner) stage of our own human organism. In playing with and inwardly recreating members of a species, a genus or a family we find that we can almost "taste" the colour or style of the group we are investigating and the "Eternal oneness in numerous manifestations revealed" starts to become the means of both our research and the verification of truths. The "type" of the Compositae becomes a tool for observation and recognition.

Take now the cabbage family and let's play a little with the edible ones. Brussels sprouts (Fig.153a) you will know are swollen side buds. Try contracting these and pulling down the stem, buds and leaves making a tight ball – a cabbage (Fig. 153b)! Or let the leaves expand and grow round and crinkly into kale (Fig. 153c). The stem swelling (reduce all buds) produces kohlrabi (Fig. 153e) and if the inflorescence is allowed to swell we find cauliflowers (Fig. 153d) (if it's one), calabrese or broccoli. Below the ground swelled radishes are a further step and, at the top, oil seed rape and mustard show the hot sulphur smell and taste within the seeds. All these plants are closely related; all show something of the sulphur hot taste and smell of cabbage. In the wallflower this is transformed into a heady sweetness in the flower – and no food for us or animals.

This is just a beginning to show a direction for you to play in. Try drawing one member, inwardly transform it into a relative and then draw the next. You may get to know the plants within a group so well that you can "invent" them.

In playing "games" like these we find we are actually entering into a deeply serious realm – that of Goethe's "serious game". When Goethe experienced the reality of the "Archetypal Plant" in Palermo he wrote to his friend Herder on May 17, 1787:

> *"Furthermore, I must confide in you that I am very close to discovering the secret of the plant generation and organisation, and that it is the simplest thing one could imagine . . . The archetypal plant will be the most magnificent creation in the world, for which nature itself will envy me. With this model and the key to it, one can go on inventing plants forever that must follow lawfully; that means: which, even if they do not exist, still could exist, and are not, for example, the shadows and illusions of painters or poets but rather have an inner truth and necessity. The same law can be applied to all other living things."*

The Archetypal Plant is no physical plant and yet it is within all plants – indeed it is that which allows us to "know" it is plant – that archetypal plantness (or that which is "of the archetype" which is plant-like. Goethe also said:

> "The Archetype is one and alone. That we speak of a plurality is not well done".

We might wonder about this "Universal Oneness" – *the* Archetype of which there is only One and which is manifest in all life. In St. John's Gospel at the beginning we read (from the New English Bible):

> "When all things began, the Word already was.
> The Word dwelt with God, and what God was, the Word was.
> The Word, then, was with God at the beginning, and through Him all things came to be; no single thing was created without him.
> All that came to be was alive with His life, and that life was the light of men."

When we "see" something truly with understanding, it is as if a light goes on within us. Meeting a flower, as the more physical representation of the being of a plant, is much akin to switching on the light of understanding/knowing. We do this in everyday life when we see something and say "I know" or "I see" you. There is a flash of recognition. When we allow ourselves the space; time to really meet, to see something or someone, then perhaps we touch, or are touched by a little of the true Name or aspect of the Word or Logos that is in all things that are made and is particularly experienceable in those things that are still alive.

At the incarnation of the Logos (at the first Christmas) we see often painted a red rose or garland of roses around Mary (Figs. 117 and 154). There is a deep secret hidden within the heart of the rose that accompanies the birth of Christ – a God has come down to earth and been made flesh. You might like to dwell on this – at Christmas – or at midsummer when the roses flower. The fruits of the brothers and sisters of the rose are the most perfect food for human beings or "fallen angels", as we are often called.

"Better and sweeter are they than all other plants and rightly called the flowers of flowers. Yes, roses and lilies, the one for virginity with no sordid toil, no warmth of love but the glow of their own sweet scent, which spreads further than their rival roses, but once bruised or crushed turns all to rankness. Therefore roses and lilies for our church, one for the symbol in His hand. Pluck them, oh maiden, roses for war and lilies for peace and think of that flower of the stem of Jesse, lilies His words were and the hallowed acts of his pleasant life, but His death re-dyed the roses."

Walahfried Strabo (809–849), abbot of the Reichenau monastery, Germany

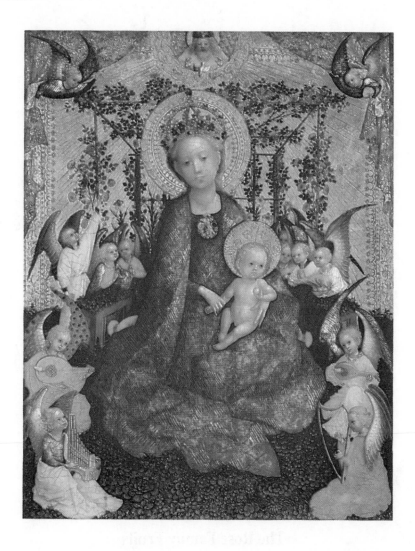

Fig. 154. *"Madonna in the Rose Garden" by Stefan Lochner.*

Fig. 155. Twig of cherry with fruit. [pencil]

Fig. 156. Section through cherry fruit [pen].

The Rose Family Fruits

Imagine that you are walking along our, by now familiar, walk. It is late summer. The leaves have entered their late summer phase of heavy green and begun, on the cherry trees, to droop on those tall trees beside the way (Fig. 155). Hidden here and there under the drooping leaves are cherry 'drops' – turning from orange to scarlet to deep purple-black. Some have fallen forming squashed purple splodges under foot. Some the birds have found with vocal joy. Our pleasure is none the less if we manage to reach a handful. The heavenly sweetness evaporates in a moment of brief enjoyment before the hard stone is rejected and joins the autumn debris on the ground.

Fig. 157. Twig of bramble
(Rubus fruticosus) *with
fruits. [pencil]*

Nearby are ripening blackberries on the other side of the path (Fig. 157). You might already have noticed a resemblance to the cherry in the five-petalled flowers you saw last month which followed hard on rose (their five-fold story we met in Chapter 5). The petals have fallen off the blackberries, a few stamens remain sitting on the rim of the receptacle around the swelling green central fruit. Looking carefully we find that these fruits are composed of a multitude of rounded green balls stuck closely together to form a whole, the future bramble (Fig. 158). Each one of these has a tiny, hair-like protuberance (the stigma) from the outer tip of the ball. Each ball contains a hard seed (which tends to get stuck between our teeth when we finally eat the bramble). Perhaps you can see already how blackberries are rather like "compound cherries" with reduced flesh and seeds. Can you make the movement inwardly by closing your eyes and "seeing" into the in-between of the relationship between a cherry and a blackberry? Shrink the fruit and allow several to grow on a slightly extended stem. Raspberries *(Rubus idaeus)* growing in the woods nearby also have a similar structure. If now, instead of shrinking the cherry we allow the fleshy part and the stem to expand we find it is not difficult to arrive at plums, nectarines, peaches or apricots. These fruits are all organized in the same way as the cherry (one seed inside a fleshy fruit, which is a swollen "leaf" (carpel)). They even had the same sort of flower but the fruits are, when ripe, much larger than the cherries.

Fig 158. Section through
the blackberry. [pen]

Next we can try inwardly letting the fruits of the blackberry become smaller, harder and drier in our imagination, and the stem, which bears these tiny fruits, expand, swell and finally turn red. We arrive at strawberry fruits (Fig. 160). That part of the strawberry plant which we enjoy so much with cream on mid-summer afternoons, is actually the swollen stem (Fig. 159). Perhaps this is why we can't eat quite so many strawberries as cherries all in one go! (In some countries they are called "earth-berries".)

Fig. 159. Section through strawberry. [pen]

Fig. 160. Twig of strawberry (Fragaria vesca) *with fruits. [pencil]*

Fig. 161. Twig of dog-rose (Rosa canina). *[pencil]*

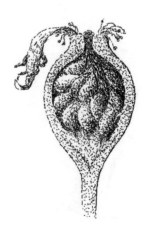

Fig. 162. Section through rosehip *[pen]*.

Now let us stretch our sculptural imagination even further. If we push the strawberry down into the hardened part of the stem below the flower and allow this part to become a swollen cup-like form we find that we end up with another fruit which we recognise from our walk (Figs. 161 and 162). Rosehips are forming under the five-fold calyx of the dog-rose adorning the hedgerows of our wayside. As the blackberries swell, the strawberries have come to a final end and the cherries are ripe and falling, rosehips sit squat on short stems like green, upright vessels turning slowly to yellow, orange and red as the leaves accompany their colour transformation. These red sentinels are often still there, shining red, at Christmas in the first snows.

Fig. 163. Twig of apple tree with fruit. [pencil]

Fig 164. Section through apple. [pen]

Another close cousin which survives the autumn gales and still hangs, gold and red in the darkening trees in November – if they have not been plucked and stored, are apples (Fig. 163). They (especially crab-apples) have much in common with the rosehip – both being somewhat tart and full of health-giving vitality. Can you see how the apples (pears and quinces too) are also swollen stems with colourful hardened skins (Fig. 164)? There is something "earthy" about these fruits. They are harder to digest, often harder to chew; even granular. They are the natural food for horses, cows and pigs – large, hoofed, earth oriented animals; compare these with the polar opposite type of fruit, the cherries, which are food for birds – animals which are nearer to heaven (like the taste of the fruit).

Perhaps you can already get a glimpse here of the story which is beginning to unfold (Fig. 165). The order within the Rose Family fruits, if we start to play with the fruit sculpturally and imaginatively, reveals itself as a continuous sequence between the polarities of fruit made of single swollen leaves, each containing one seed and the other fruit made of swollen stems with several (five) true fruits – the core of the apple – all linked together bearing up to 10 seeds. These "poles" of the family are all borne on tall trees. In between are smaller shrubs and herbs which build a transition between these two opposites. We even find the polarity reflected in the animals which eat these fruits – ungulates (hoofed animals) and birds – animals which reflect opposite ends of our own being (the birds are more akin to the bright, wide-awake head part of our organisation and in our digestive system and limbs we are more closely related to cows and horses). But here begins another story which can only be hinted at here (and may become the content of another book) – the question of the relationship of the animal kingdom in its different families to the human being.

Perhaps you can begin to see something of an echo in this family of our own organisation. To do this work justice would need many more pages. The Goethean research on the Rose Family was originally done by Gerbert Grohman and his writings – now translated into English as "The Plant I and II" – will take you further, should you wish, on the journey. Thomas Goebel, who made the drawings, as a young man, for Grohmann's books, later took the work on the Rose Family much further and in his book "Die Pflanze als Organon", unfortunately not translated into English, you can follow the story much more deeply and scientifically embrace many other members of this family and their metamorphoses.

Fig. 165. Diagram illustrating the metamorphosis of fruits within the rose family. From left to right: apple, rosehip, strawberry, blackberry, cherry. (After: Goebel, "Die Pflanze als Organon")

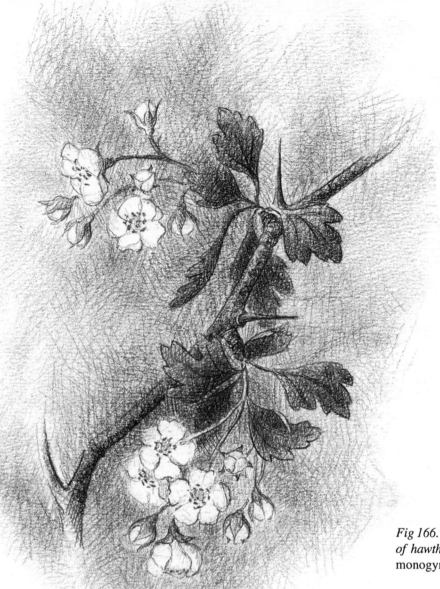

Fig 166. Flowering twig of hawthorn (Crataegus monogyna). *[pencil]*

Hawthorn

Just to complete our sketch and to pay tribute to our publisher, Hawthorn Press, we would now like to introduce one last member of the rose family which is rather more important medicinally than as a food plant – the hawthorn *(Crataegus monogyna)*. Hawthorn grows on the edge – of woods and fields. It is the *edge* in the hedge. It forms the in-between layer between open green land and the woods, between small shrubs and big trees. It is even a kind of in-between in our sequence of fruits. The fruit is formed from the swollen stem. This bright red, shiny haw, has a floury (rather than juicy) content which is rather bitter. Inside is one single true fruit, dry with a seed inside – something like a hard, dark rosehip with a single seed.

The hawthorn tree can grow to a height of 60 feet in a free-standing situation. The trunk is blue-grey and the wood within very hard. The tree lives a long time and thickens slowly. It is traditionally used for making small boxes or containers and burns with a heat greater than that of any other wood.

In spring time the grey criss-cross of branches start to burst forth in intensely green clusters. Known to us as children as "bread and cheese", the bursting buds are a welcome mouthful of fresh greens in the early spring. By May the blossom adorns the trees and hedges in lobed pink and white clusters – clouds of whitened pinkness covering the trees, bushes and hedges of England. Its very name is "May". The blossom smells sweet at a distance but does not "fly off" in fragrance. The smell is held back and drips in sourness downwards attracting flies to pollinate the tiny blossoms leading to fruit setting within the white clusters.

Then hawthorn quickly sends vigorous new shoots out and up bearing reddened stems and black-red leaves. These will eventually harden into richly foliated long green shoots that will bear next year's flowers and fruit from their leaf axils. Sitting close on the older, grey stems are clusters of leaves with no flowers and then here and there, short shoots with similar leaves to the long (red) ones, bearing thorns at the tips.

Thus we find four ways of growing, four types of exchange between centre and periphery. A solid, vital heat-bearing core and a disintegrating cloud of white presence towards its edges. The fruit in autumn is a repetition in sketch form of the whole with its hard central core and soft flesh of the fruit – food for birds and mice in deepest winter.

Living into the rhythm of hawthorn's growth and, in Goethe's words: *"recreating its creating"* we find it breathing in and out with its environment. It responds to multiple aspects of light, wind and mechanical manipulation (by man and animals). We enter, with the hawthorn, into an inner experience of pulsing and flowing between a "contained" periphery and a central "bursting" core. We are immediately present within our own bursting heart beat and the flowing circulation at the periphery of our own being.

Hawthorn proves to be an important medicinal plant which regulates the rhythm between the heart-beat and the circulation of the blood. Its intensive green shoots in spring sprouting from the grey winter stems send surges of new life into us and cleanse our blood of spring-time tiredness. A few drops of the tincture of spring-time flowers taken in the morning of the day (the spring-time) and a few drops in the evening (day-time autumn) of the autumnal fruit tincture will bring balance to many a heart trouble in today's age of stress and hectic pace.

In this brief glimpse of hawthorn we are led towards the wealth of discovery waiting to be made in the natural world (plants in this case) of processes of growing and being that correspond to imbalances within our own (human) organism. Such research, when carried out in depth, can form the basis of new medicines. A study of the plant, its way of growing, its substances and self-expression conducted together with research into the human organism in health and illness can lead to the development of creative pharmaceutical processes and the production of modern medicines that are a healthy alternative to our widespread chemical drugs. Thus a new wholistic science can help to fertilise the art of healing and wholeness (making whole).

On this note we will draw this odyssey to a close. We hope very much that you have been fired somewhat to make your own discoveries within and to draw with renewed vigour from the great *Book of Nature* with your *"New Eyes for Plants"*.

Preserving Plant Specimens and Making Leaf Sequences

Pressing Plants and Leaves

In order to press and preserve plants, as we have done on pages 80 and 175, and to make a leaf sequence as used in many places in the book, you will need good, dry specimens. Pick the plant when it is fresh, but preferably without dew drops or rain. If you want to preserve the whole plant the soil should be removed from the roots and the plant laid out with all the parts (leaves, stem, flowers) arranged to best effect on a piece of absorbent paper such as thick blotting paper (several layers of newspaper will also do the job). Another layer of blotting paper (or newspapers) should be placed carefully on top. Then a board to cover the whole and on top of this a heavy weight. This can be done on the floor, a table or any other flat, smooth surface. Of course if you have access to a plant press that is the very best, but often the more popular ones are not big enough for whole plants. If you are making a leaf sequence then choose a plant with as many leaves as possible intact, especially the first ones (even the cotyledons if they are present); the middle ones not chewed or nibbled and the top ones fully opened. Peel them off very carefully from bottom to top and lay them side by side on your paper in the order in which they grew on the plant. Then proceed as above with pressing. Your plant and/or the leaves will need to have the paper changed on a regular basis until all the moisture has been absorbed. How often this is done will depend on the humidity of your environment and the amount of water in the plant. Try changing the paper daily at first for a few days and then less often until it does not feel moist at all on removal and the leaves are quite dry. It is better to be over-cautious when drying plants. If you cover them before they are really dry they will go mouldy (especially in the south and west of Britain!)

Laying Out a Leaf Sequence

When your leaves are completely dry, lay them out on a piece of paper or card exactly as you would like them to be ordered (see pp 77–78). Take another piece of card exactly the same size and cut out some book-binding

plastic foil either slightly larger or the same size as your card. Peel off the backing and lay the transparent sheet sticky side up on your second piece of card. Now transfer all your leaves one by one – (it is best to use blunt tweezers for this job) – onto the sticky surface in a mirror image of your layout (Fig. 167). When all the leaves have been transferred, take your original piece of card, place one edge along the edges of the sticky side of your folio, and lower it slowly into place over the leaves, pressing gently as you do. Smooth everything flat with a duster or soft cloth. Any bubbles can be eased out carefully with light pressure movements. If you had left edges on the sticky paper, the corners can be cut now and the edges folded over to make a neat finish.

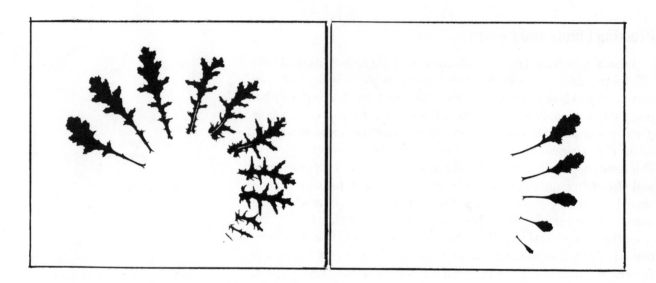

Fig. 167 Dried leaves arranged on card are then stuck in mirror image on the sticky side of plastic.

Preserving Plant Specimens under Plastic

Whole plants, if they are small, can also be treated in the same way as the leaf sequence. Flower parts, if they are very dry can be stuck directly onto the sticky material. For larger plants it is better to stick them with little dabs of glue onto a sheet of card and then cover this with sticky-backed plastic. In this case you leave the backing on the rolled-up piece of folio. Peel off one edge and stick this to your card matching edges. It is best to apply it just to the edge furthest away from you. Then unroll the folio pressing it lightly with a soft cloth over the plant as you peel the backing off the folio below. This is quite a tricky process and it is advisable to practise with small piece of card and sticky material and no plants until you know where each hand has to be when!

Preserving Plant Specimens in a Herbarium

It is often preferable to preserve plant specimens in a herbarium. For this you will need to make or buy card folders to suit the size of your plants. The dried and pressed plant itself should be attached to a sheet of card with little strips of gummed paper or masking tape. Cover with a sheet of thin or greaseproof paper and place it in your folder (Fig. 168). Always remember to label your specimens with the species name, date and place found. A small piece of paper should accompany your plant from the world outside through all the pressing process until you have labelled the plant neatly in its final resting place.

Protective Paper

Plant Specimen on card

Stiff card

Fig. 168 A plant in a herbarium.

Appendix II
Book List and
Places of Learning

Book List

If you would like to go further, and somewhat deeper, on the journey we have begun together here, the following books will help you on your way:

Adams, G. amd Whicher, O. (1980) *The Plant between Sun and Earth*. Rudolf Steiner Press.

Bockemühl, J. (1981) *In Partnership with Nature*. Biodynamic Literature, Rhode Island.

Bockemühl, J. et al (1985) *Towards a Phenomenology of the Etheric World*. Anthroposophic Press.

Bockemühl, J. (1986) *Dying Forests – A Crisis in Consciousness*. Hawthorn Press.

Bockemühl, J. (1992) *Awakening to Landscape*. Natural Science Section, Dornach.

Bortoft, H. (1986) *Goethe's Scientific Consciousness*. London: Institute for Cultural Research Monograph, Octagon Press.

Goethe, J.W.v. (1978 edn)*The Metamorphosis of Plants*. Introduction by Rudolf Steiner. Biodynamic Literature, Rhode Island.

Goethe's Botanical Writings (1952 edn). Translated by B. Muella. Honolulu.

Grohmönn, G. (1974) *The Plant: A Guide to Understanding its Nature*. Vols I and II. Rudolf Steiner Press, London.

Miller, D. (1988) *Goethean Scientific Studies*, Suhrkamp.

Steiner, R. (1989) *Goethean Science* (republication of *Goethe the Scientist*), Mercury Press.

Places of Learning

If you would like to enter more deeply into the world we have introduced here, the following places offer courses in Goethean Science and Art in the English language:

The Life Science Seminar and Life Science Trust, Kirk Bridge Cottage, Humbie, East Lothian EH36 5PA, Scotland

Emerson College, Forest Row, Sussex RH18 5JX, England

Rudolf Steiner College, Fairoaks Boulevard, Sacramento, California, USA

Acknowledgements

The authors gratefully acknowledge the use of the computer rose image on page 18 from *The Algorithmic Beauty of Plants* by Przemyslaw Prusinkiewicz and Aristid Lindenmayer, published by Springer Verlag, New York, 1990; and 'The Ideal Plant' on page 97 from *In Partnership with Nature* by Jochen Bockemühl.

Other Books from Hawthorn Press

Creative Form Drawing 1, 2 & 3

Rudolf Kutzli

These three workbooks aim to encourage people to explore in detail the ways in which forms are created. The exercises provided give a fascinating insight into the relationship between form and content.

Workbook 1
297 x 210mm; 152pp; sewn limp bound; fully illustrated; £14.95
ISBN 0 950 706 28 0

Workbook 2
297 x 210mm; 152pp; sewn limp bound; fully illustrated; £14.95
ISBN 1 869 890 14 0

Workbook 3
297 x 210mm; 152mm; sewn limp bound; fully illustrated; £16.95
ISBN 1 869 890 38 8

Drawing and Painting in Rudolf Steiner Schools

Margrit Jünemann and Fritz Weitmann

This comprehensive account of painting and drawing in the Steiner curriculum combines detailed practical advice with clearly defined philosophy on aesthetic education. The book takes readers carefully through each stage of Steiner art teaching, suggesting appropriate exercises and developments in the curriculum at appropriate stages of pupils' attainment. A vital reference source for all who are involved in teaching in Waldorf schools and an inspiration to all who are concerned with a child's creative development and fulfilment.

170 x 240mm; 206pp; paperback; colour and black & white illustrations; £19.95
ISBN 1 869 890 41 8

Sing Me the Creation

Paul Matthews

This is an inspirational workbook of creative writing exercises for poets and teachers. It provides over 300 exercises for improving writing skills and developing the life of the imagination. Although these exercises are intended for group work with adults, teachers will find them easily adaptable to the classroom. Paul Matthews, a poet himself, taught creative writing at Emerson College, Sussex.

135 x 238mm; 226pp; paperback; £10.95

ISBN 1 869 890 60 4

Orders

If you have difficulties ordering from a bookshop
you can order direct from

Hawthorn Press,
Hawthorn House,
1 Lansdown Lane,
Lansdown,
Stroud,
Gloucestershire GL5 1BJ,
United Kingdom

Telephone 01453 757040
Fax 01453 751138